"EVERY CULTURE IS
A PRECIOUS FLOWER THAT
DESERVES TO BE PRESERVED AND
CULTIVATED. IT WILL MAKE
US MORE HUMAN."

—E. GENE SMITH

BHUTAN
THIMPHU

ASSAM
Guwahati Dispur

NAGALAND
Kohima

Shillong
MEGHALAYA

MANIPUR
Imphal

BANGLADESH

TRIPURA
Agartala Aizawl

MIZORAM

DACCA

MYANMA
(BUR

Kolkata

Digital Dharma

RECOVERING WISDOM

Dafna Zahavi Yachin and Arthur M. Fischman

with the
Buddhist Digital Resource Center

● SEATTLE

● NEW YORK

UNITED STATES

St. Pierre
and Miquelon
(FRANCE)

Azores
(POR.)

Bermuda
(U.K.)

Madeira
(PO

Cana

MEXICO

THE
BAHAMAS

CUBA

Oh, my ? *Aksisuang D H,¿ Duugpu,*

Have you returned from India?
Did you feel tired and weary on the journey?
Has your mind been sharpened and refreshed?
Has your voice been good for singing?
Did you practice and follow your Guru's instructions?
Did you secure the teachings that you wanted?
Did you obtain all the various instructions?
Have you gained much knowledge and much learning?
Have you noticed your pride and egotism?
Are you altruistic in your thoughts and actions?
This is my song of welcoming for you,
On your return.

In reply, Rechungpa sang:
Obeying my Guru, I went to India.
My journey was hazardous and full of fear,
I underwent great pain and toil—
But the trip was well worthwhile.
I saw Dipupa, the great Tantric Master,
And met Magi, the great Yogini.
Also I saw the wondrous Patron Buddha
And witnessed fulfillment of the Dakinis' prophecy.

།རྒྱ་གར་ཡུལ་ནས་འཁོར་ལགས་སམ།
།གཞི་དང་ལམ་བར་ཐམས་ཅད་དུ།
།ཁྱུས་མེམས་ངལ་བས་མ་དུབ་བམ།

།བློ་དང་རིག་པ་བཀྲ་ལགས་སམ།
།མགུར་དང་གྱེ་སྟེ་བདེ་ལགས་སམ།
།བླ་མའི་གསུང་བཞིན་བསྒྲུབ་ལགས་སམ།
།འདོད་པའི་དམ་ཚོས་ཐོབ་ལགས་སམ།
།གདམས་ངག་མ་ཐོབ་དགུ་ཐོབ་བམ།

།ཡོན་ཏན་མི་ཤེས་དགུ་ཤེས་སམ།
།ང་རྒྱལ་རང་མཐོང་མེད་ལགས་སམ།
།བྱས་ཆད་གཞན་དོན་ཡིན་ལགས་སམ།
།རས་ཆུང་བྱེས་ནས་སླེབ་པ་ཡི།
།ཆོན་སྐྱེས་ཐུན་ག་དབངས་ལ་མཆོད།
།ཅེས་གསུངས་པས།

།རས་ཆུང་པས་ཞུས་ལན་དབྱངས་འདི་ཕུལ་ལོ།
།རྗེ་བླ་མའི་བཀའ་ལུང་ཌོ་རྗེའི་གསུང་།
།བསྒྲུབ་ཕྱིར་རྒྱ་གར་ཡུལ་དུ་ཕྱིན།
།ལམ་འཕྲང་འཇིགས་པ་ཆེ་བས་ན།
།དཀའ་སྤྱད་སྡུག་བསྒྲལ་མང་པོ་བྱུང་།

The Deities and Gurus were all well pleased,
And my mind united well with theirs.
Like a rain of flowers,
Accomplishments fell upon me.
Heavenly food was fed into my mouth,
The Pith-Instructions were put into my hand.
In farewell, the Deities wished me good luck.
My desires were met and success was won.
 Like the rising sun
My heart is bright with joy.
Now I am back, my Jetsun Guru!
Now I give you the Dakinis' teachings!
Please observe them,
Praise and serve them—
The holy Dharmas that have brought me my
 achievement.

—excerpts from *The Hundred Thousand Songs
of Milarepa*, translated by Garma C. C. Chang

ཁོན་ཀྱང་དགའ་བ་སྐྱུད་རིན་ཆོག
ཅི་ཕུ་གསང་སྔགས་སྟོང་པོ་དང་།
ཁ་གཅིག་གྲུབ་པའི་རྒྱལ་མོ་མཛད།
ཚོ་མཆོར་ཆེ་བའི་ཡི་དམ་མཐོང་།
མཁའ་འགྲོའི་ཀྱུང་བསྟན་ཏུགས་དང་མཛད།

སྐུ་དང་བླ་མས་མཉེས་མཉེས་མཛད།
བདག་དང་ཐུགས་ཡིད་གཅིག་ཏུ་འདྲེས།
དངོས་གྲུབ་མེ་ཏོག་ཆར་བ་བབས།
ལྷས་བཟང་རྟེན་འབྲེལ་མགུལ་དུ་བཏགས།
ལྷ་ཡི་ཁ་འབབས་ཁ་རུ་བཅུག
མན་ངག་དམར་ཁྲིད་ལག་ཏུ་གཏད།
བཀྲ་ཤིས་སྨོན་ལམ་སྐྱེལ་མ་མཛད།

ཁོའི་ཆེན་བསམ་པ་དགུང་དུ་འགྲུབ།
དགའ་སྤྲོ་སྐྱིད་པའི་ཉི་མ་ཤར།
ད་ནི་བླ་མ་རྗེ་བཙུན་མཛད།

ལུས་མེད་མཁའ་འགྲོའི་ཆོས་སྐོར་སོགས།
བདག་གིས་ཐོབ་པའི་དམ་ཆོས་ལ།
གོང་དུ་ཕྱིན་ལས་འབྱུང་བའི་ཕྱིར།
ཐུགས་ལ་ཨེ་འཕོད་གཟིགས་ནས་ཀྱང་།
མཆོད་བསྟོད་མཉམ་གསོལ་མཛད་པར་ཞུ།

Remembering Peter Gruber

PETER GRUBER was intellectually curious and a lifelong seeker. Like E. Gene Smith, he recognized the importance of Tibetan wisdom texts and, in his own way, sowed the seeds for what would become Gene's historic effort to preserve a culture.

Fleeing Nazi occupation in his native Hungary with his family in 1938, young Peter briefly settled in Calcutta and was soon sent to school in the foothills of the Himalayas. There he met Garma C. C. Chang, who introduced Peter to Tibetan Buddhism—an experience that would provide Peter with a rich spiritual foundation for the rest of his life. In return, Peter shared his knowledge of the English language with Chang.

After briefly studying textile engineering in Australia, Peter worked on Wall Street. Following a stint with the US Army Finance Corps, he returned to Wall Street, where he eventually built a successful asset management business and became known as a pioneer in emerging markets. Financial success enabled him to support his interest in Tibetan Buddhism. Now a Buddhist, he founded the Oriental Studies Foundation to publish English translations of Tibetan Buddhist works. His first endeavor was Chang's translation of the Tibetan classic *The Hundred Thousand Songs of Milarepa*, which is still in print. With Peter's support, Chang would go on to translate other Buddhist classics.

Through a mutual friend, Peter and and his wife, Patricia, were introduced to Gene Smith and his project of preserving Tibetan wisdom texts through digitization. Gene and Peter developed a deep friendship and mutual appreciation rather quickly. Gene called Peter's foreword to *The Hundred Thousand Songs of Milarepa* "a marvelous piece of philosophical thinking about the relationship between spirituality and science." Of Gene, Peter said: "He was like the prophets of the Old Testament, or the preeminent writers of the New Testament. . . . He expressed Buddhism with another set of eyes."

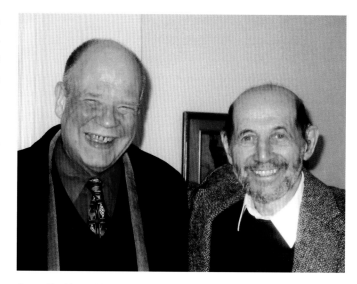

Gene Smith and Peter Gruber

The Peter and Patricia Gruber Foundation grew out of Peter's wish to leave the world a better place by investing in individuals of great promise. The foundation is well known for awarding prizes in the sciences and social justice. As he famously explained: "I throw my glass so that others would throw their jade."

While Peter is no longer here to share his brilliant insights, whether in the form of a poem, or the wit and wisdom he managed to infuse into each conversation, Pat has continued the mission they shared. Through her work establishing the Peter and Patricia Gruber Foundation at Yale University and serving as the foundation's past president, and as a longtime board member of the Tibetan Buddhist Resource Center, she has carried forward their joint vision and Peter's inspiration. It is due in large measure to Pat Gruber's encouragement and assistance that Gene's remarkable story has received the public recognition and appreciation it so richly deserves.

We honor Peter's memory in gratitude for the broad scope of his inspiration and generosity.

CONTENTS

PROLOGUE BY DZONGSAR KHYENTSE RINPOCHE, THUBTEN CHÖKYI GYAMTSO

IN THE 1970S I used to visit Gene Smith at his Delhi home, together with two of his spiritual advisors, Kyabje Dilgo Khyentse Rinpoche and Dezhung Rinpoche. Gene was at that time serving as Delhi field officer for the United States Library of Congress.

I still vividly recall how Gene's home was like an exquisite Tibetan Buddhist library, with every room beautifully stacked and arranged wall to wall with Tibetan Buddhist manuscripts—almost all of them carefully printed under his own supervision. But the real miracle is that Gene had personally tracked down and found these precious original manuscripts, which, at that time, were literally on the brink of destruction and disappearance.

Not only that, but Gene Smith's knowledge of Buddhism and Tibet and his mastery of the language were so good that even Tibetan scholars were awed speaking with him about Buddhist philosophy, Tibetan history and language, and more. Years later, when I visited Gene Smith in Indonesia where he had been transferred by the Library of Congress, he was already well on his way to full fluency in Bahasa Indonesia. Yet his affinity remained Tibetan, and there, too, his house was filled with Tibetan Buddhist manuscripts.

When I stayed with him in Jakarta, Gene was the most hospitable host. As his guests, we could do whatever we liked—feeling entirely at home and going in and out whenever we wished. But there were just a few things on which he insisted. In those days before mobile phones, Gene only let us use his personal landline for which he himself paid, never the phone for which his government paid. And he always used Indonesian taxis for everything personal, never using his US Embassy car for anything except trips to work and back.

Such was the integrity of this man that I used to think that the reason the United States of America was so powerful and influential was that it had people as dedicated and honest as Gene Smith working for them.

It's hard to express or even fathom Gene's direct and indirect contribution to Tibetan Buddhism through the preservation and publication of so many of these rare texts. Let's just say that if a Tibetan native had done even a small fraction of what Gene Smith did for Tibetan Buddhism, he would almost certainly be considered a renowned *tulku*.

Years before Gene passed away, he asked my opinion about where he should donate his extraordinary lifetime's collection of precious texts. A few days later, he came up with a decision that would never even have occurred to me: He decided to offer all of it to the Southwest University for Nationalities in Chengdu, China. Such is the unbiased and far-reaching vision this man embodies.

At a personal level, I must add that many of my current endeavors in the Khyentse Foundation and 84000 owe so much to Gene for his guidance and inspiration.

We cannot forget Gene Smith!

MATTHIEU RICARD REMEMBERS GENE

AT THE END of the 1970s, I made four trips of several months each to Delhi to print fifty volumes of precious Tibetan texts for the monastery of Kangyur Rinpoche and his son Pema Wangyal Rinpoche in Darjeeling, where I lived for seven years.

It was also during these visits to Delhi that I met E. Gene Smith, an unparalleled scholar who was, by all accounts, the most learned Tibetologist of the twentieth century, and who made a major contribution to safeguarding the scriptural heritage of Tibet. He was appointed director of the Indian office of the US Library of Congress and accepted this position with the aim of contributing to the preservation of Tibetan texts. Due to a fortunate set of circumstances, the Indian government had to repay in local currency a debt owed to the US government, which enabled Gene to finance the efforts of Tibetans to print the rare and valuable texts they had brought with them when fleeing the invasion of Tibet by Communist China. The Library of Congress would buy fifteen to twenty copies of each volume at a very good price, enough to cover the cost of printing two hundred copies, which the Tibetans could then distribute to monasteries, practitioners, and all those who needed them, or they could sell them at cost if they printed more.

Gene Smith took me under his friendly protection and, on my third visit to Delhi to print texts, generously invited me to his home in an airy district of New Delhi—indeed, much more comfortable conditions than the very modest room I was renting in Old Delhi near the printing house. I would take the bus in the morning to the printing house on the other side of Delhi and return in the evening after completing my work.

Gene constantly received Tibetans who brought him texts and asked him if the Library of Congress would be willing to take them. He had an encyclopedic knowledge and could immediately see whether the book in question would be a rare gem, useful to the heirs of Tibetan culture and scholars, or a mere duplicate of a book already available. Sometimes he would shout with enthusiasm as soon as someone brought him a text that was feared to be missing. But he could also be outspoken: "What are you bringing me here," he would say in Tibetan, "an incomplete manuscript, with spelling mistakes every two lines, and of which there are much better versions?" Gene had an eagle eye and could instantly spot the slightest spelling or grammatical mistake on a page.

Once the book was accepted, Gene would write a preface in English for each volume or collection, outlining its importance, and a table of contents. All of the prefaces he wrote constitute a wealth of information on Tibetan literature. Once the texts were printed, the Library of Congress sent copies to the libraries of various American universities and a few others around the world. One of these institutions, however, unaware of the importance of these texts, asked Gene to stop sending him those books that were the size and shape of baseball bats and were impossible to fit on their shelves.

Gene was a man of strong stature—fleshy, with an imposing-sounding voice—yet extremely kind and helpful. He was a hard worker who got up at four o'clock in the morning and had already accomplished much of his daily work by breakfast time; I could sometimes hear the clicking of his old typewriter much before dawn. His faithful butler, Mangaram Kashyap, and two Dalmatians, Dorje and Lhamo, whom he adored, were his only family. But his house, where he had an open table and hospitality, was also a hub for Tibetologists from all over the world who were passing through India.

In addition to having a unique mastery of Tibetan literature and history, Gene knew Indonesian and read Mongolian and other languages. Before coming to India, he had studied with Dezhung Rinpoche, a great Tibetan scholar who had immigrated to the United States. In India, he developed an immense respect for my teacher Dilgo Khyentse Rinpoche, whose many beautifully framed photographs adorned the walls of his home. When Khyentse Rinpoche passed through Delhi, he stayed with Gene. So, when I accompanied Khyentse Rinpoche from 1979 onward for twelve years, I was part of the party. There were usually quite a few of us, and Gene used to put his

entire house and Mangaram at the service of Khyentse Rinpoche. He would give his room to Rinpoche and stay at a nearby hotel! Gene would spend the day with us and discuss at length with Khyentse Rinpoche not only texts, but also historical subjects. Khyentse Rinpoche loved Gene very much and affectionately called him "Mahapandita Jamyang Namgyal." *Mahapandita* is the Indian title given to great scholars and Jamyang Namgyal, Gene's Tibetan name, means "Gentle Victorious Glory"—Gentle Glory being the translation of the Tibetan name of Manjushri, the buddha of knowledge. When Khyentse Rinpoche called him that, Gene wiggled and laughed modestly, for he was very humble despite his immense knowledge.

It was also at Gene's home that I had the opportunity to meet the Tibetologist Michael Aris and his wife, future Nobel laureate and political leader Aung San Suu Kyi, who had stayed in Bhutan when Michael became tutor to the crown prince of Bhutan for a few years. Michael was a colorful character, while Suu, little known at the time, remained more discreet.

In his more than twenty-five years in India, Gene was able to save nearly ten thousand volumes of Tibetan texts, the essence of the heritage of the Land of Snow. He also taught me that Tibetan classical literature is the third largest classical literature in the East, after Sanskrit and Chinese, even before Japanese.

When the funds available to purchase Tibetan books came to an end, Gene decided to return to the United States. He had his entire library shipped, and Mangaram went to New York for a few months to put it all in his apartment. But Gene did not stop there. With the help of the Rubin Museum of Art, he founded the Tibetan Buddhist Resource Center (TBRC) and formed a team of Tibetans living in the United States, and together with the help of computer scientists they digitized and indexed all available Tibetan texts and made them accessible on the internet. Soon all the books newly reprinted in China by Tibetans would be added to these works. Today, in its new incarnation as the Buddhist Digital Resource Center, BDRC is the largest virtual Tibetan library in the world. When all of Gene's books were scanned, he considered donating them to the National Library of Bhutan or to our monastery in Shechen, Nepal. Eventually, he chose the city of Chengdu, China, the metropolis where most Tibetans from the highlands come and where the Gene Smith Library was built. Gene died in 2010, but BDRC is valiantly continuing his immense work in Boston.

"Buddhism is found in many forms. The basic tenets are compassion and cultivation of nonduality, the following of the middle way."
—E. GENE SMITH

E. Gene Smith smiles at the 2008 graduating class of Sakya College during the 7th Convocation Ceremony in Lumbini, Nepal.

Next page: E. Gene Smith, Rangjung Yeshe Institute, 2008.

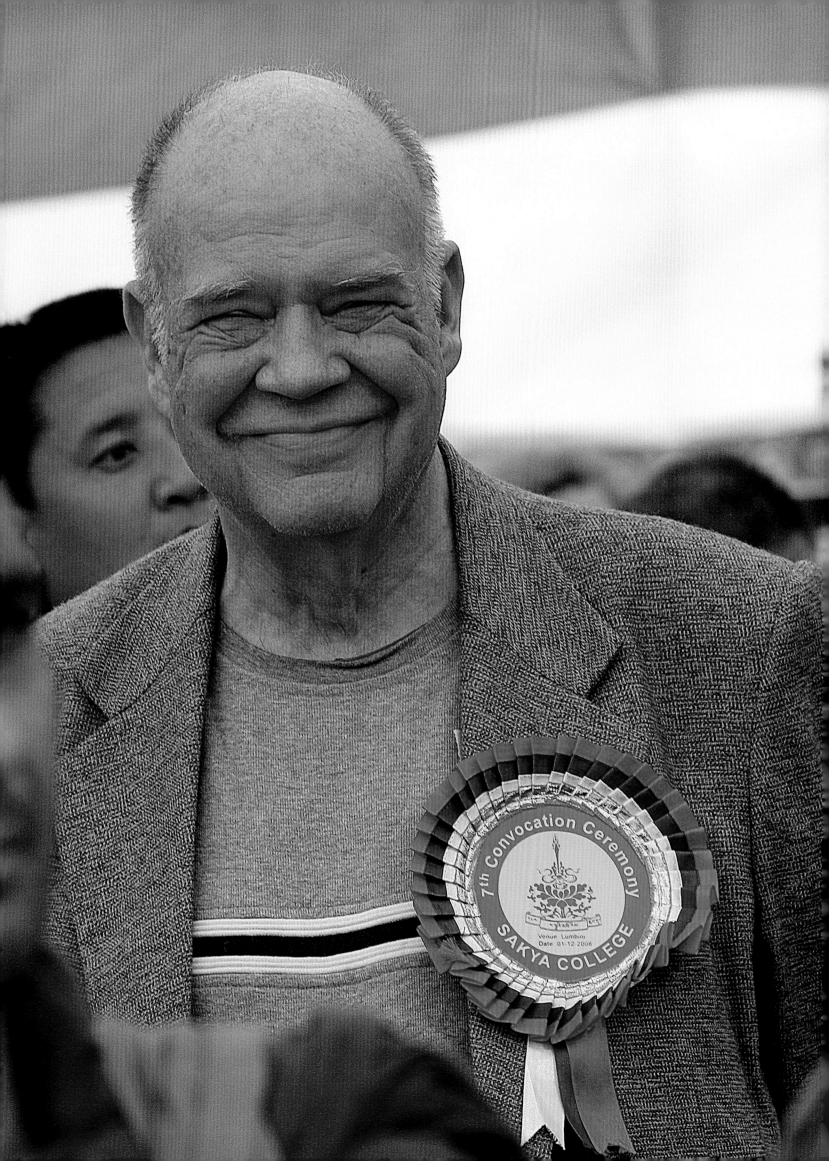

INTRODUCTION BY DAFNA YACHIN, DIRECTOR OF *DIGITAL DHARMA*

I T HAS BEEN SAID that all great literature is one of two stories: a man goes on a journey or a stranger comes to town. The story of E. Gene Smith is both.

Gene was an amazing human being. On that, all who knew him can agree. In 2008, a humble Gene reluctantly gave me permission to follow him back to India as he set out to deliver, to the main lamas of the four leading Buddhist traditions and the Bön, twelve thousand digitized texts produced from a total of twenty thousand texts that had been salvaged. Like Gene, these lamas had spent their lives finding and preserving the Tibetan texts lost since the 1950s and especially during China's Cultural Revolution.

For the next two years we were able to document key turning points of this cultural rescue and international mission through the eyes of its catalyst. We witnessed unexpected setbacks—from salvaged texts ruined by flooding in refugee camps to the government crackdown following Tibetan protests during the 2008 Olympics in China. These protests and their aftermath threatened to undo twenty years of negotiations and every bit of progress with the preservationists. Gene faced every challenge with courage and resourcefulness.

Throughout Gene's journey, our film crew had unique access to leaders, locations, and communities. We used the resulting footage to create *Digital Dharma*, a feature-length documentary about Gene's mission. Without Gene's blessing, none of this ever could have happened.

Gene began his journey fifty years earlier following a request from a high-ranking lama, along with a letter of introduction for Gene to use in approaching other lamas in South Asia. His journey crossed multiple borders—geographical, political, and philosophical—and led to international humanitarian and academic efforts to find and preserve the documents that form the core of Tibetan culture. This was truly an incredible gift to the Tibetan people and to all of humanity. Who could put a price on fifteen hundred years of teachings, many of them drawn from the Buddha's original words? These documents chronicle the advancements of mankind—from the medical to the mystical—and include the Tibetans' original contributions as well as the traditional works of great Indian scholars and masters that were systematically documented and preserved in Tibet.

But beyond the texts, there is the ineffable beauty of South Asia and its native cultures. The photos from our journey with Gene reveal a world that few of us would ever have seen—a world of secluded monasteries, learned lamas and cloistered acolytes, and the centuries-old rituals that are still revered and practiced.

When we completed the feature documentary about Gene in 2012, we were left feeling that here was a life and a body of work just too big to be captured in a single ninety-minute documentary. Thousands of photographs (I never put down my camera)—made possible because Gene was welcomed wherever we went—were mostly left on the cutting-room floor.

In 2013, we began to organize the many photos and stories that could not be included in the film, hoping for a companion piece to it. Then, in 2018, Jann Ronis became director of BDRC and Pat Gruber made an introduction that would plant the seed for using the book to commemorate the ten years since Gene's passing. Perhaps we were also beginning to feel a sense of urgency since some of the abbots, lamas, and scholars we had interviewed for the film and hoped to interview for the book were getting on in years. Several had already passed away. So we sifted through hundreds more photos and added what we considered useful background material. Jann, along with Tenzin Dickie (communications coordinator at BDRC), provided the more-detailed Buddhist content and checked our forays into Tibetan Buddhism throughout, while Pat was the invaluable sounding board who helped keep us true to Gene's mission.

It is my hope that in these pages you will feel some of the wordless wonder that we experienced on our trip. That wonder—it, too, was Gene's gift to us.

DELHI
"The Hub"

KYRGYZSTAN

CHINA

● NEPAL BHUTAN

DELHI

BANGLADESH

INDIA BURMA

LAOS

THAILAND

Bay of
Bengal VIETNAM

Andaman CAMBODIA
islands
(INDIA) PHILIP

Nicobar
islands
(INDIA)

SRI
LANKA

ON HIS RETURN trips to India to share the digitized volumes of Tibetan texts with Tibetan Buddhist lineage holders, Gene stops in Delhi to visit old friends. The film crew sees the neighborhood where Gene lived when he first came to India in the 1960s, and the bookstore he often visited. We meet Mangaram Kashyap, who became Gene's assistant when he was only sixteen and remained his right-hand man during Gene's many years in Delhi with the Library of Congress.

"He was unlike Westerners. He was very humble."
—HER EMINENCE JAMYANG DAGMO KUSHO

Gene and cameraman Wade Mueller walk the markets near Gene's old home in Delhi.

A bookstore that Gene frequented in the '60s is still open.

Right: Doboom Rinpoche welcomes us to the library at the Tibet House and shows us the many books that have an introduction written by E. Gene Smith.

With Gene at another meeting, the Tibet House—the Dalai Lama's cultural center in Delhi—welcomes the crew. The Tibet House serves as a museum and library—a cultural exchange venue where Tibetans, as well as scholars and students of Tibetan culture and history, can meet to share ideas. The director, Lama Doboom Tulku Rinpoche, gives us a tour of their gorgeous collection, which includes many first editions collected, printed, and with an introduction by E. Gene Smith.

"...Here is an American gentleman who knows so much about Tibetan culture, Tibetan studies, and Tibetan practice."
—DOBOOM RINPOCHE

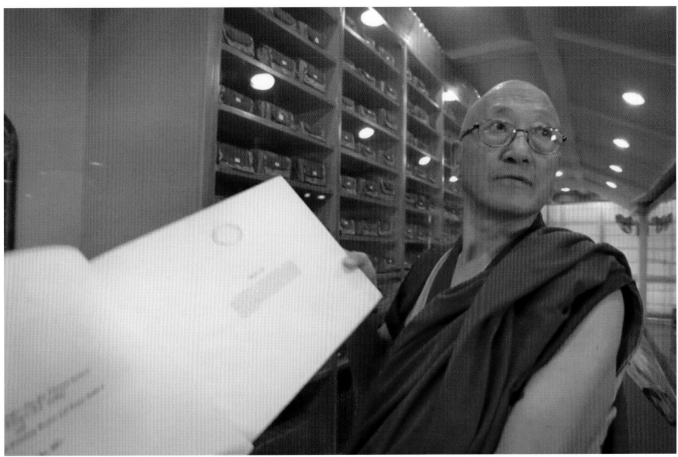

We also visit the Tibetan refugee colony, where we meet one of Gene's "publishers"—someone who published 116 books for Gene as part of the project whereby he successfully secured PL 480* funds from the government for use in paying locals for their published texts. This refugee colony, an assortment of tin shacks in the 1960s, is now a bustling refugee market and settlement— the commercial crossroads of Tibetan exile life.

*"Food for Peace": see page 44 for more information.

"The idea is to help them preserve their own culture. It's not our culture. We're not the actor, we're just the encourager." —E. GENE SMITH

Gene, Mangaram, and the film crew walk around the Tibetan refugee camp on the outskirts of Delhi.

Facing page: The polluted river that often floods the camp homes and shops.

This page: Cement barrier wall topped with embedded broken glass.

Barbed wire fence with impaled Tibetan prayer flag.

Water-damaged texts and books lining the pathway outside shops.

 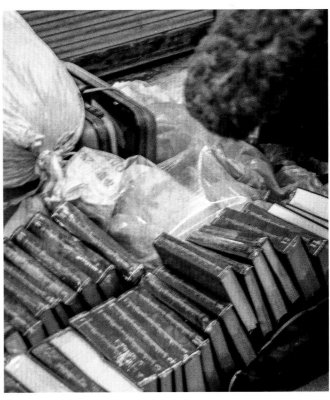

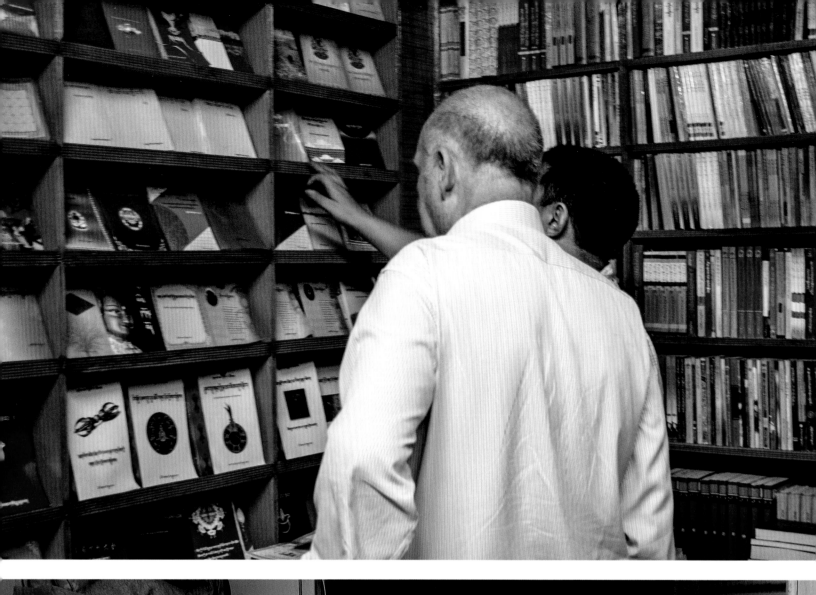

"He was basically the point person for all of the Tibetan refugees and scholars who had brought all of their literature out of Tibet. He was the organizer and editor, and he managed to get hundreds and hundreds of volumes published."

—Janet Gyatso, PhD, Harvard University professor

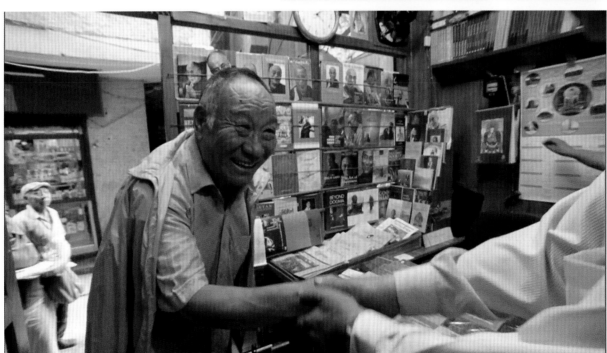

Rickshaw driver hoping the crew will need a ride.

Left: A bookstore owner shows Gene the newest listings. Many paperbacks in this shop are reprints of the texts saved by Gene.

Monk and friend in a serious game of carom.

Next two photos: Gene stops by a Tibetan bookstore he used to frequent and greets book publisher Tsondue Senge and Dabsang—old friends and book collectors who helped him find texts to publish.

Gene's assimilation into Indian society began with meeting India's secretary of education, Dr. Prem Kirpal, at a party. When Dr. Kirpal learned that Gene was staying in a hostel, he invited Gene to move in with him and his wife. "I got to meet everyone," said Gene, including important figures such as Indira Gandhi. According to Gene, Dr. Kirpal looked after him and told him he need not worry about being expelled. This had been a genuine concern of Gene's because India, a Non-Aligned Nation—that is, one of a group of developing countries that had decided not to align with either bloc during the Cold War—had become a base for CIA assistance to Tibet, and Gene might well have been suspected of being a spy.

When Gene moved out on his own, his house in Delhi became a stopping-off point for any traveler interested in Tibetan Buddhism. Great teachers would stay with him, such as Dilgo Khyentse, who often arrived with a busload of people. Gene never turned anyone away. As Leonard van der Kuijp, a Harvard professor of Tibetan and Himalayan studies, notes, "Some people stayed a week, some, two weeks. . . some, a month."

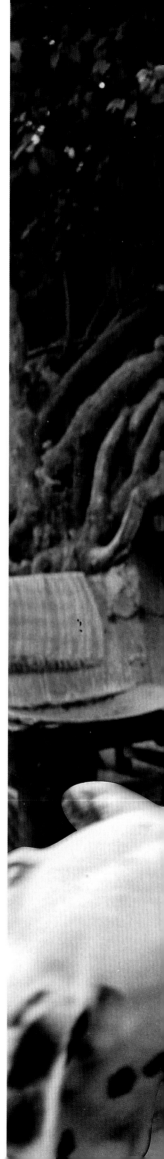

Gene loved Dalmatians and is credited with introducing them to Bhutan.

Next page: Gene in front of his infamous house in Delhi with his staff.
A young Mangaram in a plaid shirt, 1971.

These two photos are courtesy of Gene's good friend, photographer Rosalind Fox Solomon.

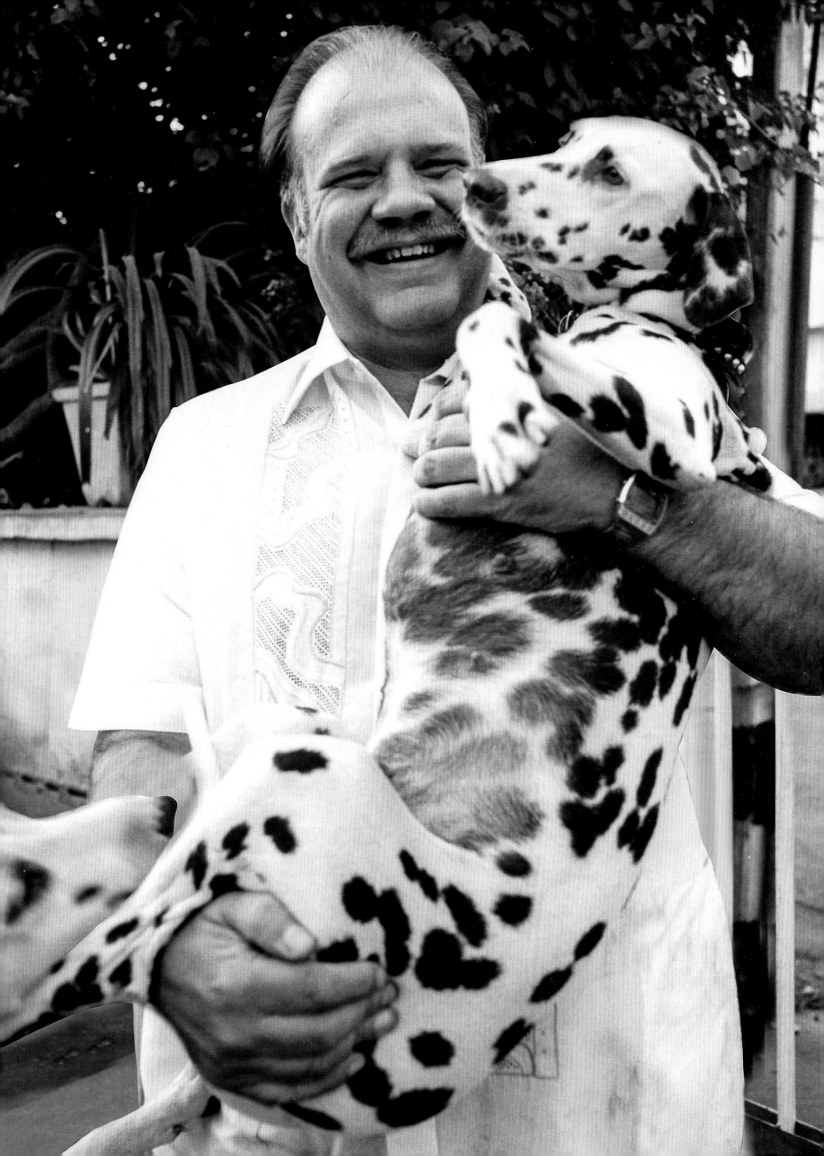

"I just knew there was this one white man in Delhi—a white man, big man. I went into his room and it was wall-to-wall texts, more than many high lamas would have."
—Dzongsar Khyentse Rinpoche

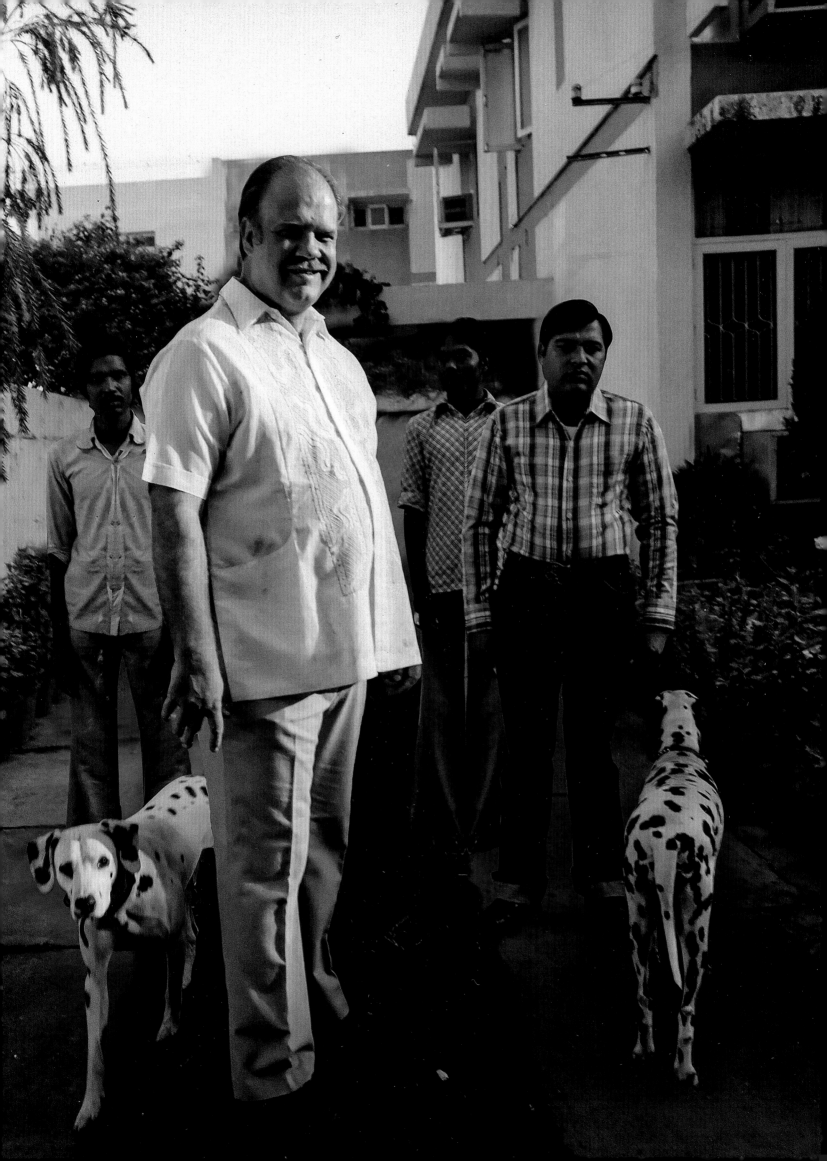

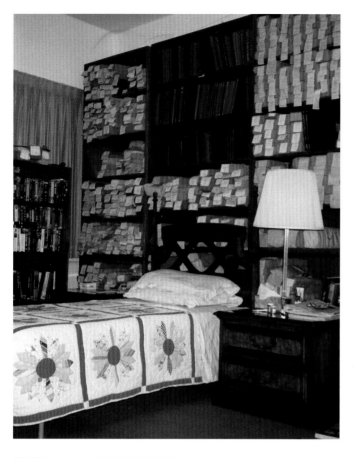

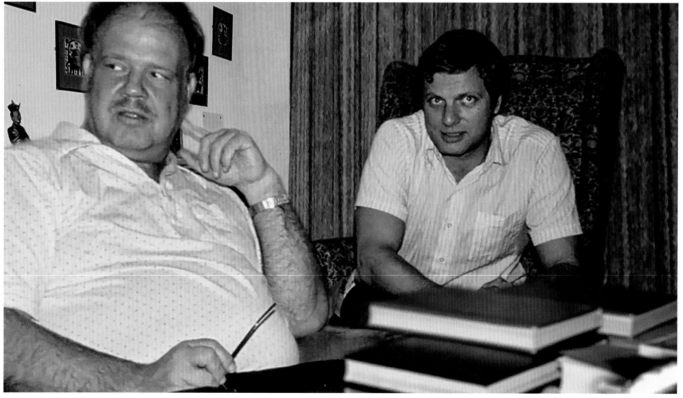

Gene's bedroom, furnished primarily with books.

India's secretary of education, Dr. Prem Kirpal, at one of the many events at Gene's house.

Gene with friend and colleague Professor Leonard van der Kuijp.

Opposite: Guest list for one of Gene's dinners held to promote preservation efforts.

GUEST LIST FOR DINNER IN HONOUR OF PROF. FRANZ
MICHAEL AND DR. EUGENE KNEZ ON JULY 30, 1979, at 7:30

Prof. Franz Michael
Dr. Eugene Knez
Mr. Tashi Tshering
Dr. Lokesh Chandra and Sharada Rani -- he is director of the Inter-
 national Academy of Indian Culture and a member of
 Parliament (Raja Sabha)
Dr. Romila Thapar -- professor of history at Jawahbrlal Nehru Univer-
 sity
Mr. Yousuf Ali -- Ministry of Home Affairs, formerly Chief Secretary
 of Arunachal Pradesh (former NEFA)
 interested in research in Bhotia culture
Mr. Don Lopez -- research scholar from the University of Virginia
 in Buddhist Studies
Mr. and Mrs. Geza Bethlenfalvy -- he is a Tibetologist and Mongolist,
 she a Turcologist -- both are students of Ligeti Lajos
Dr. and Mrs. D. R. Khurana -- physician (formerly of the Rangoon
 Medical School)
Prof. Norman Zide -- linguist from University of Chicago -- field
 Munda linguistics
Dr. Caroline Humphreys -- Cambridge anthropologist -- has worked in
 the Buriat ASSR -- will work on Lhomi people of Nepal
Mr. Piers Witebsky -- Cambridge anthropologist -- has been working
 with the Saora tribe in Orissa
Mr. Matthieu Riccard -- Buddhist monk French
Mr. Mani Dorji -- Bhutanese calligrapher from eastern Bhutan
Mr. and Mrs. Cees Keur -- American Embassy -- formerly from Peach
 Corps in Thailand and Laos -- Mrs. Keur is Laotian
Mr. Muangnil and a friend -- linguistics students at Delhi University
 interested in Thai linguistics

Ted and Marie Aeler — Canadian High Commission

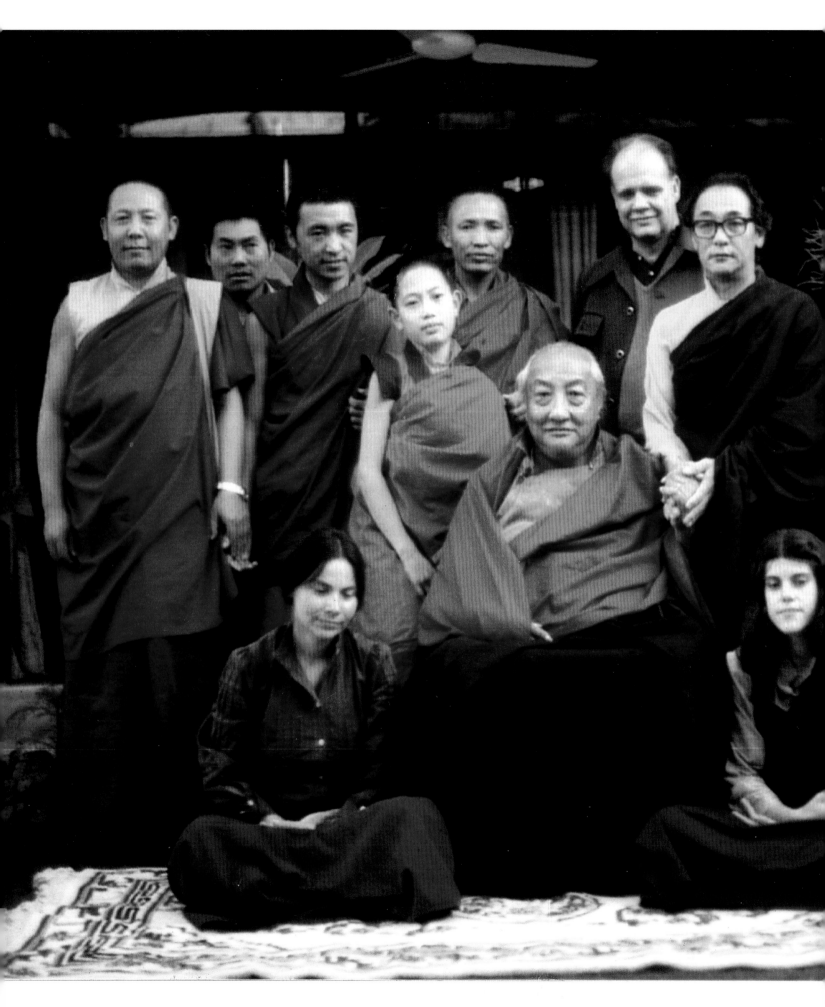

Gene, monks, professors, and students welcome Gene's second teacher, Dilgo Khyentse Rinpoche (1979).

From top right to left: Khandro Lhamo (Dilgo Khyentse Rinpoche's spouse), His Holiness Jigdal Sakya Dagchen Rinpoche, Gene, Rinpoche (seated), Khenpo Jigme Tsultrim (to Gene's left), Shechen Rabjam Rinpoche, Pema Wangyal Rinpoche, an unknown monk, and Lama Ngodrup. In the front, from left to right, Helena Blankleder, Jill Heald, and Matthieu Ricard.

While in Delhi, Gene brings a drive to Dr. Tashi Yangphel Tashigang, a Tibetan Ayurvedic medical doctor who worked in parallel with Gene at the Library of Congress. Perhaps the foremost authority in exile on the literature of Tibetan medicine, Dr. Tashi is credited with finding and printing valuable Tibetan medical texts now used worldwide. His published works include a series of more than 250 medical and astrological texts, for which he was recognized in 2000 at the International Academic Conference on Tibetan Medicine in Lhasa. Dr. Tashi's son, Tsering, who is trained as an allopathic physician, integrates the traditional Ayurvedic approach of his father with Western medicine. The two have been working on translating the Four Medical Tantras—ancient texts that are the basis of the Tibetan system.

Dr. Tashi Yangphel and his son, Tsering, share their translation project and show us their pharmacy of Tibetan medicine.

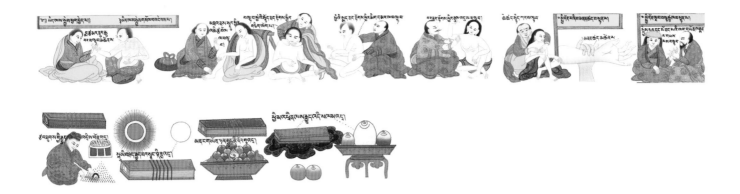

"Buddhism has no problem collaborating with science. There's no risk of suddenly losing the basic tenets of Buddhism because science would prove it's wrong. If something is wrong, it's wrong. What's the problem? If the Earth is not flat, so what? That's the way it is."
—MATTHIEU RICARD

"Tibetan medicine is a really interesting melting pot of many traditional Asian systems of medicine . . . and there's a kind of writing based on clinical experience of particular physicians and that's what Gene Smith was collecting. And it might well be that there are some insights on how the body works and how to treat the body that we haven't really come to terms with yet in contemporary biomedicine."
—JANET GYATSO, PhD

DHARAMSALA
"SANCTUARY"

CHINA

KYRGYZSTAN

KISTAN

Dharamsala

Delhi

NEPAL

BHUTAN

BANGLADESH

BURMA

INDIA

LAOS

THAILAND

VIETNAM

CAMBODIA

PHILI

Bay of
Bengal

Andaman
islands
(INDIA)

Nicobar
islands
(INDIA)

M A

SRI
LANKA

ES

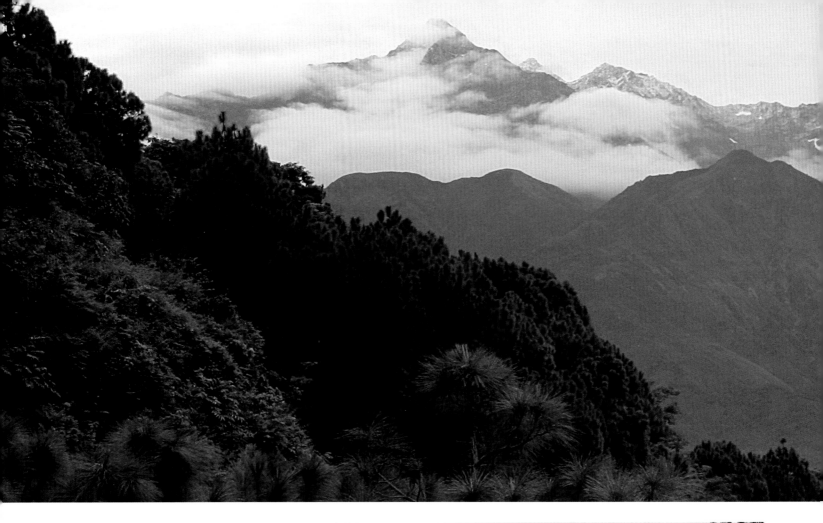

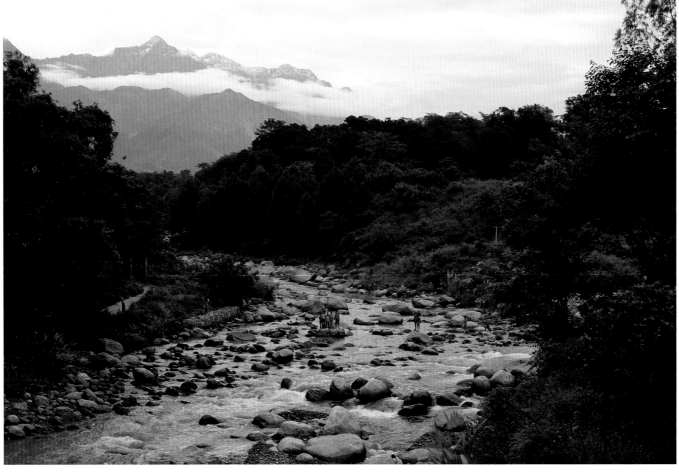

Leaving Delhi, we enjoy the lush scenery on our gorgeous fourteen-hour ride to Dharamsala, in the northern Indian state of Himachal Pradesh. Here we get our first look at the snow-capped Himalayas.

Gene is eager to make his first trip ever to Dharamsala. Jawaharlal Nehru, the first prime minister of free India, offered this area to the Dalai Lama and the eighty thousand Tibetan refugees who followed him in 1959. Dharamsala, which means "sanctuary" or "rest stop," is now home to the Tibetan Parliament-in-Exile. It is also where the Dalai Lama first established a library outside of Tibet. The Library of Tibetan Works and Archives is one of several key Tibetan cultural institutions located in Dharamsala.

A slice of life in one of the bustling towns at the base of Dharamsala.

Above: Farmer contemplates his sacred herd.

Facing page: Woman walks a small boy to school.

Sikh student waits for a bus.

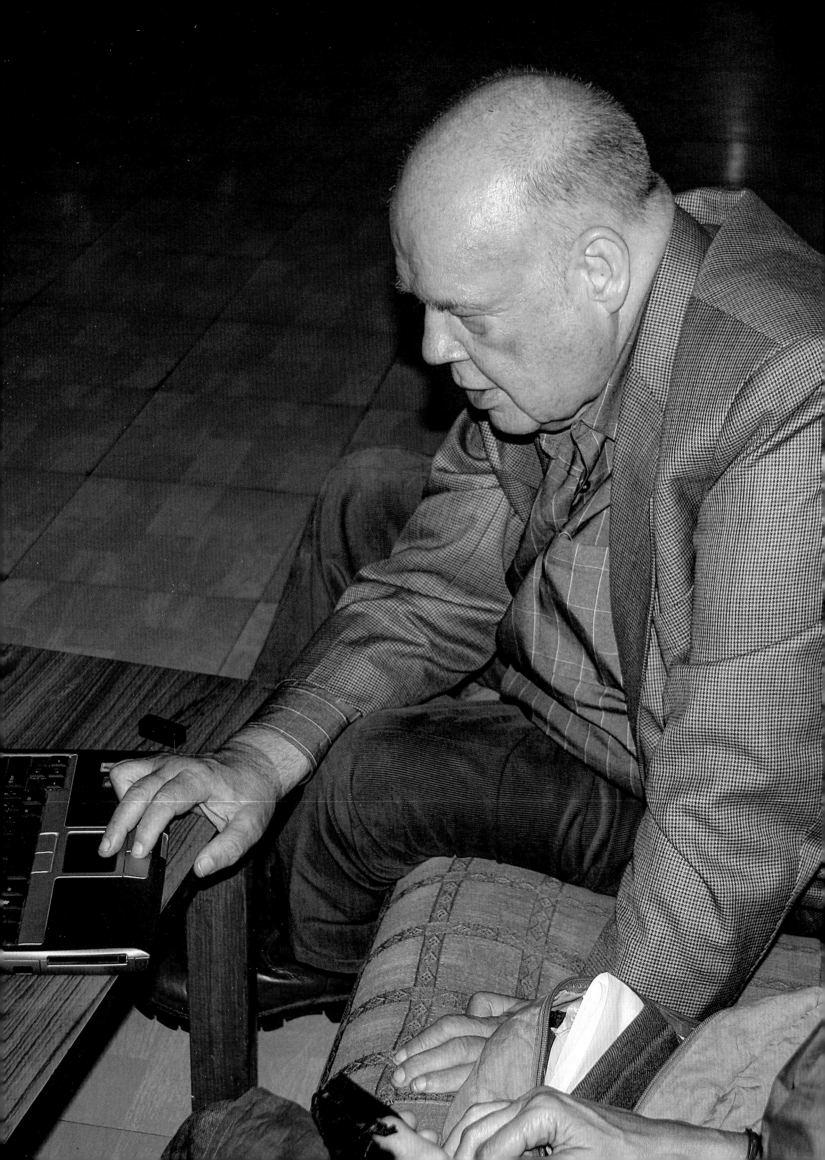

At our hotel in Dharamsala, Gene is delighted to run into an old friend, Rana Helmi, and to show off the TBRC website (even with a sluggish internet). Gene first met Ms. Helmi in Jakarta while he was working for the Library of Congress.

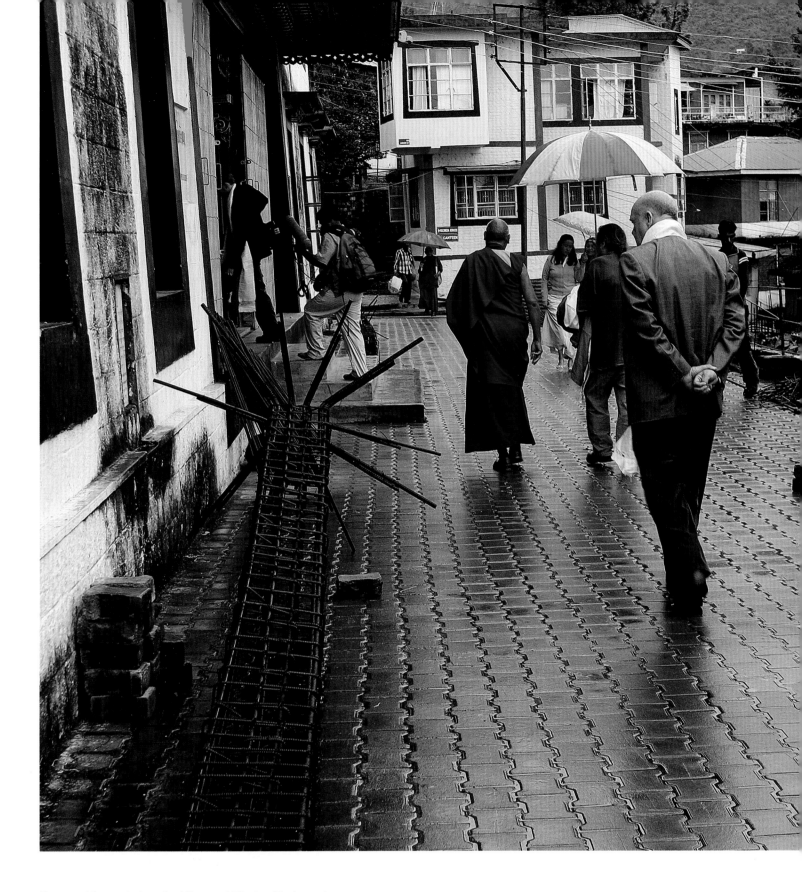

Gene on his way to tour the Library of Tibetan Works and
Archives in Dharamsala.

Left: A view of the terraced rice fields.

A beautiful hawk flies toward the Himalayas, eyeing the crew.

བོད་ཀྱི་དཔེ་

तिब्बती ग्रन्थ एवं अ

LIBRARY OF TIBETAN

ꠉꠦꠀꠀꠇꠣꠣ

लेख पुस्तकालय

WORKS & ARCHIVES

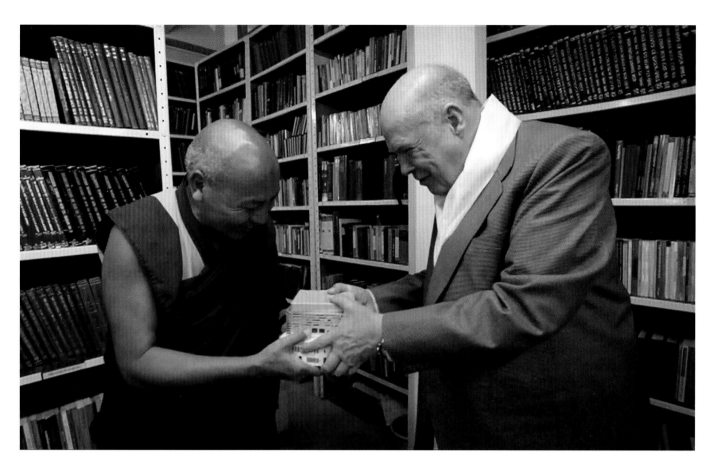

Samdhong Rinpoche, at this time the prime minister of the Tibetan government-in-exile, tells the story of his own escape and settling the camps in India. In front of an audience of Tibetan students, Gene presents Rinpoche with the first twelve thousand documents that have been digitized—all in one small, square white box.

About Gene, Samdhong Rinpoche says, "None of the Tibet scholars have such a comprehensive knowledge about the texts. His name will remain for all time in our history of the Tibetan canon."

Samdhong Rinpoche, the prime minister of the Tibetan government-in-exile.

Gene and Samdhong Rinpoche talk to students about the digital drive and preserving the texts.

Left: Gene offers a drive to Geshe Lhakdor, director of the Library of Tibetan Works and Archives, at the newly remodeled library.

Next page: Samdhong Rinpoche greets Gene with a traditional *khata*.

PL 480: Books for Peace

In the forty-five-year standoff that was the Cold War, both the United States and the Soviet Union sought to recruit Non-Aligned Nations as trading partners and allies. In 1954, President Eisenhower signed into law the Agricultural Trade Development and Assistance Act (commonly referred to as PL 480), an important strategic tool for bringing neutral countries into the Western bloc. PL 480 was the basis for the Food for Peace program, which continues to provide assistance to citizens in most countries around the world. Originally intended as a vehicle for creating secondary markets for surplus US agricultural commodities, PL 480 has expanded over the years to provide a more comprehensive basis for American food assistance to foreign nations. In the 1960s, the Kennedy and Johnson administrations recognized the potential importance of Food for Peace in supporting a broad range of diplomatic and strategic US foreign policy objectives.

In the words of Gene Smith, "When you want to do something, bureaucratic precedent is essential." During his tenure with the Library of Congress in New Delhi in the 1960s, Gene was spending much of his time helping to recover the texts lost when the Chinese invaded Tibet in 1959 and to make the recovered books available to university libraries in the United States. A program designed to acquire Tibetan texts had begun in 1961, but Gene knew that his monumental project to reproduce all of the important texts brought out of Tibet would require a generous and continuous source of funding. He believed that finding a suitable precedent was the key to supporting the publication of recovered Tibetan texts.

A program of the size and importance of PL 480 certainly could serve as a significant precedent for something, but what did the publication of ancient texts have to do with the distribution of food?

A central feature of PL 480 was that it enabled countries with food shortages to pay for American food imports in their own currencies instead of in US dollars. As Gene noted, "We had a Public Law 480 program in Israel. We had it in Egypt, Tunisia, Morocco, Indonesia, Brazil. We were feeding the whole world." And, he explained, of more immediate importance to his objective of publishing the recovered texts, "Eventually we owned one rupee of every ten in circulation in India and this became a real problem."

It was a problem because India was blocked from using its own currency to repay the debt. To do so would have necessitated India's borrowing an additional rupee for every ten repaid, in effect perpetuating the debt indefinitely. In Gene's words, "It was a debt that they could never pay." Gene's proposed solution was to capitalize on the increasing reach of PL 480 and expand Food for Peace into "food for thought"—that is, to have the Library of Congress use some of that US-owned local currency to purchase Tibetan texts.

The Library of Congress had been using rupees from the PL 480 sale of agricultural products to India to purchase regional Indian books, including some Tibetan works. Thanks to Gene, the Library of Congress expanded this program, especially its Tibetan acquisitions, because Gene succeeded in having Tibetan classified, for the purpose of this program, as a regional Indian language.

A couple of additional challenges remained, however. First, the Library of Congress was authorized to buy anything that had been recently printed in India. However, most of the texts that Gene sought to recover and

preserve were quite old—fragile heirlooms brought over the Himalayas from Tibet or belonging to people with Tibetan Buddhist roots in countries such as Bhutan and Nepal. His solution was to engineer the printing of these ancient texts using photomechanical means so that they could be made into new publications eligible for purchase. It was a primitive methodology for book production by our standards, but an undeniably brilliant solution. The new introductions and prefaces that Gene wrote for some of these ancient texts were a crucial part of the strategy to gain clearance from the Library of Congress to purchase the books for American libraries. The introductions themselves went on to become legendary essays in Tibetan studies. Kurtis Schaeffer, former chair of religious studies at the University of Virginia, has referred to them as "a literature of scholarly inspiration."

The other challenge was finding a way to finance the printing of these copies; PL 480 covered only acquisition expenses, not printing. The core of Gene's proposal incentivized local printers to get involved. He would ask them to print one hundred copies of each work and would guarantee the sale of twenty-five copies of every book at an artificially inflated price—paid with PL 480 funds—that would cover the cost of their entire print run. The remaining seventy-five copies would be sold to Tibetans at cost. In effect, the purchase of the newly published books supported the reprinting of the older texts from which they were derived—Gene's creative formula for encouraging Tibetans to publish Tibetan texts in danger of being permanently lost. His efforts resulted in the authorization of the purchase of ancient Tibetan texts that otherwise would not have qualified under PL 480.

Gene had the same kind of aha moment decades later when he realized that the internet could be the key, over the long term, to achieving the dual goals of preserving and distributing the Tibetan Buddhist canon. He led this effort to digitize the sacred texts largely through the creation of the Tibetan Buddhist Resource Center.

TREASURES
OF THE
HIMALAYAS

DHARAMSALA

SHERABLING MONASTERY

HIMACHAL
PRADESH

MENRI MONASTERY

DELHI

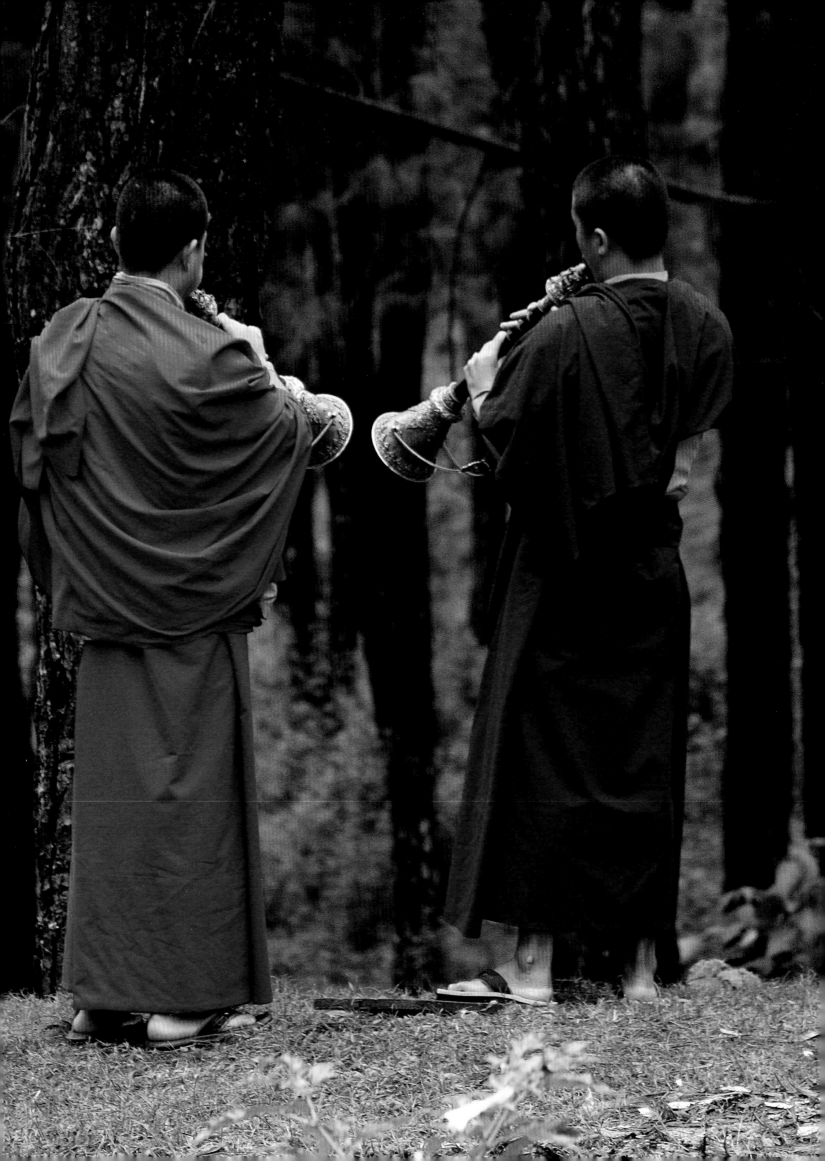

Palpung Sherabling Monastery, Bhattu

PALPUNG MONASTERY WAS a great center of learning located in Eastern Tibet and home to the nineteenth-century Tibetan lama Jamgön Kongtrul. It was reestablished in India under the name Sherabling and is the seat of the Twelfth Tai Situpa, one of the leading lamas of the Kagyü tradition. This is the film crew's first exposure to monastic life, and they enjoy learning about the monks' work to preserve texts and music. This group of monks has won a Grammy!

Left and next page: At the edge of the woods, monks practice their *gyaling*, or Tibetan horn.

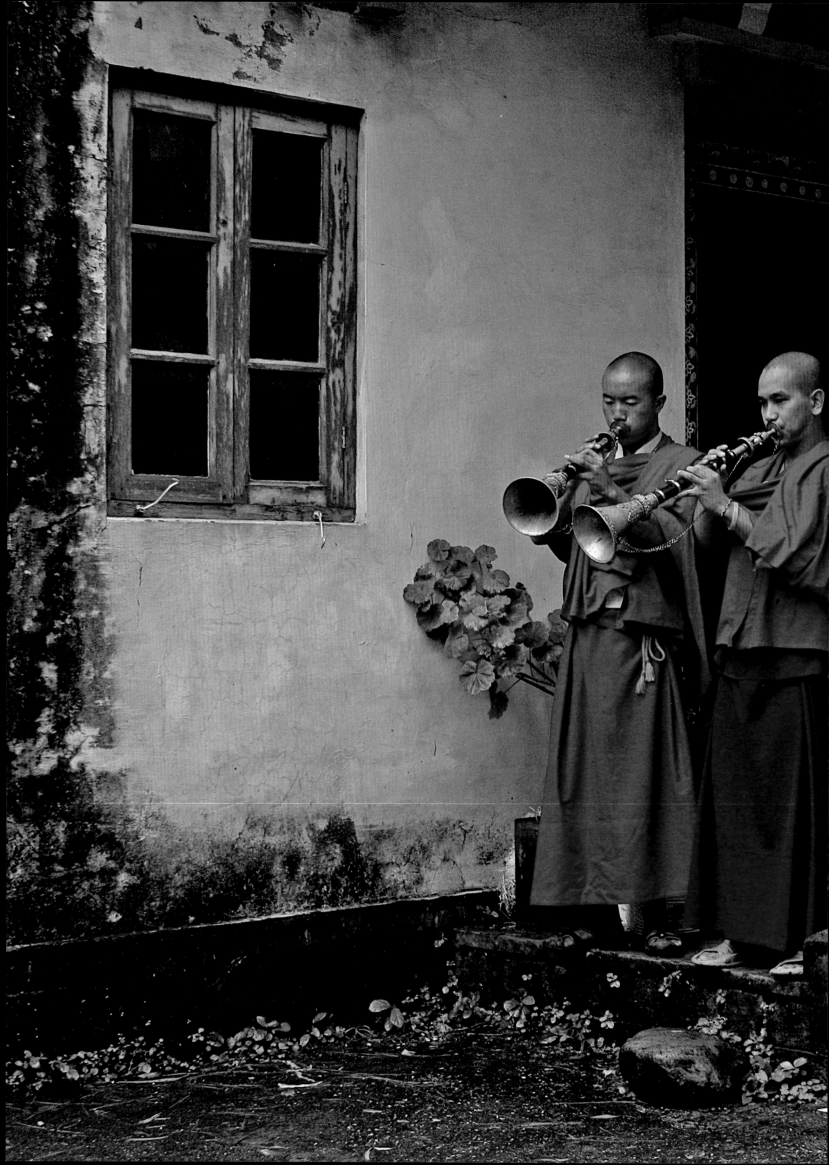

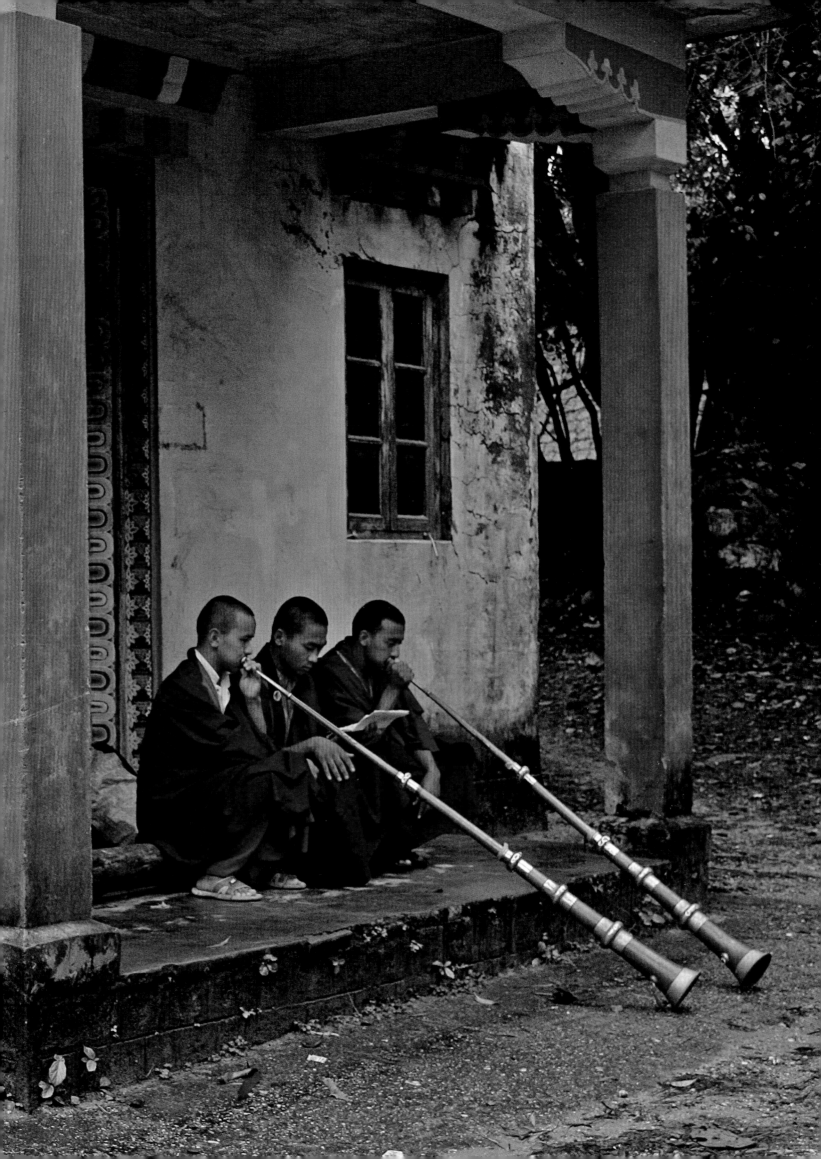

Top: Local woman with prayer wheel heading to site of transmission.

Bottom: Two women from monastery support staff.

Facing page: Nun spins giant prayer wheel.

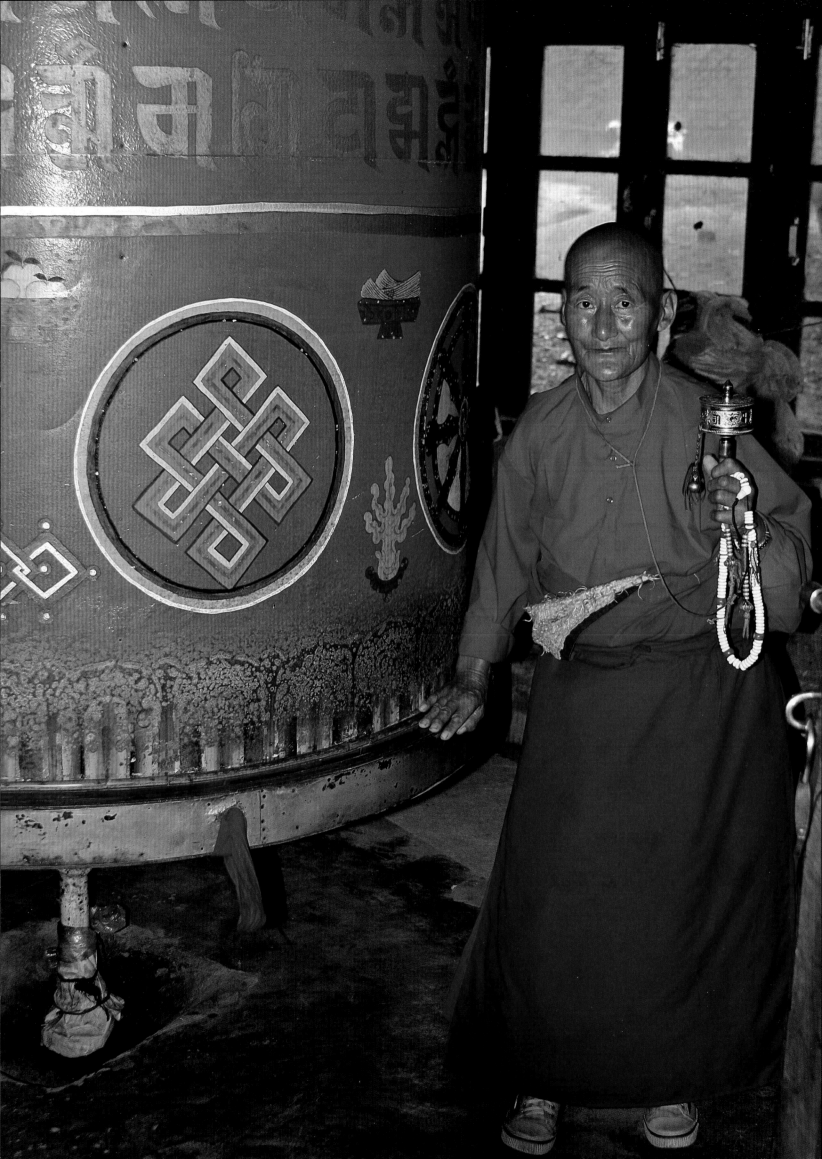

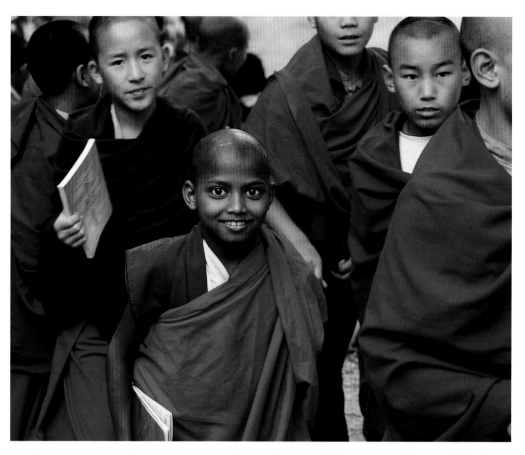

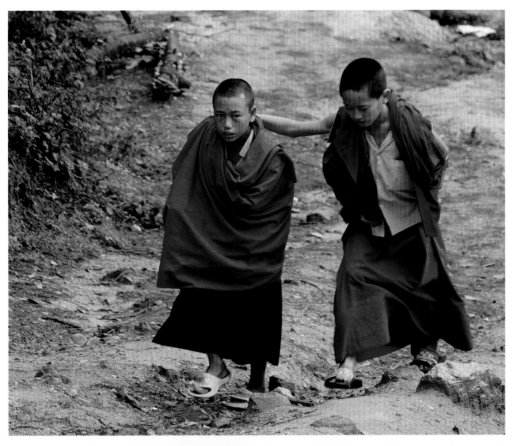

Left and this page: Young students take a short break from the day's transmission.

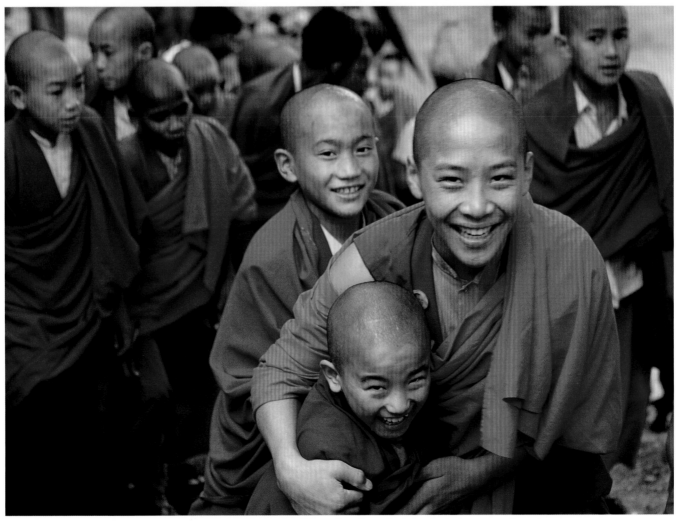

The Tai Situpa incarnation line of the Kagyü tradition dates back to 1407. The Twelfth Tai Situpa, Pema Dönyö Nyinje, was enthroned at the age of eighteen months. At the age of six he was taken to Bhutan and later to India, where he received his formal religious training. When he was twenty-two, he founded Sherabling as his monastic seat in exile. As a member of the new generation of lamas trained in India, the Twelfth Tai Situpa benefited from his relationship with Gene. Gene worked with him and other lamas to help collect and reprint the texts they needed to perform special transmissions at ceremonies and thereby expanded the extraordinary role he was already playing in the continuation of the Tibetan Buddhist tradition in exile.

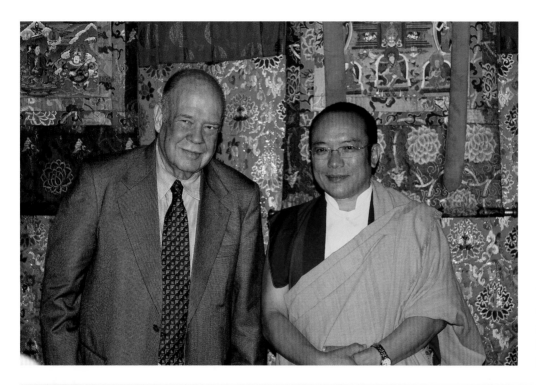

The Twelfth Tai Situpa and Gene pose for a quick photo before resuming a transmission of the Five Great Treasuries.

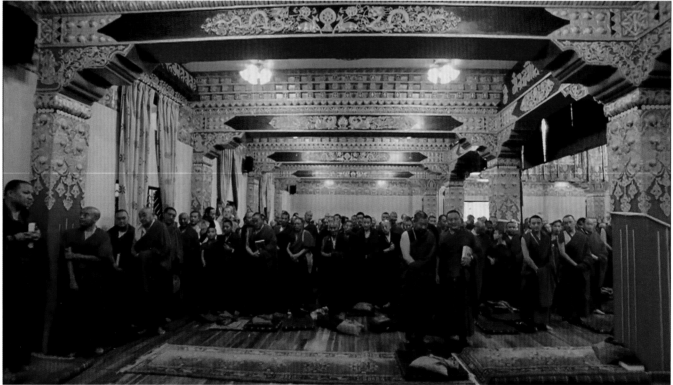

The Five Great Treasuries

The living tradition of Tibetan Buddhism holds that sacred texts are imbued with blessings. These are conveyed through the ritual of transmission, in which a lama recites aloud the entire text to an audience. This blessing is an indispensable preliminary to engaging with the texts, whether for study or meditation. Texts for which the line of blessings has died out are effectively extinct and no longer in circulation. As the Twelfth Tai Situpa explains, "We cannot read a text and get transmission. We have to receive [transmission] from a master who has the lineage. This lineage has to be continued, and I am doing my best to continue the works of my predecessor and also my gurus."

Gene felt fortunate to deliver drives containing the digitized Tibetan Buddhist canon at a time when the Twelfth Tai Situpa was orally transmitting the Five Great Treasuries to three *tulkus*, or reincarnate lineage holders, and an assemblage of hundreds of lamas, monks, nuns, students, and other followers of Tibetan Buddhism.

In his 2001 book of essays, *Among Tibetan Texts*, Gene called the Five Great Treasuries one of "our chief literary sources for the nonsectarian movement, one of the most important developments in the nineteenth-century Tibetan Buddhist world." As he noted, "The roots of eclecticism and tolerance are sunk as deep into the soil of Tibetan tradition as those of sectarianism and bigotry."

The Five Great Treasuries were written by Jamgön Kongtrul, whom Gene described as "perhaps the greatest artist, thinker, and literary figure of Eastern Tibet." The collection comprises:

1. *The Treasury of Kagyü Tantras*
2. *The Treasury of Revealed Scriptures*
3. *The Treasury of Knowledge*
4. *The Treasury of Precious Instructions*
5. *The Expansive Treasury*

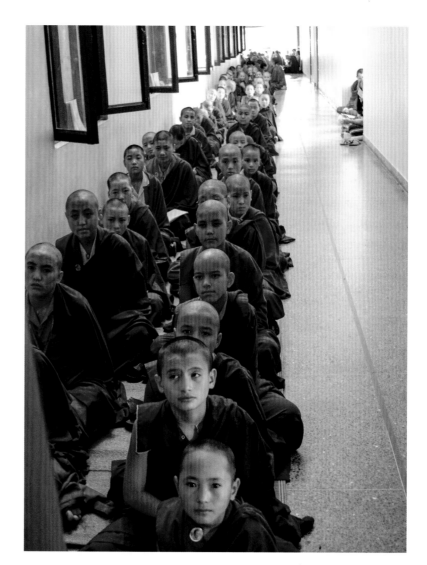

Children and nuns participate in the transmission immediately outside the temple through high-tech surround sound and large screens. The monastery was installing a skycam while we were there.

Following page: Local woman spins prayer wheel during break from transmission.

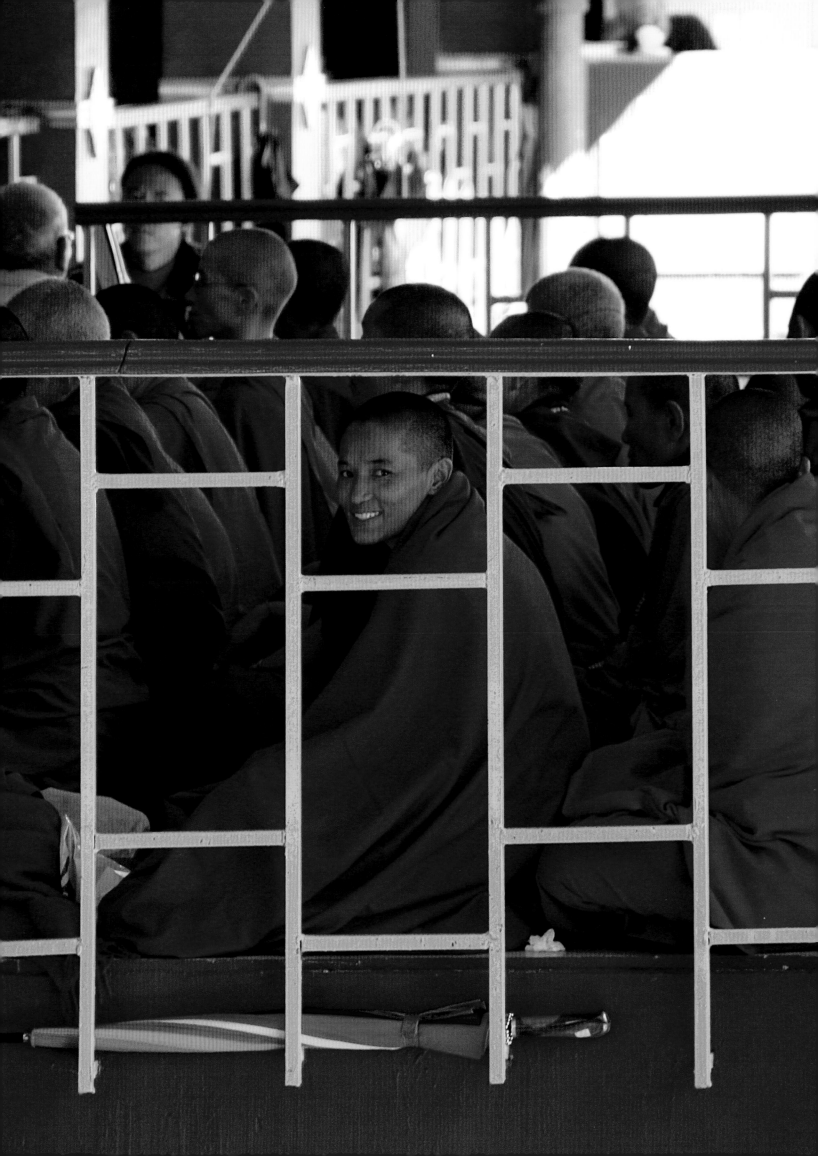

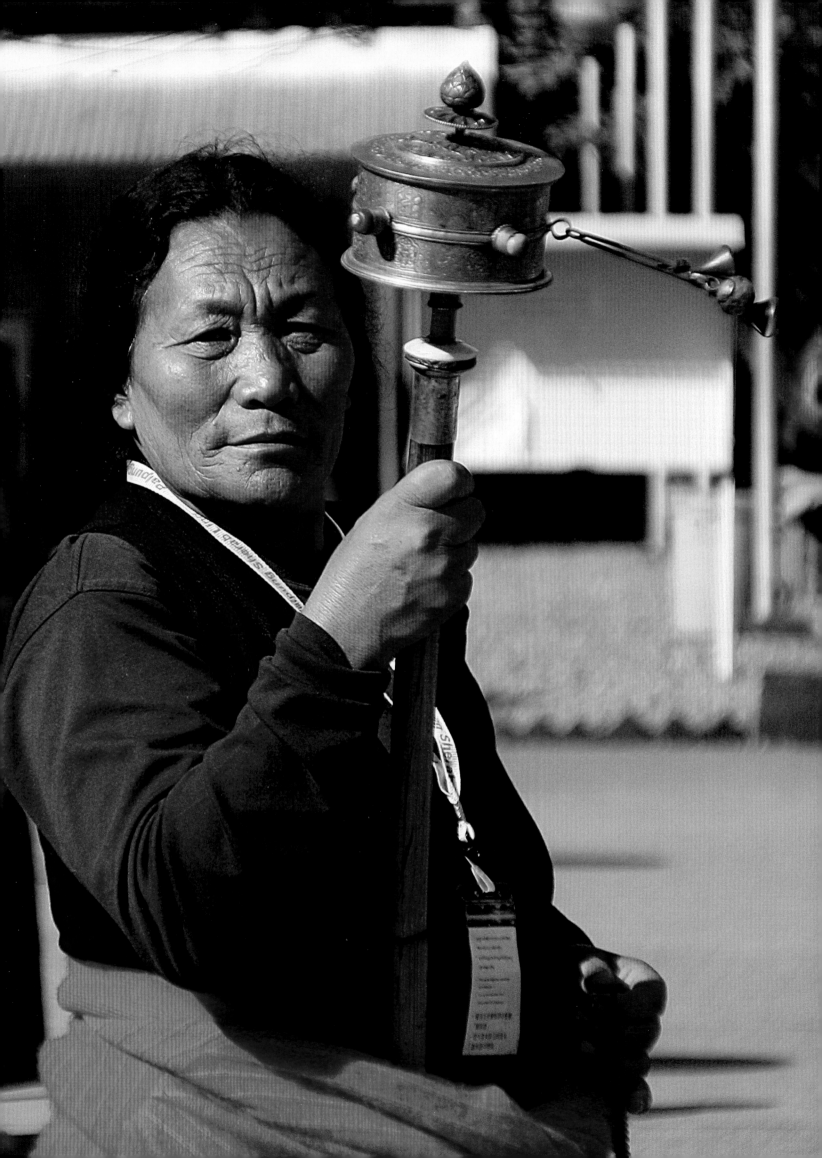

Who Was the Buddha?

The founder of Buddhism was a historical person who lived during the fifth and fourth centuries BCE. Given the name Siddhartha at birth, the future Buddha was born into a royal family that ruled one of many city-states in the Gangetic River Plain in Northern India.

After his enlightenment—nirvana—the Buddha taught for forty years across the Gangetic River Plain. He gathered many students and donors and taught them the Dharma: the truth, law, and doctrine. In addition to giving teachings about renunciation and contemplation, the Buddha organized his community according to an unprecedented monastic law, which still governs the global Buddhist monastic community. This community prospered in India for well over a thousand years and contributed countless treasures to Indian civilization. Within a couple of centuries of the Buddha's passing, monks began to travel far beyond the Gangetic River Plain, establishing the Dharma throughout South Asia and beyond.

The Himalayas provided a formidable obstacle to Indian Buddhist monks for a long time. Buddhist culture finally reached Tibet in the seventh century. According to Tibetan tradition, the founder of the Tibetan empire—Songtsen Gampo, or Songtsen the Wise (569–649?)—entered into marriage alliances with several powerful neighbors, and his brides from the ruling families of Nepal and China brought Buddhist images, texts, and priests with them to Tibet. For three hundred years, Buddhist activities in Tibet were limited to the royal court; during this time, Buddhism was not promoted to the kingdom at large. The first monastery was established in the late eighth century, over one hundred years after the arrival of Buddhism. Throughout this period, the Tibetan empire devoted substantial resources to translating Buddhist scriptures from Sanskrit and other Indic languages. Most of the Buddhist canon was translated with great accuracy and efficiency from the middle of the seventh century to the middle of the ninth century.

The Tibetan empire collapsed in 842, and for one hundred years the cross-Himalayan trade in Dharma was paused. The middle of the tenth century saw the start of a second wave of Buddhist transmissions from India, Kashmir, and the Kathmandu Valley that lasted until the middle of the thirteenth century. During this time, many South Asian masters made the arduous trip to Tibet to help reestablish the Dharma in the Land of Snows, and likewise, many Tibetan translators journeyed across the Himalayas in search of transmissions and manuscripts to take back to their homeland.

What Is Buddhism?

Dedication to Buddhism is expressed through "going for refuge" in the core elements of Buddhism. The metaphor of refuge is ancient and found across all Buddhist traditions. Seeking Buddhist refuge is analogous to fleeing danger for a safe haven or taking up a course of medicine to heal a disease. A first step involves recognizing the defects of worldly existence, or samsara. Buddhist refuge is also a matter of identifying the Buddhist path as the way to peace, and understanding Buddhist enlightenment as the ultimate form of release from the dangers and miseries of one's starting point. It is seeking guidance, inspiration, companionship, and blessings on the path out of our current states as ordinary sentient beings, all the way to the permanent sanctuary of enlightenment. In Buddhism, taking refuge is directed at a trinity of sorts: Buddha, Dharma, and Sangha, collectively known as the Triple Gem or Three Jewels. Each one is distinct and indispensable. The Buddha is the teacher and the Dharma is the canon of his teachings. Sangha means "assembly" and refers to the community of Buddhist monks and nuns. An ancient Buddhist text about the three objects of refuge gives the following vivid similes of the Three Jewels:

> [T]he Buddha is like a good guide; the dharma is like a good path to a land of safety; and the saṅgha is like (people) who enter upon the path and reach the land of safety.
>
> The Buddha is like a good pilot; the dharma is like a ship; and the saṅgha is like people who have succeeded in reaching the farther shore.
>
> The Buddha is like the Himalaya Mountain; the dharma is like the healing herbs that are given their being by that mountain; and the saṅgha is like people free from ailment owing to the use of the healing herbs.
>
> —*Paramatthajotikā*, translated by
> Bhikkhu Ñāṇamoli

The teachings of the Buddha are known as the holy Dharma, which is recorded in the texts that Gene Smith helped preserve and disseminate. The Dharma could be considered the chief jewel of the three refuges in its being the actual means for attaining liberation. It provides a map of the escape route and the complete regimen of self-transformation. The Buddhist texts preserved by Gene are the repositories of Dharma, as are the oral traditions maintained by the lamas to the present day.

The Dharma is a guide for sentient beings through the intellectual, contemplative, and ethical training needed to eliminate the ignorance, aversion, and craving that perpetuate samsara. Buddhist texts prescribe a training regimen composed of virtuous conduct, the cultivation of deep states of meditative concentration, and perfect insight into the nature of the self and reality. Another cardinal feature of Tibetan Buddhism is the development of compassion, both in outlook and behavior, as are rituals of merit-making, repentance, and devotion. Thanks to Gene's successful efforts to preserve Tibetan books and later to make digital copies freely available, many Dharma classics have been translated into English.

The third refuge is the Sangha—the advanced practitioners within one's midst who can offer guidance and fellowship. The Triple Gem text cited earlier also includes this verse, which gives a particularly evocative image of the Sangha: "The Buddha is like a good horse trainer; the true dharma is like the means for the disciplining of thorough-bred horses; and the saṅgha is like a team of well-disciplined thoroughbreds." Sangha members know the teachings well and have internalized them, they are available for consultation and rituals, and they are concerned about the progress of rank-and-file Buddhists. Traditionally the term *Sangha* referred to a quorum of fully ordained monks and nuns, but in contemporary teachings it is often said that one's friends in the Dharma also serve in the role of a refuge.

The many photos in this book illustrate each of the Three Jewels—Buddha, Dharma, and Sangha—in all their many dimensions. The Buddha is seen in the many statues and paintings that appear in the photos. For believers, the high lamas, as enlightened beings, also represent the Buddha jewel. The Dharma jewel is embodied in all of the scripture texts and in the acts of teaching and transmission also captured in the photos taken during Gene's journey. The Sangha jewel is still a vibrant presence in the Tibetan community, as the monastic community is still receiving the teachings and blessings from unbroken lineages. While we normally talk about Gene's service to the Dharma, we can now see that indeed he served the Buddha, Dharma, and Sangha by making available a refuge to all of humanity.

The Four Schools of Tibetan Buddhism

Gene Smith wanted the entirety of the Tibetan Buddhist literary heritage to be preserved. He worked with lamas from all traditions and saved many obscure works that were no longer actively being studied. Gene downplayed sectarian divisions, but an understanding of the institutional landscape of Tibetan Buddhism remains important. There are four major sects, or schools, of Tibetan Buddhism and an adjacent tradition called Bön. On his last trips to India, Gene visited monasteries representing each of these five traditions.

The four schools of Tibetan Buddhism have much more in common with each other than an outsider might expect. Several factors explain the formation of the four schools: the highly diverse nature of Indian Buddhism, the centuries-long period of transmission to Tibet during which several new traditions emerged in India, and the competitive environment in Tibet that encouraged monasteries and masters to specialize in one form of Indian Buddhism or another.

The first of the four schools of Tibetan Buddhism is called Nyingma, a name that means "Ancient Ones." True to its name, the Nyingma school prides itself on faithfully preserving the first wave of Buddhism to reach Tibet, which is viewed as the patrimony of the Tibetan people because it was the faith of the hallowed Tibetan Dharma Kings during the Imperial Period.

As noted above, the Bön or Bönpo school is not one of the four schools but is a major tradition of Tibetan religion. The Bönpo considers itself Buddhist but traces its origins to a prior Buddha named Shenrab Miwo, who lived and taught in a kingdom to the west of Tibet. Shenrab is held to have lived nearly twenty thousand years ago, which would give his tradition great seniority over Indian Bud-

dhism. Some corners of Tibetan Buddhism harbor some prejudice against the Bönpo, but Gene fully embraced the tradition and collaborated with their lamas to preserve and propagate their distinctive writings.

The second of the four schools of Tibetan Buddhism is the Sakya school. The name Sakya means "Gray Earth" and refers to the ancestral homeland of the clan that founded Sakya Monastery. During the second wave of Buddhist importation from India, this tradition received exclusive transmission of a set of esoteric teachings from India that the early Sakya masters developed into a comprehensive system leading to full enlightenment: the *lamdré*, or "the path and its result."

Founded around the same time as the Sakya school, the Kagyü school is also closely associated with a distinctive set of teachings from India and Nepal. Kagyü translates to "Oral Lineage." Its founder was the translator Marpa Lotsawa (1012–1097). Marpa made three trips to South Asia to study under leading lamas, a remarkable feat in the eleventh century. His best-known disciple was the yogi Milarepa, the subject of Tibet's most beloved literary work, *The Life of Milarepa*, which has been translated into many European languages.

The fourth of the major schools of Tibetan Buddhism, the Geluk, was originally called the Ganden school after the monastery of Ganden, which was founded in 1409 by Tsongkhapa. One of the teachings the school is particularly known for is the *lamrim*, the "stages on the path to enlightenment." The Geluk school became politically dominant in Tibet, Mongolia, and even Qing-era China, beginning with the founding of the Lhasa-based Ganden Palace government, the seat of the Dalai Lamas.

"We were trying to develop a method for preserving a literary and cultural heritage. . . . There are four major Tibetan traditions: . . . Nyingma, Kagyü, Sakya, and Geluk. And we were trying to preserve and restore all of the traditions. It's making things accessible. And nobody's ever done it before. No one has ever tried to bring all the texts together."
—Matthieu Ricard

Mudslide

Our eight-hour drive from Palpung Monastery to Menri Monastery turns into fourteen due to storms and mudslides. Unlike the American crew, for whom this is a new experience, Gene and Mangaram take it in stride, using the time to discuss work. The crew spends its time watching in disbelief as busloads of people seamlessly transfer from one side of a barrier to a bus on the other side, climbing over rocks and fallen trees while clutching their suitcases, children, and groceries. Gene is clearly concerned about

arriving on time for a reunion at the Bön monastery with one of his oldest friends, His Holiness the Thirty-Third Menri Trizin. He must know that the monks have spent the morning clearing the mud ponds left by the monsoon rains so that Gene can walk safely to greet the abbot. All of us are moved by the beauty of a double rainbow as we finally pull up to the entrance and dozens of monks rush to Gene's side of the car.

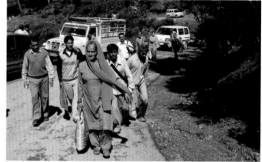

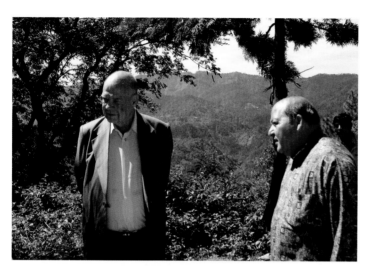

After a flash flood at the base of Menri Monastery, monks take the high road to greet Gene.

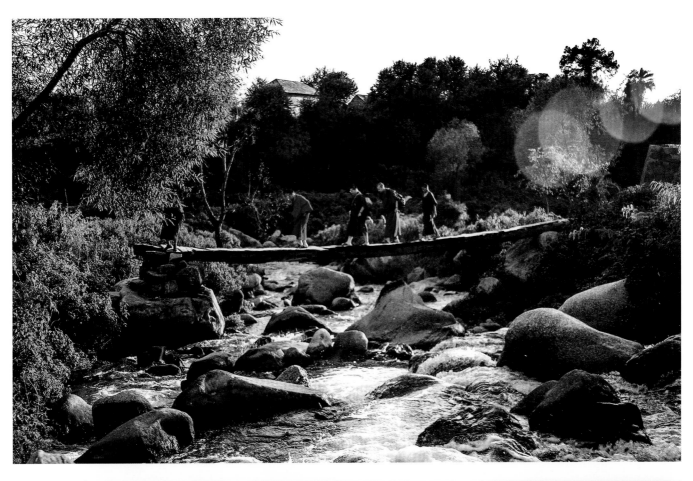

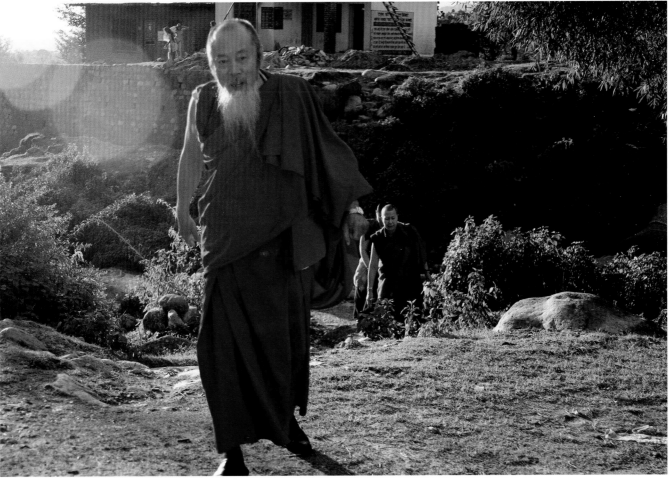

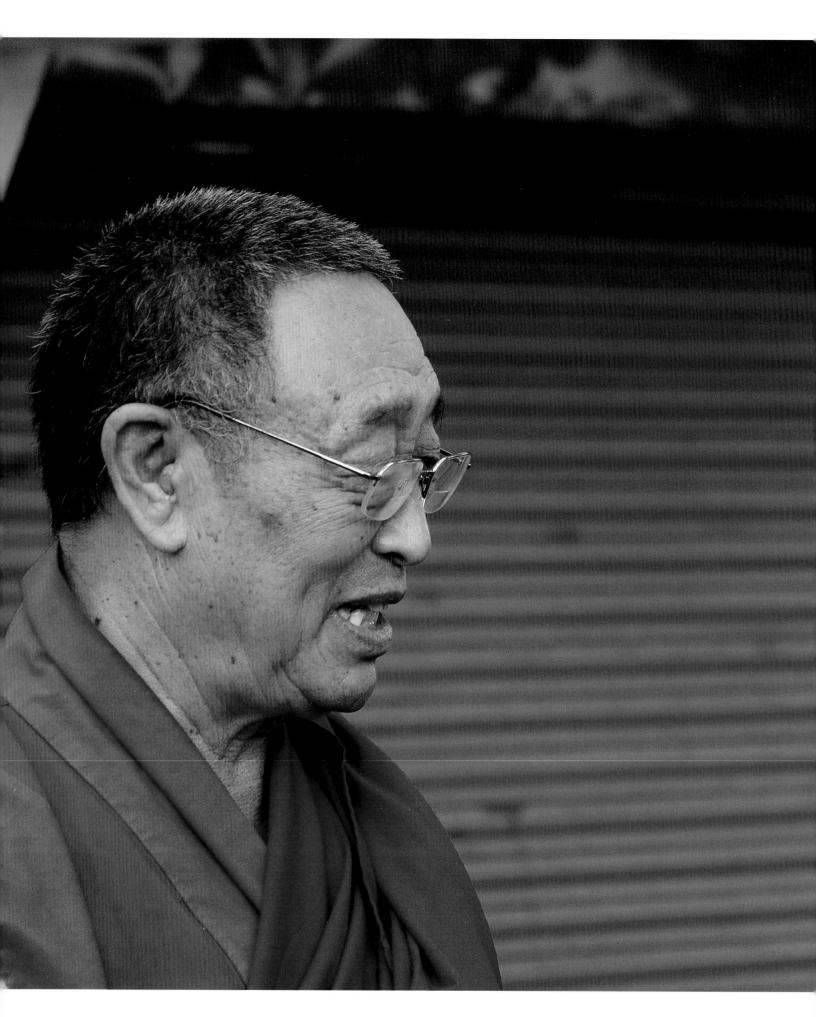

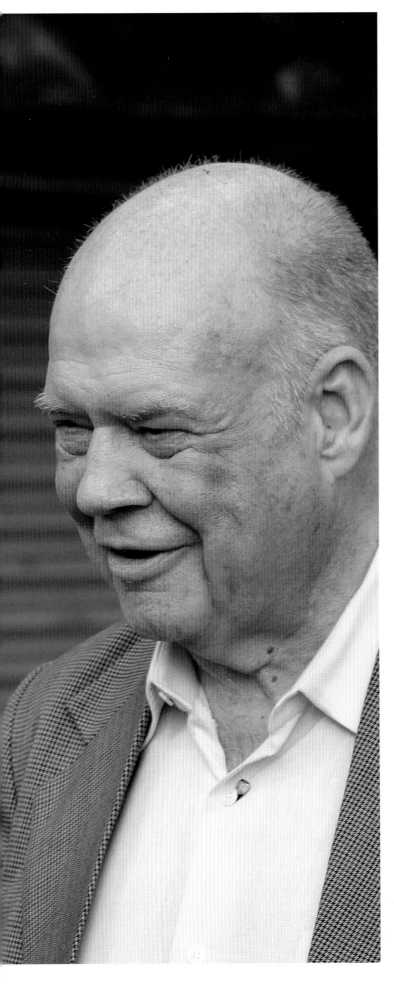

Menri Monastery and the Bönpo Tradition

Bön is often thought of as the foundation from which Tibetan Buddhism evolved. Although technically not one of the four Tibetan Buddhist lineages, it is largely what distinguishes Tibetan Buddhism from the kinds of Buddhism practiced in other Asian countries. As Richard Lanier, president emeritus of the Asian Cultural Council, explains, "[W]hat makes Tibetan Buddhism Tibetan, as opposed to Thai or Korean, is the influence of the Bön."

At Menri Monastery, Gene is reunited for the first time in decades with his old friend His Holiness the Thirty-Third Menri Trizin. It is here we learn the origins and history of the Bön through the eyes of the abbot and a young monk, Geshe Samdup Lama. The abbot takes us through his gripping tale of how he escaped from Tibet with only a seventeen-page loose-leaf catalog of the Bön texts. We experience the ancient ceremonies and infamous debate rituals directly related to the texts. We learn also how technology is helping this remote monastery safeguard traditions as the younger monks accept the challenge of learning to preserve texts and create one of the best libraries blessed by the Dalai Lama. These monks also embrace filmmaking as a way to help save their own ancient culture and transmit it to a new generation.

His Holiness the Thirty-Third Menri Trizin greets his close friend E. Gene Smith.

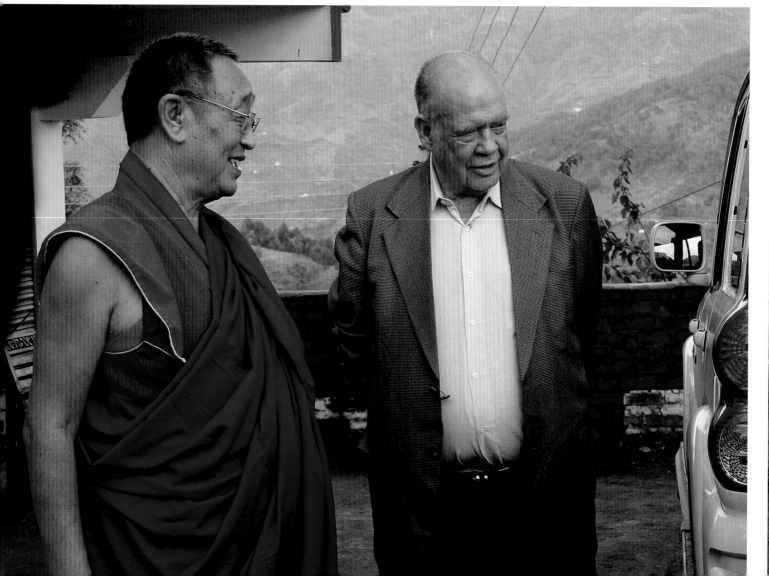

An important part of the Buddhist tradition is the ritual of circumambulating (walking around the perimeter of) a *stupa*, or Buddhist shrine. This practice, which is found among certain non-Buddhists as well, is believed to be both purifying and enlightening. The Bönpo is unique among Buddhist traditions in that pilgrims circumambulate in a counterclockwise direction, which is counter to the sun's apparent movement in the sky but consistent with the directionality of the Bönpo's sacred symbol.

Gene, Menri Trizin, and Bön monks circumambulate the monastery.

Next page: His Holiness Gyalwa Menri Trizin Rinpoche shows Gene the only text he brought with him when he fled Tibet in 1959.

Craftsman works on wood carving toward replicating the monastery left behind in Tibet.

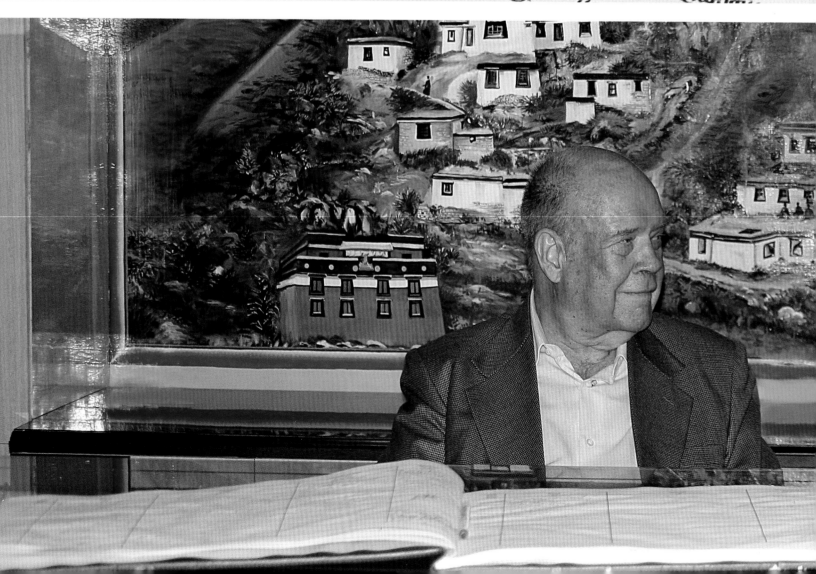

ཁྱབ་ཤི་ཆེ་བ། ཁྱེན་ལ་གོལ་བདག་ལ་འགྲུགས་པ་འདི་ན་མ་ཤས་པའི་ཕྲིན་རྒྱབ།
པ་ལ། རིག་ཤ་འཁྱུགས་ལ་བ་ལ་ངེས་པ་འདྲི་རྟོགས་ཀུན་ཅུ། ཁྱབ་པ་ཀྱི་བཟེང་ཅིག་འཁྱི།
ཅེ་ལ་འགག་ཤུག་ཅིག། ཁྱུབ་ལ་ཤྲེང་ལ་ཆེབ་ལུ་ལ་ཅུ་ཆྲེང་པོ་ལ་ཀུན་ལ་འདེ་ལ།
ཁྲ་ལ་ལ་ཁུ་ བ་ལ། ཐ་བ་ལ་ག་ཏ་ཤྲེ་ནི་ལ་ལ་ལ་ལ་འ་ངག་ལ་འདི། ཅེ་ཡ་ལ་བདུ་ལ་ན།
ཐ། ཁྲ་ཞི་ལ་ལ་འདི་ཆི་ན་ཁྲི་ལ་ལ་ཆི་ལ་ལ་ཅུ་རྒྱི་ལ་ལ་པ། ཡ་ལ་ཞེ་ན་ལ་ཀུ་ལུ།
ལ་ན་ལྔ་ཤ་ཆྲེ་ལ་ང་རྒྱང་པ། གུ་ཅེ་ན་ལ་ཐུ་པ་ལ་ལ་ཆེ་ལ་ཆི་ལ་ལ་བྲེ་ལ་ཀུ། ཅི་ལ།
ཅྲི་ན་ཅེ་ན། ཐྲ་ལ་ཅྲེ་ཆི་ཆེ་ར་ལ་ལ་ཅྲི་ཆི་ལ་ར་ཆུ་ལ་པ། ཆི་ཆྲ།
ཆྲི་ལ་བ་ལ་ཤྲུ་ལ་ཆེ།
 57

ཁྲ་ལ་ཆི་པ་ལ་ཀ་ར་ལ་ཆྲེ་ན། ཆེ་ལ་ལ་པ། ཆི་ལ་ཆྲེ་ལ་ར་ལ་པུ་ཆ་ལ་ལ། ཆི་ན་ཆ་ལ།
ཆྲི་ཁྲ་ལ་ལ་ཤ་ལ་ཆ་ར་ར་ཆྲི་ལ་ཆ་ཆྲུ་ར་ཆུ། ཆྲེ་ལ་ཆ་མུ་ཆྲ། ཆ་ལ་ཆྲི་ཆྲི་ལ་ལ་པ་ལ།
ལ་ཆྲི་ལ་ཆ་ཆྲ་ཆི་ལ་ཆྲ་ལ། ཆྲེ་ལ་ཆ་བུ་ཆྲ། སྐ་ལ་ཆྲི་ཆྲི་ལ་ཆ་ལ།

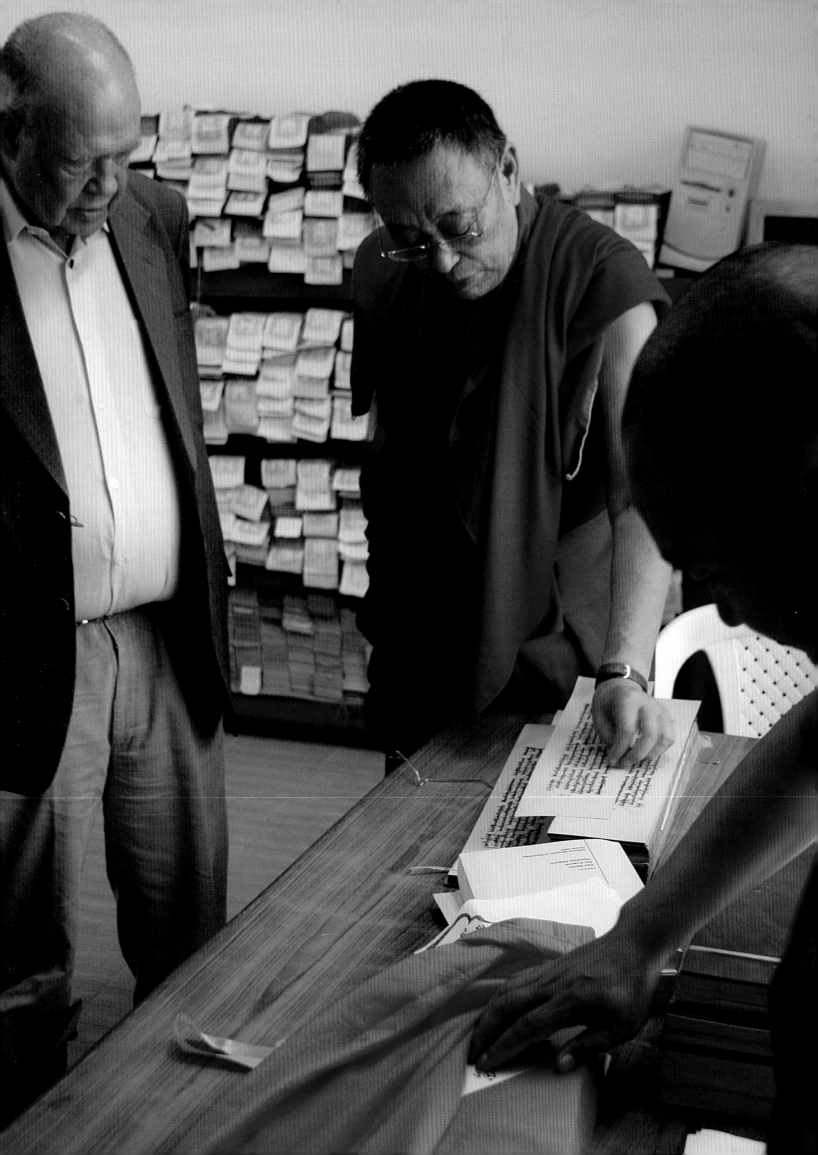

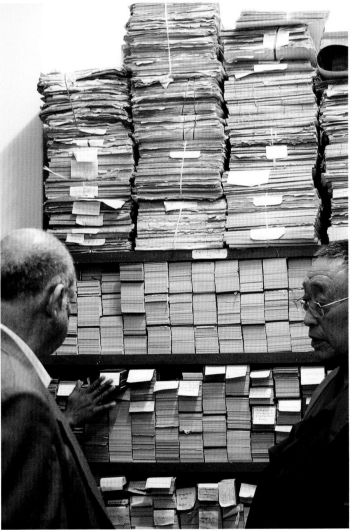

"We actually couldn't bring any texts with us when we came to India on foot. Then, after, there was a little freedom and I went back to Tibet three times. There in the old Bönpo monastery . . . they had the hidden texts. The whole time, we are connected with Gene, who advised us. We borrowed the manuscripts from them and brought them to India. Then, we published. . . . Then, gave to Gene. He is the only master and professor. He is a good one."

—His Holiness the Thirty-Third Menri Trizin

This page: Geshe Samdup Lama and Menri Trizin show Gene the volumes they are about to scan.

Opposite: Menri Trizin reviews the Bön's preservation and printing works.

Previous page, top: Sample of reprint of Bön text.

Previous page, bottom: Gene and Menri Trizin rest in front of the entrance to the monastery and the painting of the home that the Bön left behind in Tibet. In front of them is the sign-in page for His Holiness the Dalai Lama's visit.

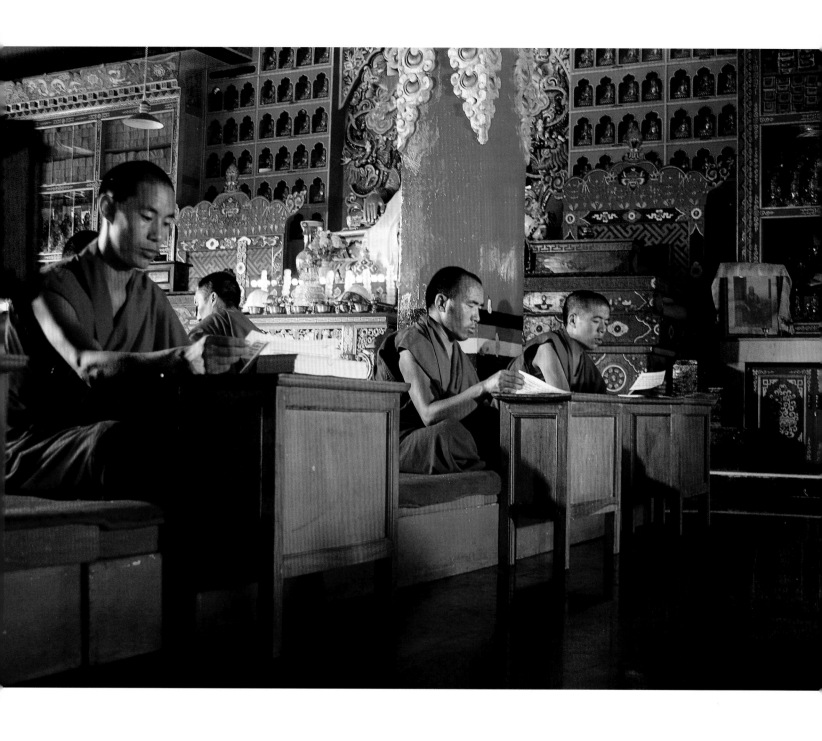

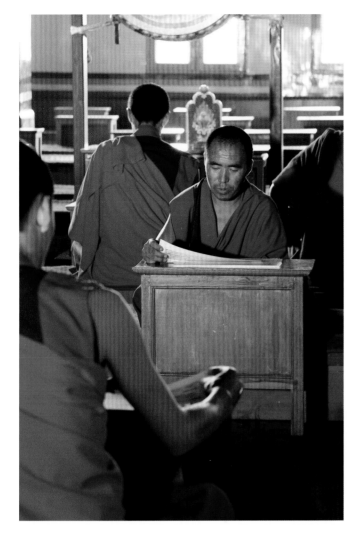

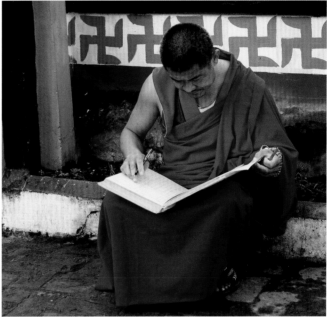

Bön monks read their texts.

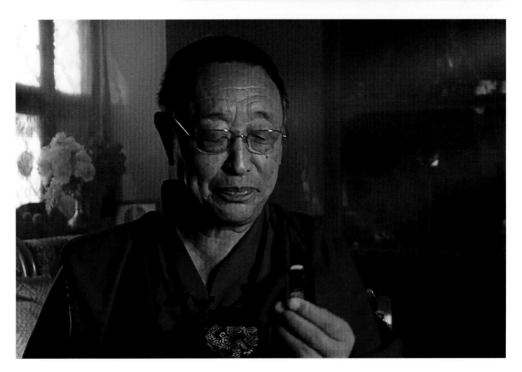

Menri Trizin shows the small drive, given to him by Gene, of the text he escaped with.

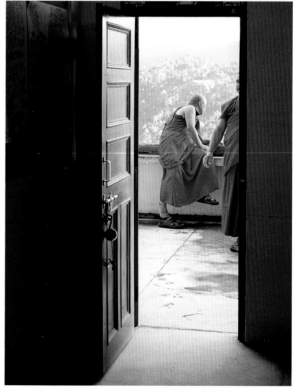

Previous page: Deck view of the valley with the nunnery visible at the fog line.

Top: Double rainbow.

Bön monks look out from classroom.

Right: Geshe Samdup in morning fog.

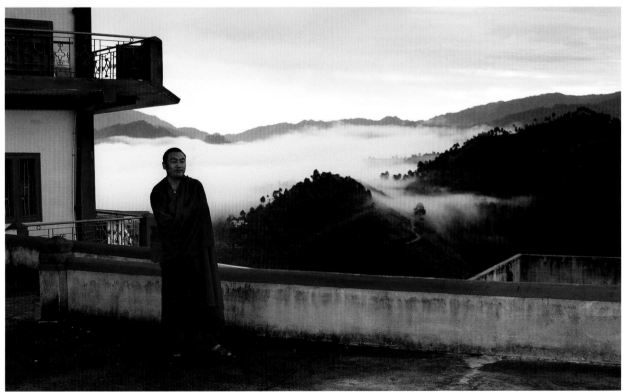

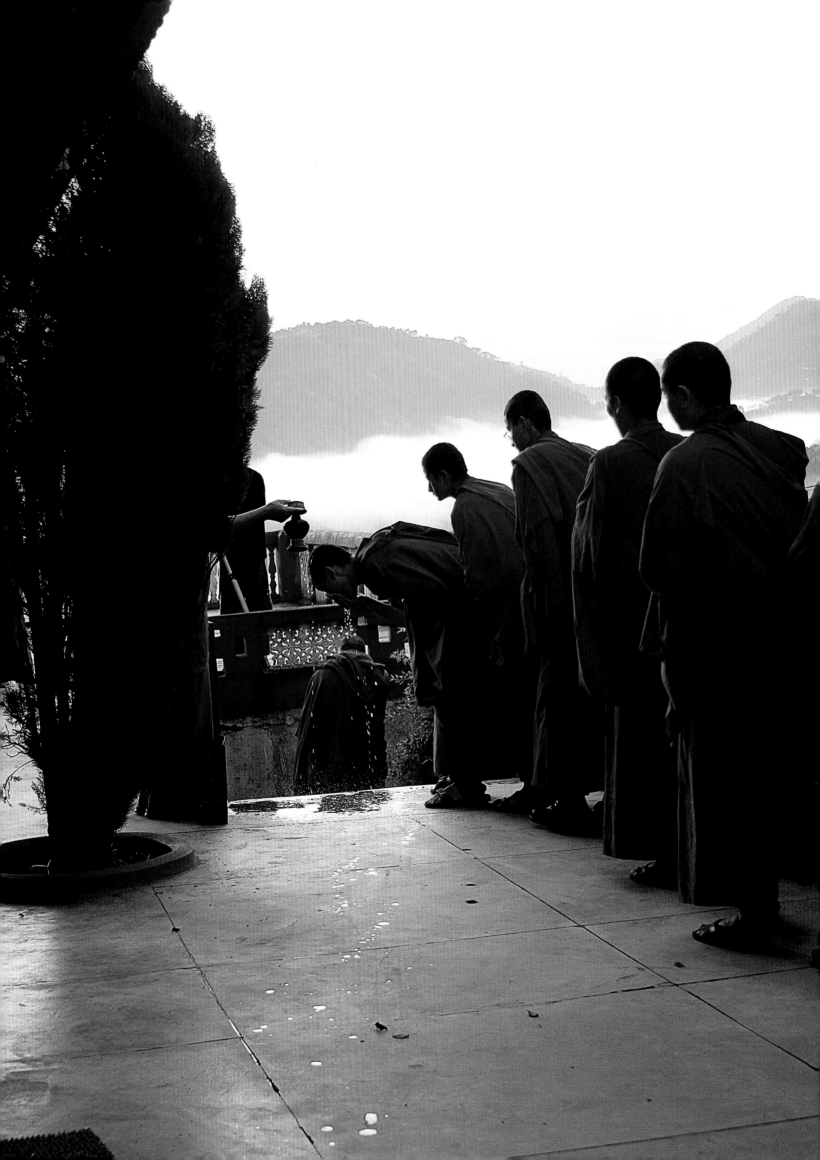

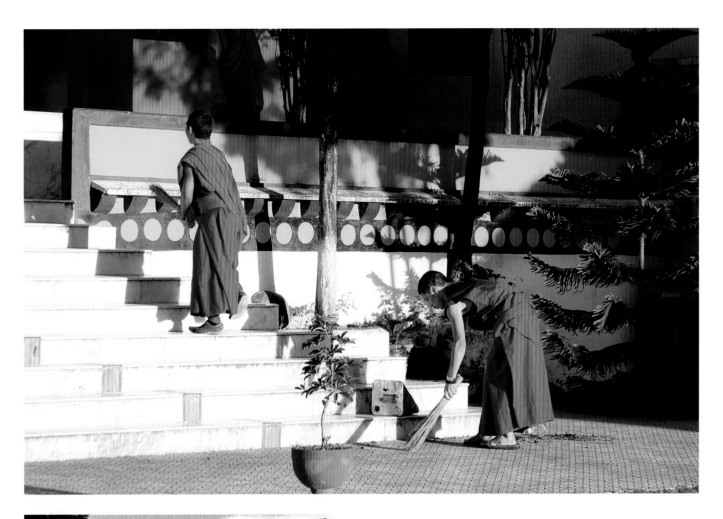

Menri Trizin and the monks were so gracious in allowing us to observe a day in their life at the Bönpo monastery. It is a day delineated by a series of rituals, including the reciting of morning prayers, receiving blessings, and debating.

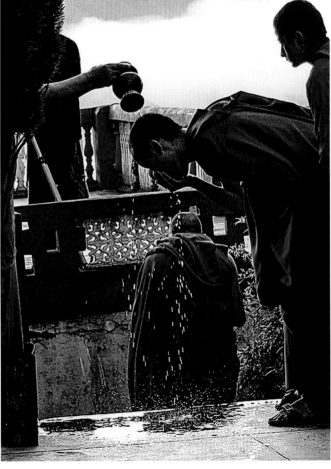

Above: Early morning sweep before prayers.

Left and facing page: Monks receive a morning blessing from their abbot.

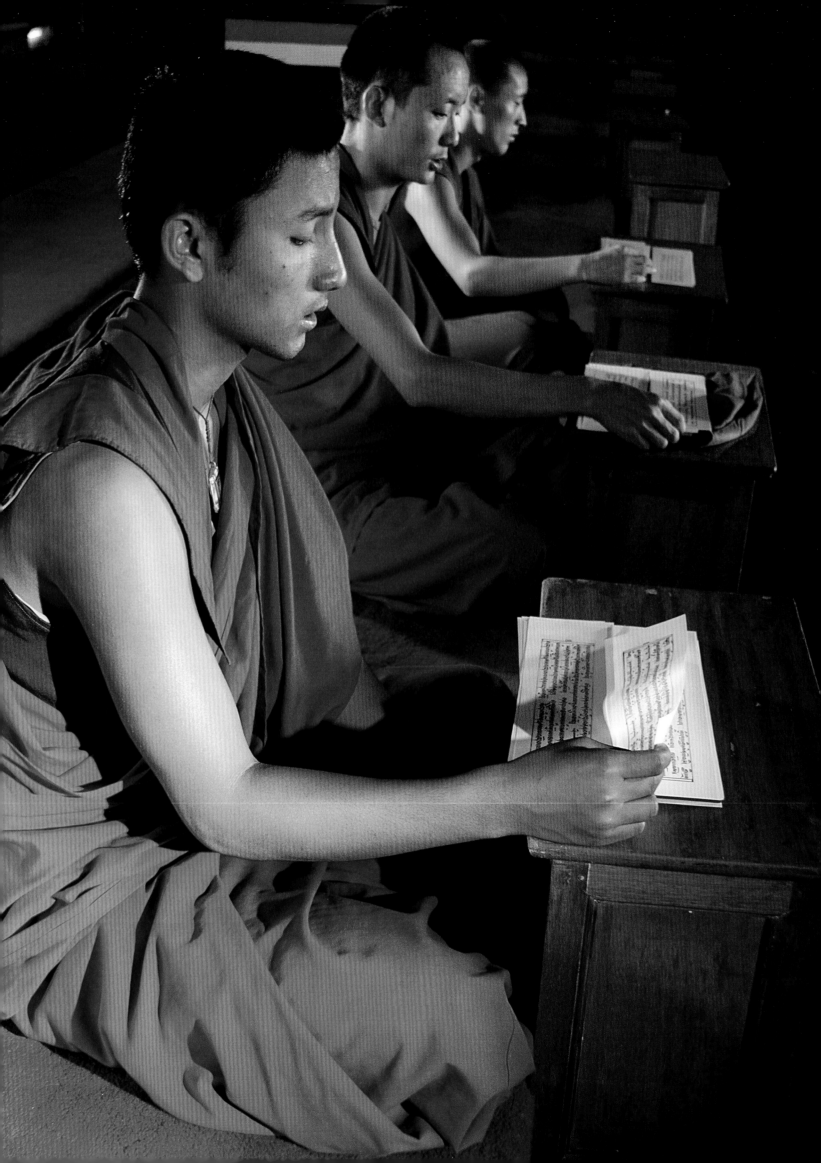

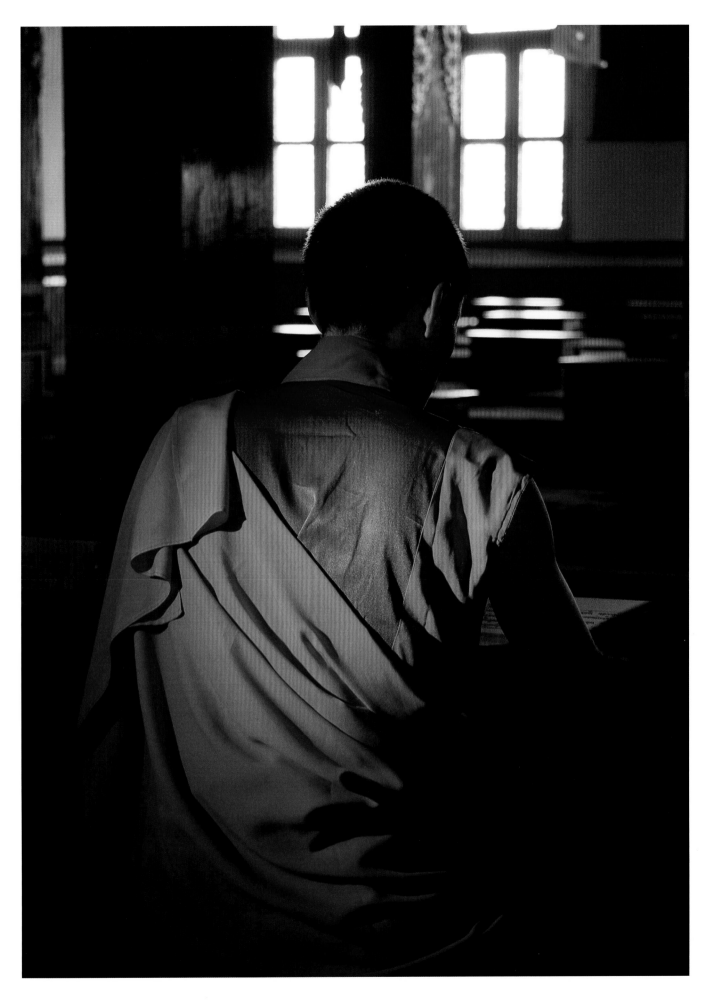

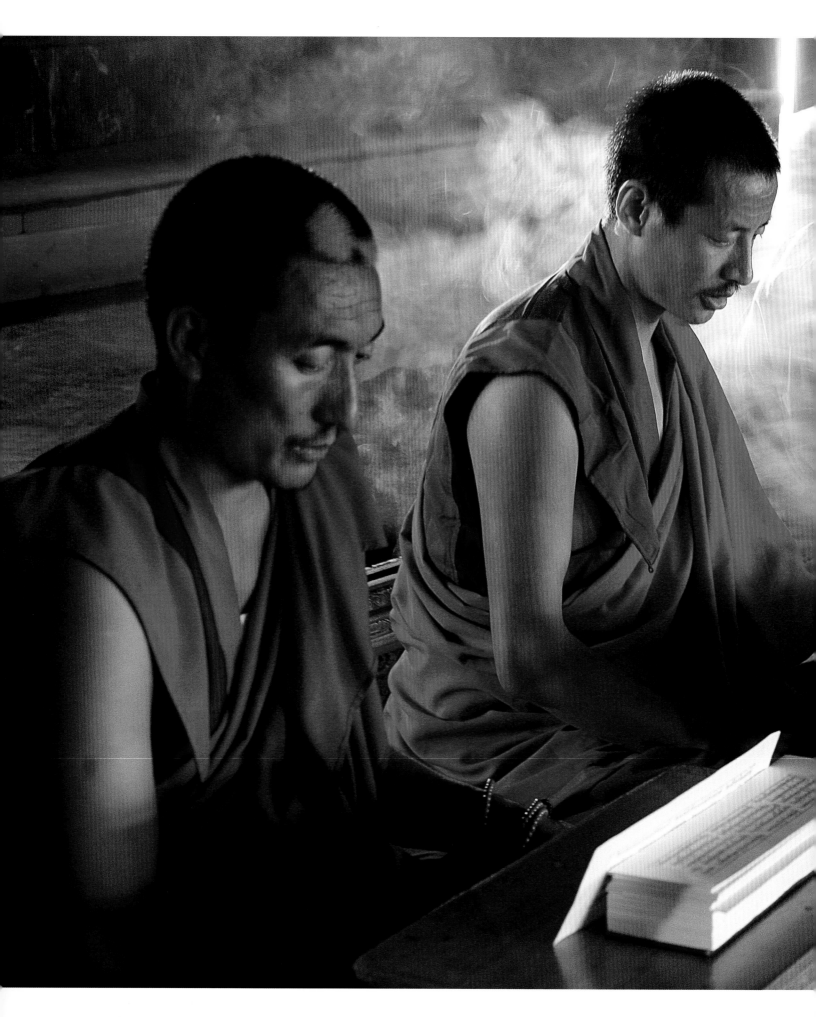

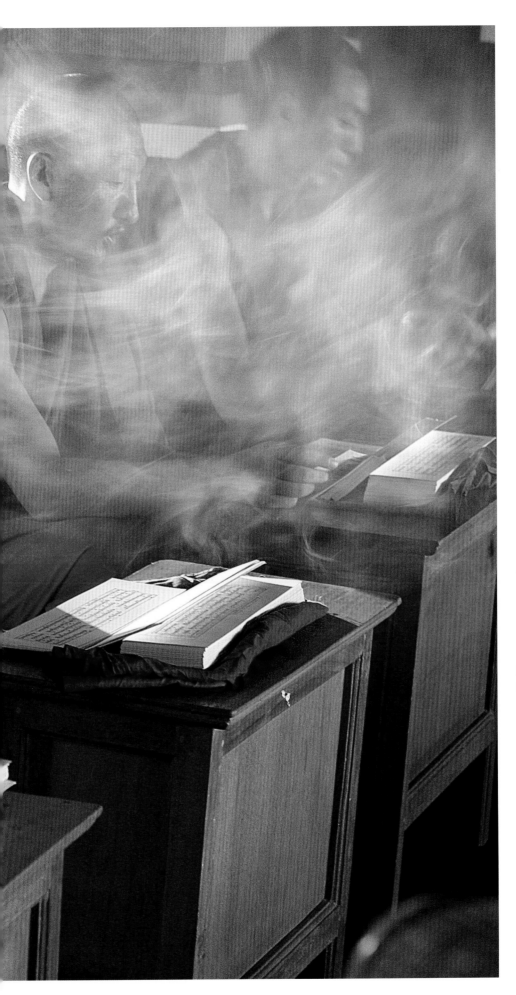

Bön monks study and recite
from the texts.

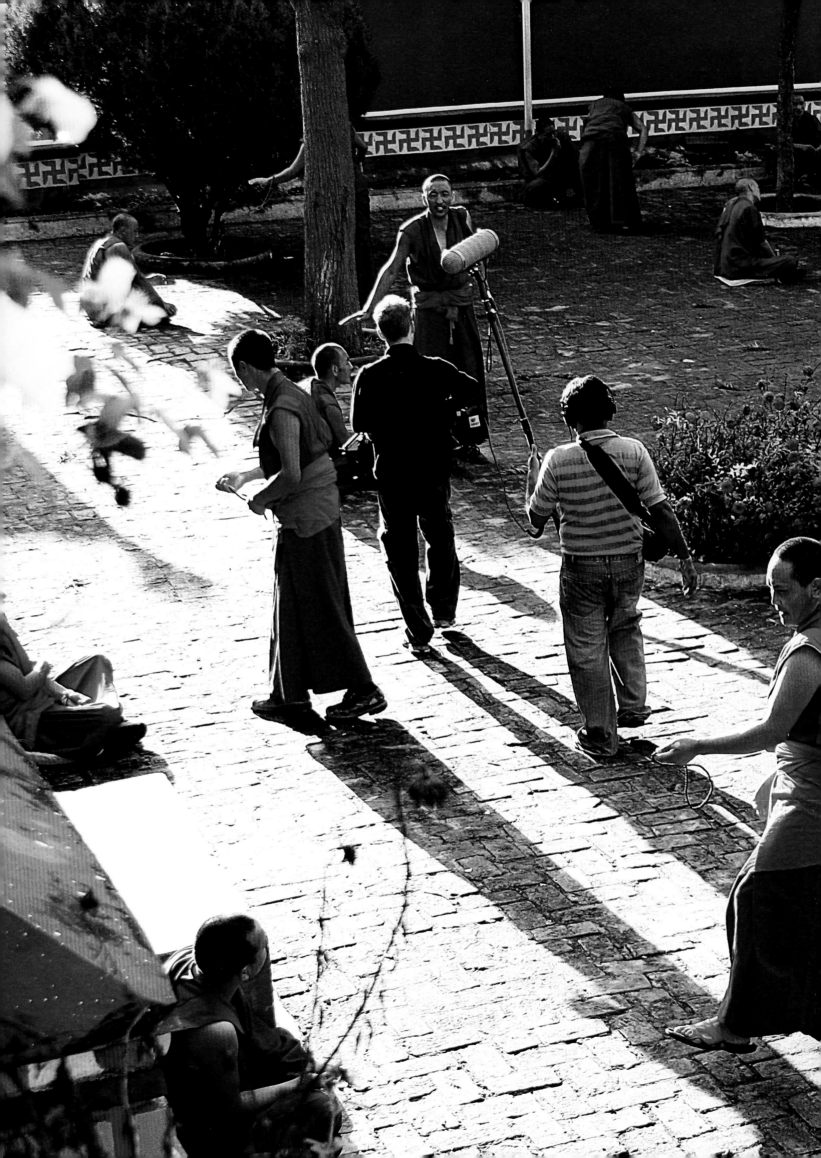

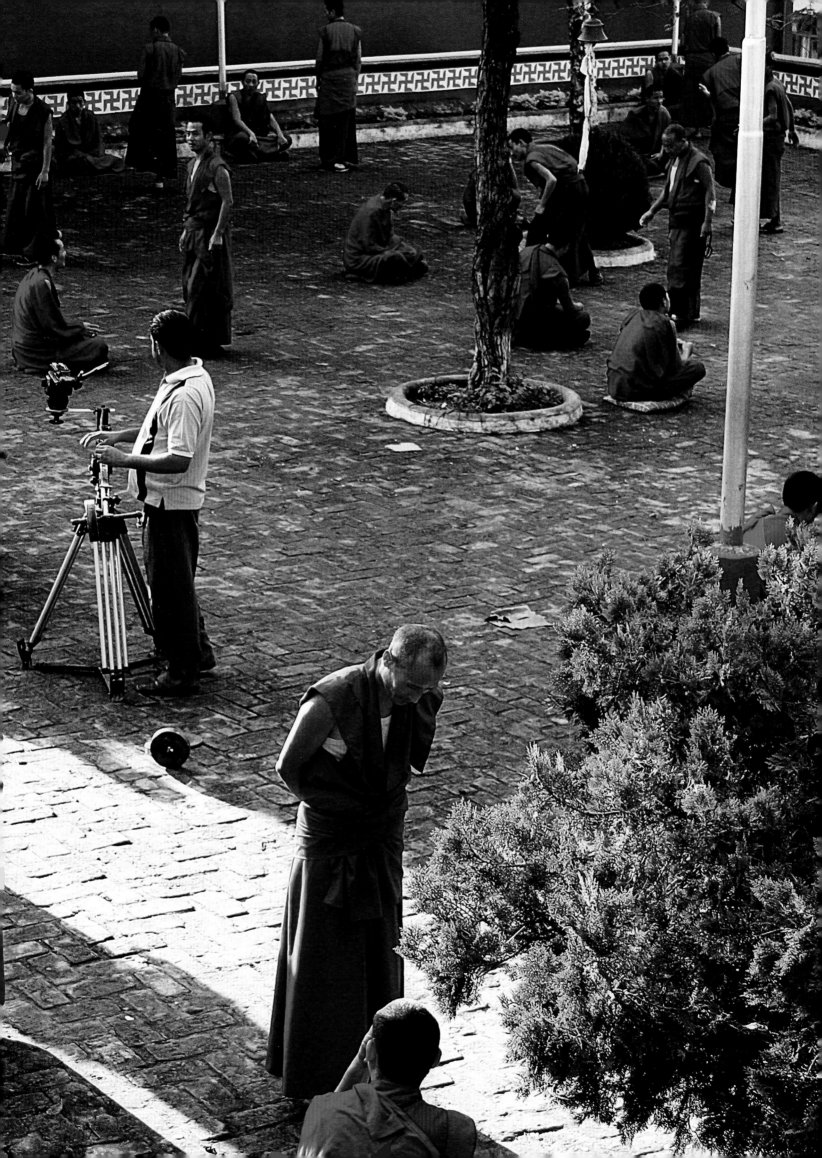

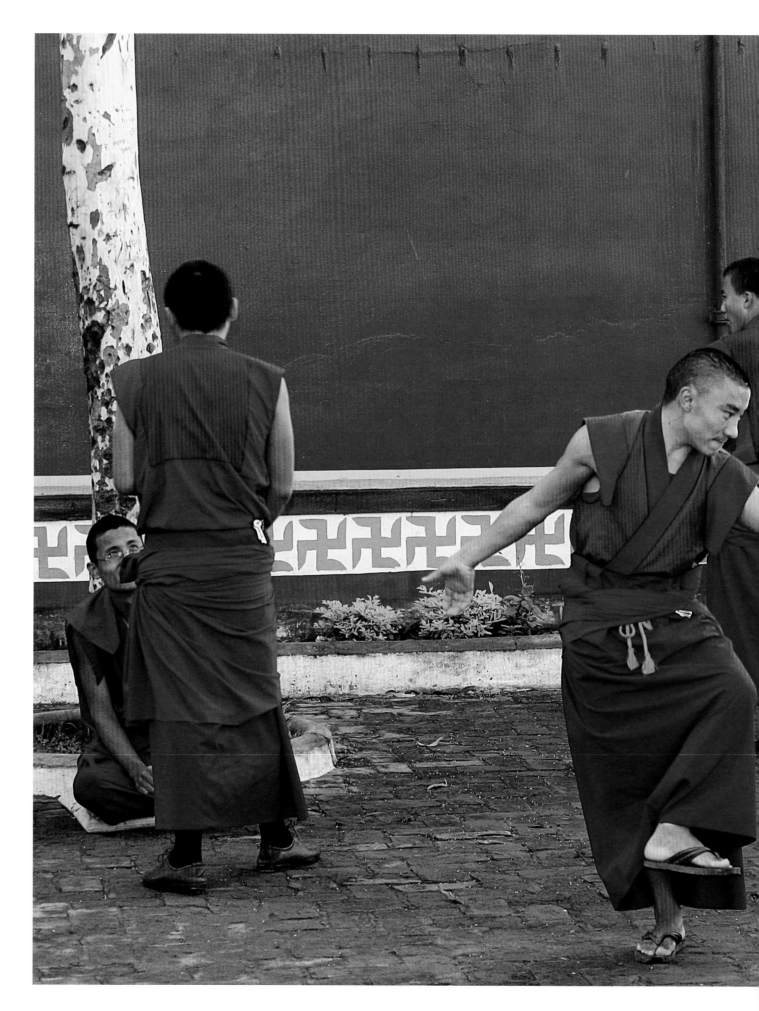

While at the monastery, we have an opportunity to watch monks debating, which includes a prescribed sequence of steps. One monk, who is standing, asks a question as a challenge to the sitting monk, who must defend his position. Questions and answers, memorized from the texts just studied in class, are followed by discussion. During the debate, the standing monk claps his hands and stomps his foot in carefully choreographed movements to emphasize the point that he is making. The debate, which must always return to the main point of the text, is an important part of the transmission ritual.

Capturing the unique debates of the Bön tradition.

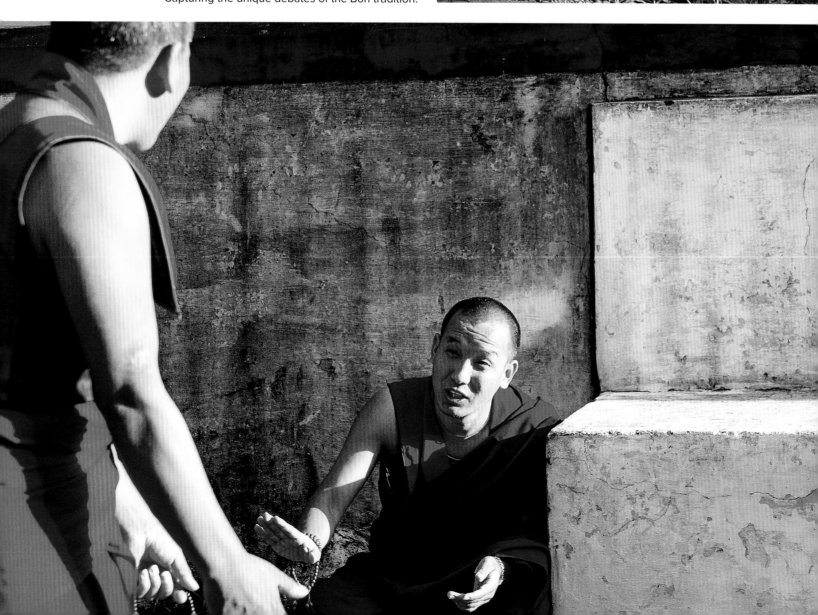

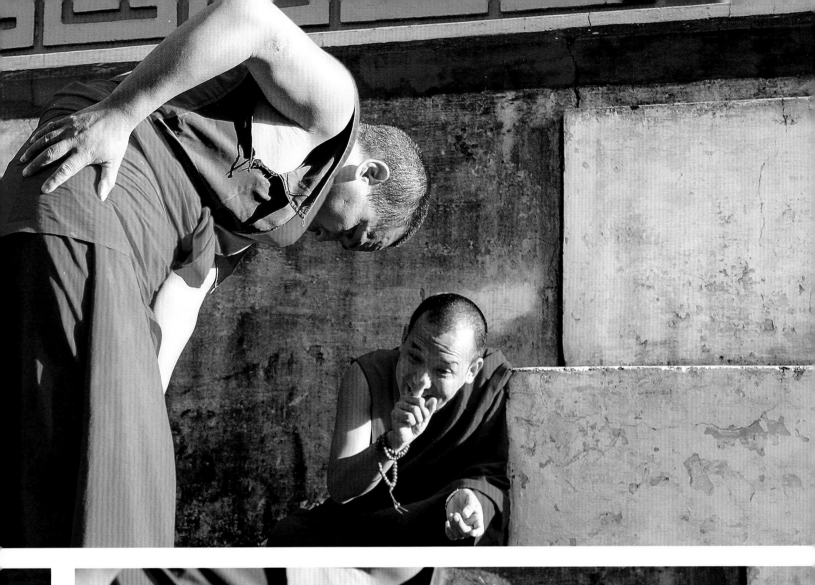
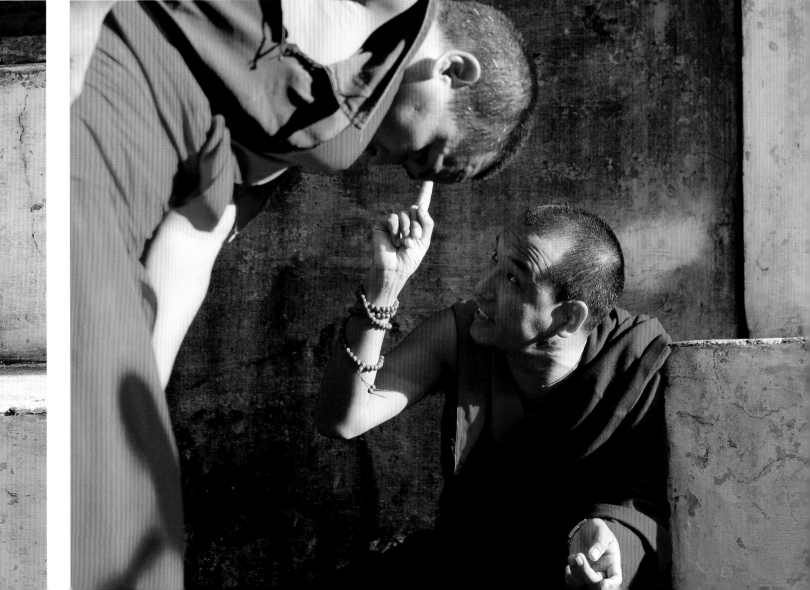

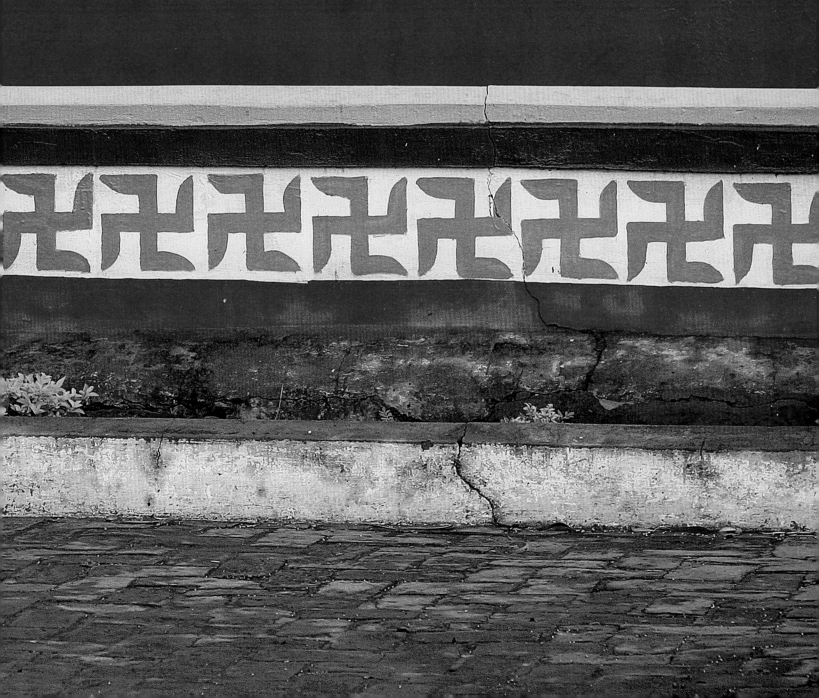

KATHMANDU
"JEWEL AND GEM"

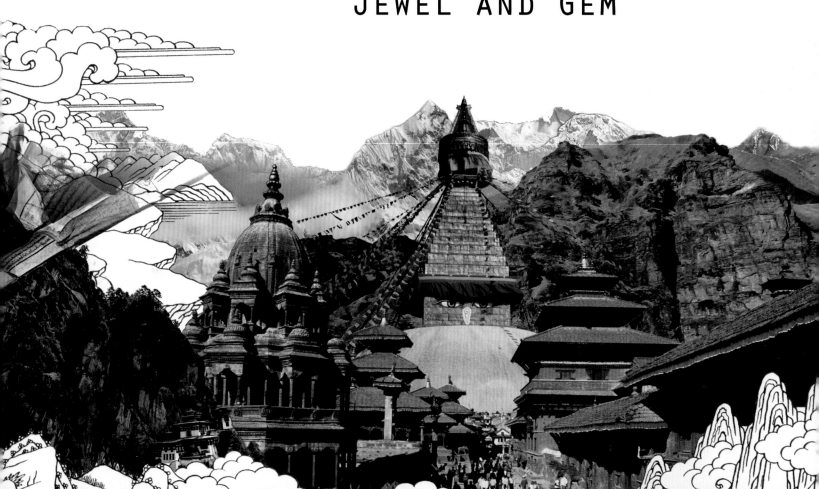

DELHI

KATHMANDU

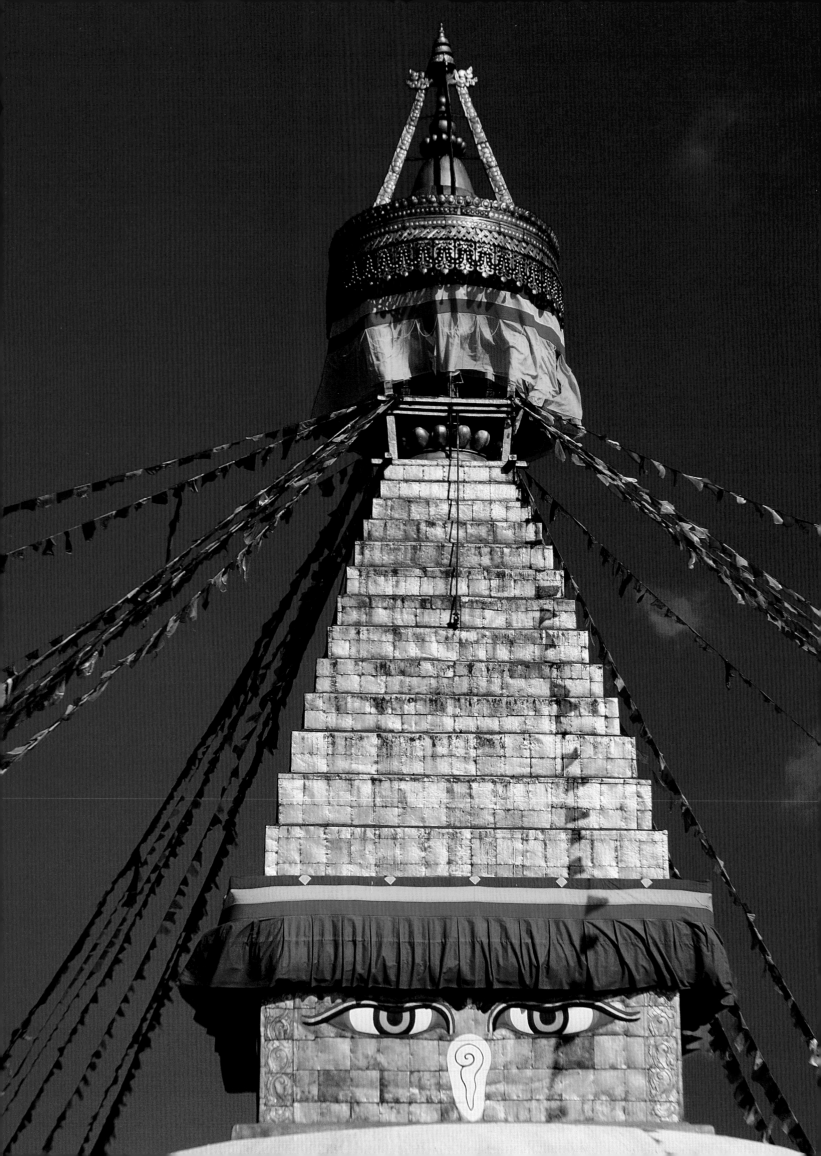

Shechen Monastery

S HECHEN MONASTERY was built by the late Dilgo Khyentse Rinpoche, teacher of the Dalai Lama and regarded as one of the great meditation masters of the twentieth century. Dilgo Khyentse, who was Gene's second teacher, helped to build and sustain numerous monasteries and colleges throughout the region. Shechen was the last monastery he established before his death in 1991. Shechen is known for its music school and art program, which specializes in traditional Tibetan *thangka* painting. Shechen's Tsering Art School produces some of the best-trained thangka painters anywhere in the world.

During this visit, Matthieu Ricard shows us how preserving the text is vital to the art history of the Himalayas and talks about the changes in technology over the last three years that have allowed his team of preservationists to analyze and compare rediscovered texts more quickly.

Boudhanath Stupa (or Bodnath Stupa) is the largest stupa in Nepal and the center of Tibetan culture in Kathmandu. Rich in Buddhist symbolism, the stupa is located in the town of Boudha, on the eastern outskirts of Kathmandu, next to Shechen Monastery.

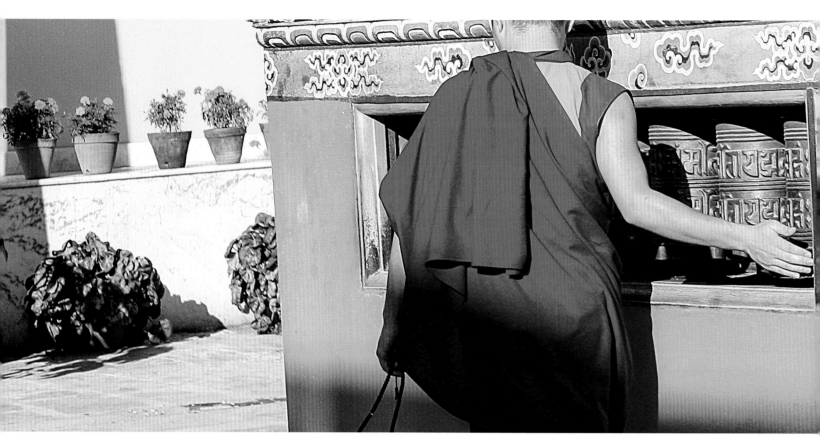

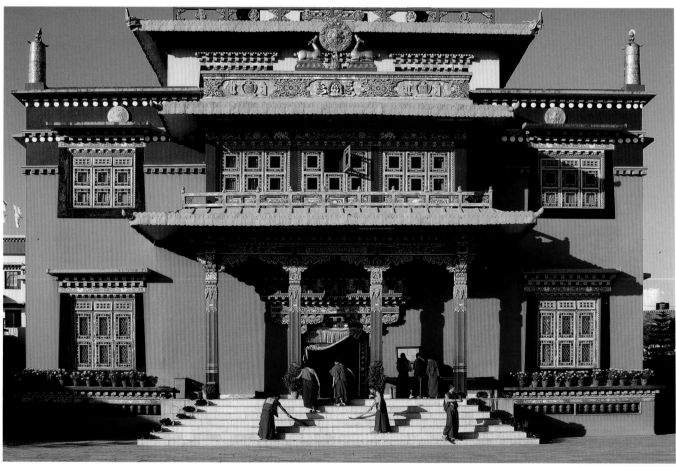

To become an expert thangka artist requires ten years of supervised training from a master, followed by another five to ten years of experience.

Monk carries traditional butter sculptures to ceremony.

Opposite top: A monk walks the perimeter of Shechen Monastery, spinning prayer wheels.

Opposite bottom: Monks sweep the steps to the assembly hall.

"So the whole description is many many pages and . . . the iconography is entirely based on that precise description. Chapter by chapter we can follow the traveling [the writer] envisioned and all we have is the text. The whole process is a very complex and complete structure that involves everyone and the text is always at the heart of it."
—MATTHIEU RICARD

Matthieu Ricard and Gene take a moment to happily catch up after many years, though most of what we overhear is their excitedly circling back to upcoming preservation efforts.

A Buddhist monk, photographer, humanitarian, and PhD in molecular genetics, Matthieu is the author of dozens of essays, articles, translations of Buddhist texts, and his own books on a wide range of topics, including Buddhism, meditation, history, philosophy, biography, photography, and animal rights. He is also the founder of Karuna-Shechen, a humanitarian association that provides health care, education, and social services for the underserved people of India, Nepal, and Tibet, and is dedicated to building a more altruistic world. We are a bit awed to find ourselves in the presence of this internationally known figure, and more than a little intimidated to be shooting photos in the presence of one of the world's great photographers, but Matthieu's warm, engaging manner quickly puts us at ease.

Matthieu and Gene have been close friends for many years. They met in India in the early 1970s, when Matthieu developed an interest in Buddhism, and he spent a great deal of time at Gene's house in Delhi, helping him to begin his journey to recover, preserve, and disseminate sacred Tibetan Buddhist texts. (Matthieu recalled for us how hot and steamy the printing shops in Delhi were then.) A major part of Matthieu's work is still dedicated to transmitting the vision of his first mentor and Gene's second teacher, Dilgo Khyentse Rinpoche.

We are fortunate to be "flies on the wall" as Matthieu and Gene spend hours reminiscing. To see them together— these two great men who, in the intervening years, had achieved so much yet also succeeded in retaining their humility—it is as if time had stood still.

Matthieu's unofficial title—"the happiest man alive"— comes as a result of his participation in a twelve-year study at the University of Wisconsin in which his brain produced an unprecedented level of gamma waves during meditation. Hardly surprising, for someone who believes that happiness is a skill that can be learned through practice.

Matthieu being interviewed in one of the chapels at Shechen.

Left and next page: Matthieu Ricard and Gene review the progress of inputting and cross-checking Tibetan texts.

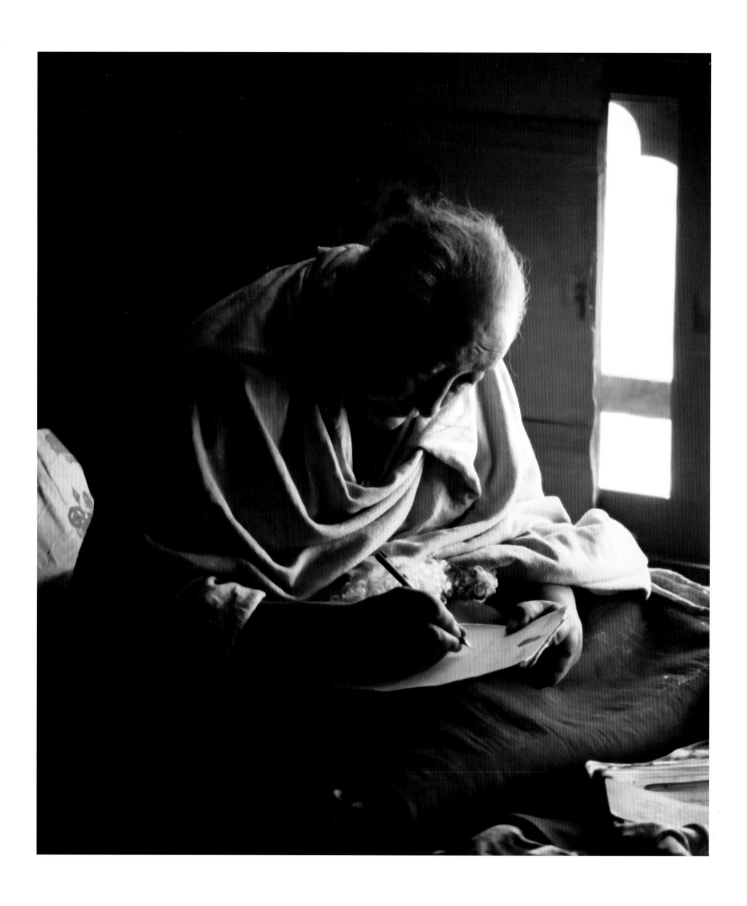

Dilgo Khyentse Rinpoche

Kyabje Dilgo Khyentse Rinpoche was the Dalai Lama's principal teacher in the Nyingma tradition. Following the Dalai Lama's departure from Tibet in 1959, Dilgo Khyentse moved, with his family and disciples, to Bhutan, where he lived and taught at the invitation of Bhutan's royal family. He subsequently began teaching throughout the Himalayan region, where his students included Matthieu Ricard and Gene. Dilgo Khyentse became head of the Nyingma school in 1987 and remained so until his death in 1991. He dedicated the latter part of his life to supporting ritual, artistic, and textual transmissions that were in danger of becoming extinct because of the challenges of exile.

Left: Dilgo Khyentse Rinpoche writes in his room at Shechen Monastery. Photo courtesy of Matthieu Ricard.

This page: Gene looks on as Matthieu prostrates before the shrine to Dilgo Khyentse in their teacher's room.

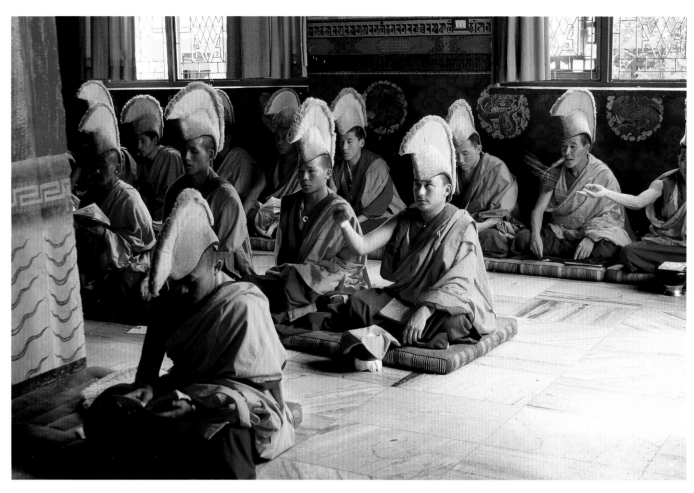

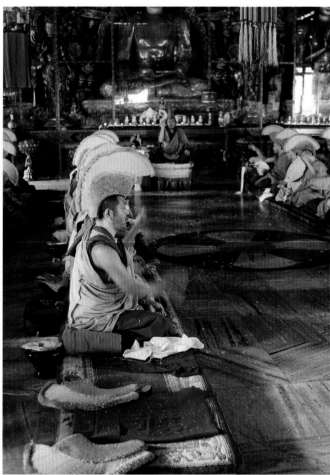

Monks throw rice in the air during traditional prayer ceremony.

Facing page: Lighting incense at the Shechen entrance closest to the stupa.

Life around the stupa.

Left: Lighting butter lamps.

Right: Laying flowers to remember a departed loved one at the bell.

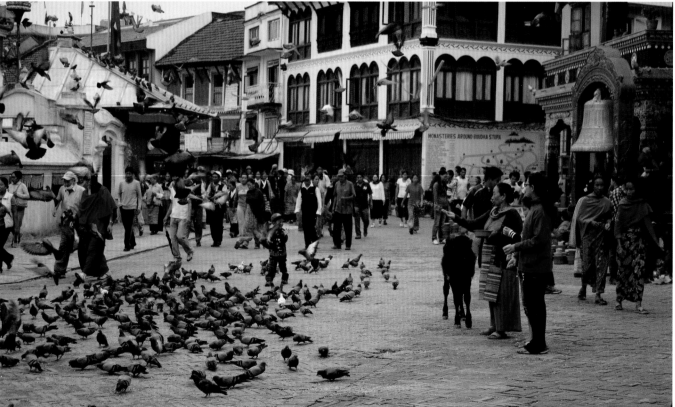

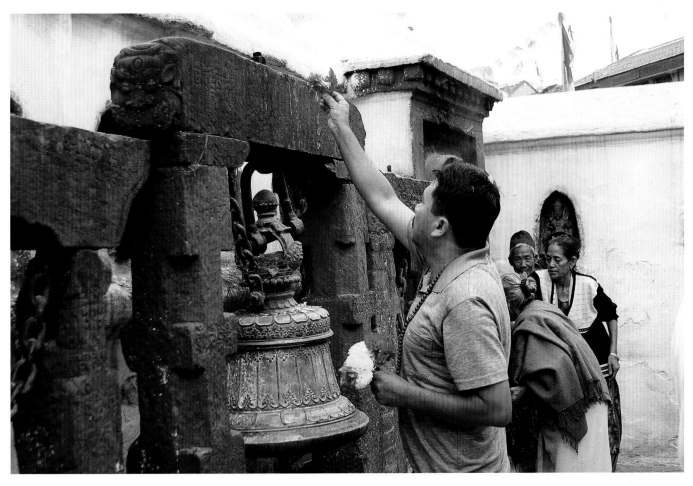

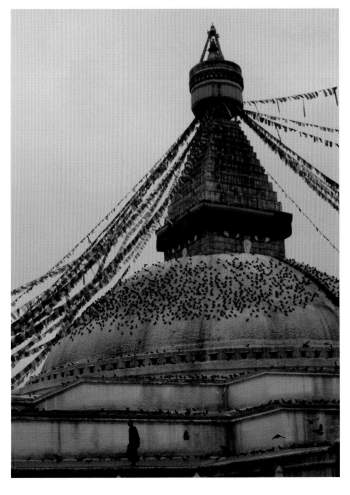

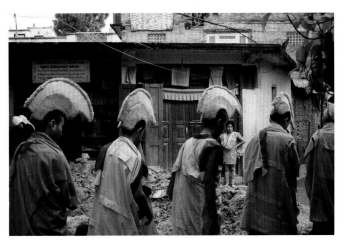

Matthieu and Gene return from circumambulating
the Boudhanath Stupa.

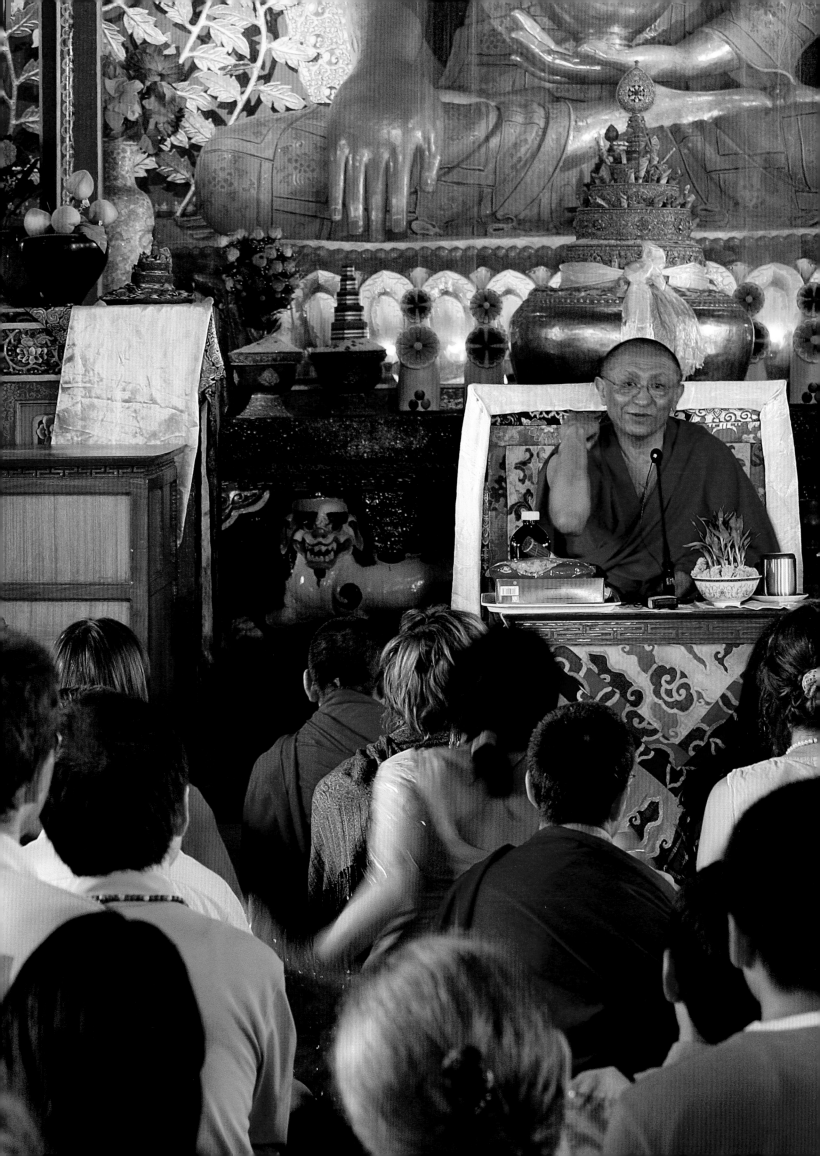

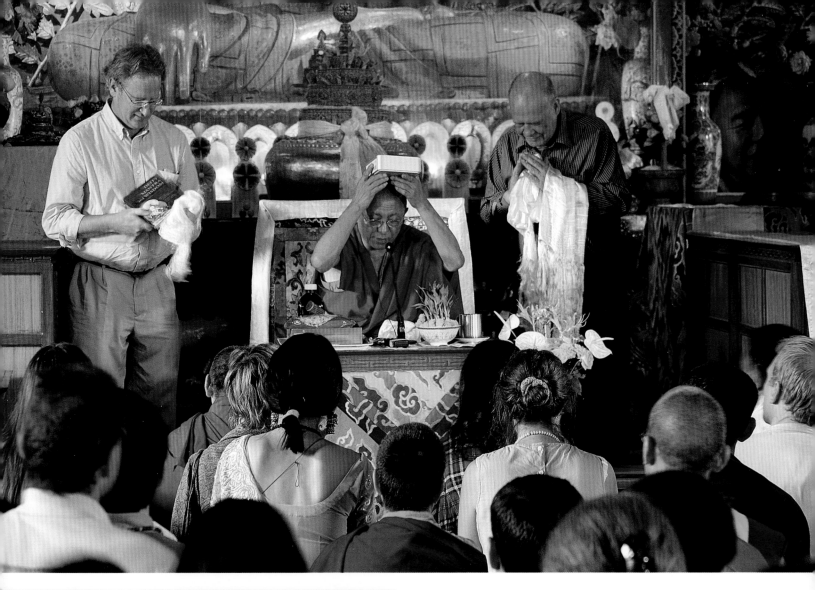

With one last drive in his suitcase, Gene goes to a college in Kathmandu founded by the beloved Chökyi Nyima Rinpoche. It's an institution that has more international students studying Buddhism than anywhere else in the world. They are embarking on a new translation program. Gene delivers the text at a ceremony led by Rinpoche at his temple, Ka-Nying Shedrub Ling.

Gene is pleasantly surprised and honored when Chökyi Nyima Rinpoche invites Gene to join him. Rinpoche accepts the drive with enthusiasm, giving us one of the most iconic photos of this journey, as he praises Gene for being a great scholar. He exclaims, "You're giving all of us a jewel and gem," and then "prostrates" himself with the drive.

"So now, the teaching of Buddha is
not only in Tibetan hands. Now, the
teaching of Buddha is in each of your
hands. A good practitioner needs to be
a scholar. A good scholar needs to be a
good practitioner."
—CHÖKYI NYIMA RINPOCHE

E. Gene Smith: Roots

Ellis Gene Smith was born in Ogden, Utah, in 1936, the oldest of four children in a traditional Mormon family. Gene's father worked for the government on a federal missile project and brought the family with him when he took jobs at the Herlong (CA) Ordnance Depot and later the Seneca (NY) Ordnance Depot. Gene was rumored to be a descendant of either Joseph Smith or his elder brother, Hyrum Smith. Whether true or not, Gene's youngest sister, Rosanne Smith, believes that Gene's Mormon upbringing may have played a significant role in his future interest in Tibetan culture. "Genealogy is just in the blood of Mormons," she notes. "They're almost more interested in the dead than in the living at times, and Gene was fascinated by his ancestors. There were the values of the Mormon pioneers, how they got here, what country they were from, who their fathers were. I think that's where he developed an interest in the various Tibetan lineages that he eventually specialized in."

Much of what we know about Gene's early years comes from Rosanne. "He was really smart," she says. "He was gifted with intelligence as well as a personality and a love for people. That's just kind of who he was." Although Gene's father was said to be supportive of all of Gene's endeavors and "the first to write a check," they may not have had much in common. A geologist, Gene's father "loved to be outside and in the dirt, and that definitely wasn't Gene." And, although Gene's father was a reader, "they didn't read the same kinds of things." It was the special relationship between Gene and his mother, according to Rosanne, that was "the secret of his success" and what "actualized" Gene's extraordinary natural gifts.

Unbeknownst to those who did not know Gene well, he reportedly was quite the prankster. "Most of our family is very conservative," Rosanne says, "with Gene being probably the only liberal." She tells how, in conversations around the dinner table, Gene "would say just the opposite of what he knew to be the flow of the conversation, just to get everybody fighting and arguing, and then he would sit back and watch the action. He stirred the pot. That was kind of his role in the family—to keep everybody thinking."

Gene loved music and played the bassoon in his high school band. According to Rosanne, he also was a wonderful writer. He was editor of *The Literary Harvest*, Ogden High School's short story and poetry magazine. He loved writing poetry and won several poetry contests. By the time Gene graduated from high school, he reportedly was fluent in all of the Romance languages. "He read everything foreign," says Rosanne. "I think that was just part of who he was. He was always buying books. At that time it wasn't necessarily Tibetan books, but he had books of every language that he was studying—books about the people and the culture. We had a small house in Ogden and the books took over. They were stacked in the basement along a certain wall, and whenever we had to get the Christmas decorations, we had to move all of the books. Even up until the very time that my mother passed, we were still getting rid of the books that he was storing in our family home. He had an unquenchable thirst for knowledge.

"It was hard for anyone to compete with that drive and that force," says Rosanne. "My mother wanted him to have someone who would love and cherish him and help him fulfill that part of his life, and a lot of people did love and cherish him, and Gene was very generous to them. But as far as that 'one and only person' is concerned, Gene and I had heart-to-heart talks and I do think he was in love with his work, first and primary. That was the driving force in his life."

The many faces of young Gene.

Left : Big brother Gene with his sisters.

LION'S SHARE—These Ogden High students took just that at a recent poetry contest in Salt Lake City. Left to right, Lorna Hart, Claire Billings, Sharon Slater and Gene Smith.

Gene with his youngest sister, Rosanne.

Gene was always interested in Russian but he finally trained his considerable gifts on studying the Tibetan people and their culture. "Everything about Tibet seemed second nature to him," says Rosanne. "For as long as I can remember, it seemed like he was most at home when studying Tibetan."

Gene tells of his becoming disaffected with religion when in high school and subsequently taking courses in various universities to avoid the draft. He studied what were, for him at that time, "the most useless things I could think of—Asian languages," including Tibetan, Mongolian, and Turkish. He eventually decided to focus on Tibetan, which turned out to be perhaps the most important decision of his life.

Following the Chinese invasion of Tibet in 1959 and the Dalai Lama's going into exile, the Rockefeller Foundation sought to bring high-ranking Tibetans to American universities. The University of Washington received a three-year grant to host a Tibetan master, His Holiness Dagchen Rinpoche; his wife, Her Eminence Jamyang

Dagmo Kusho, known as Dagmola; their three children; and the children's tutor, Dezhung Rinpoche, who was Dagmola's uncle. Because of his fluency in the Tibetan language, Gene, a student at the university, was asked to live with the family and to help them adapt to American society.

Dagmola has described how the members of her family, who spoke no English at the time, felt confused when they arrived in America. After Gene stayed with them for four years, "to watch for what needed to be done, if the children get sick or we need anything," she felt as if Gene had become her brother. "It was wonderful," she recalls, "because he took care of the children, and the first Christmas we had, he made the American tradition and brought all Christmas presents. From then on, we still have to have Christmas because he spoiled them."

Gene recalled: "I was primarily interested in being a scholar, not a Buddhist." Soon, however, he became impressed with Dezhung Rinpoche, whom he described as one of the most learned men in the Tibetan Buddhist

Right: Gene with his parents, his sisters, and his brothers-in-law.

Below: Gene in Hope, Alaska.

tradition, and became his student. "This is a pretty cool religion if it makes such nice people," he explained. Dezhung Rinpoche, who gave Gene the Tibetan name Jamyang Namgyal, took note of Gene's interest and encouraged him to understand Buddhism at a deeper level—as more than simply an academic or historical pursuit. This, however, would require access to the texts of the Tibetan Buddhist canon, many of which had been hidden or destroyed during the Chinese invasion.

After trying unsuccessfully to find the needed books in Europe, Gene learned Sanskrit and went to India on a Ford Foundation scholarship, equipped with a letter of introduction from Dezhung Rinpoche. While in India, he studied with a number of lamas and went to work for the Library of Congress as a government employee. For the next fifty years, Gene dedicated his life to the recovery and preservation of the Tibetan Buddhist canon.

Dagmola remembers her uncle, Dezhung Rinpoche, telling her that he and Gene were strongly connected in a previous life. "He was Tibetan," he said, "and maybe that's why, even though his background is different, he's interested in Buddhism and serving lamas. He was previously a monk."

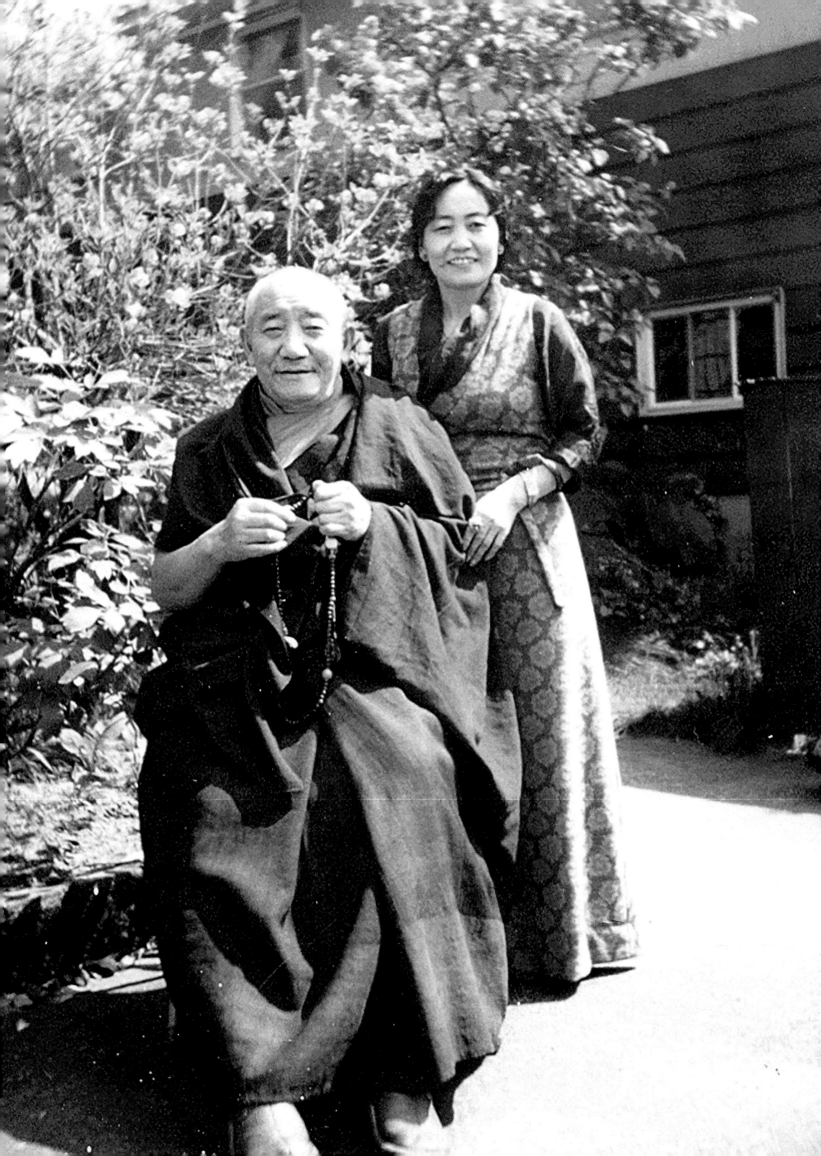

Gene with the sons of Her Eminence Jamyang Dagmo Kusho and His Holiness Dagchen Rinpoche.

Left: Dezhung Rinpoche with prayer beads.

Below: Rinpoche with a sacred text he brought from Tibet.

Facing page: Dagmola and her uncle, Dezhung Rinpoche.

New York City
"Headquarters"

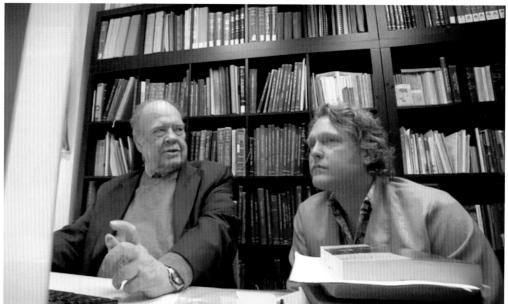

Gene and TBRC Director
Jeff Wallman.

Break from the Journey

D URING THE FALL of 2008, Gene returns to New York for two months. We visit Gene often at his office at the Tibetan Buddhist Resource Center, located above the Rubin Museum of Art in Manhattan.

We interview Gene and his friends and fellow scholars for insight into Gene's life and the history of Tibetan Buddhism. The Rubin Museum is working on opening its galleries to the public for the first time while we're there. At one point, the noise becomes so loud that we are forced to move from the gorgeous spiral staircase to what was formerly the changing room in Barney's men's clothing store. It is a mind-blowing experience to be in a backroom now housing metal storage shelves holding thousand-year-old sacred texts. To our surprise, the interviews shot there turn out to be some of our more intimate and beautifully shot moments.

The gracious TBRC board members who informed our film include Janet Gyatso, professor in Buddhist studies at Harvard, former president of the International Association of Tibetan Studies, a student of Gene's, and an incredible scholar on the subjects of women and medicine in Tibetan culture; Leonard van der Kuijp, chair of the department of Sanskrit and Indian studies and professor of Tibetan and Himalayan studies at Harvard; Gray Tuttle, professor of modern Tibetan studies at Columbia; Richard Lanier, president of the Asian Cultural Council; and Jeff Wallman, TBRC director, who guided the team at TBRC in scanning the texts and helping to fulfill Gene's wish to develop a comprehensive Tibetan library.

Gene started TBRC when he came back from Indonesia. As Jeff Wallman explains, it's difficult to "morph a Tibetan book into a Western library. . . . It's like having one record for an encyclopedia." You need to be able to "search, in a structured way, developing a web of links to the literature."

Gene had known that the books were disintegrating based on the quality of their paper and all they had been through, and he wanted to find the fastest way to save them. Following his retirement from the Library of Congress, he had looked, without success, for a home for TBRC, first at Harvard and then with the Trace Foundation. Eventually it was Donald and Shelley Rubin who provided TBRC with what would become its home, in New York City, for the next ten years.

While in New York, Gene picks up more drives to bring with us on our next trip to Asia. Because of Gene's warning to us about the prevalence of theft during our flights from one location to another, we had brought with us, on the first leg of our journey, only the number of drives we could physically carry on to a plane; anything stowed in baggage might never be seen again.

During that time, Gene also shares his thoughts about where he hopes his collection of Tibetan texts will eventu-

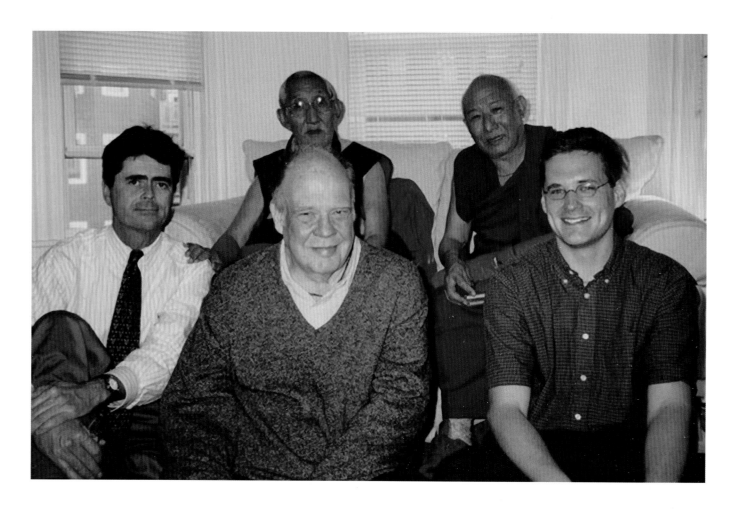

ally find a home. Gene, sensing that his mission is nearing its end, has previously told some of his colleagues that he believes the books should be in China. Leonard van der Kuijp quotes Gene as saying, "They don't belong to us; they belong to the Tibetans." And Richard Lanier tells us, "Gene is very committed to making sure that, whatever material is collected, [it] will be available to the culture that produced it."

Others may have shared with Gene what sounded to be a reasonable hope—that his personal library of Tibetan texts would be given to China and made accessible to everyone with an interest in studying them. Reasonable because, explains Gray Tuttle, through the 1990s and early 2000s, everything in China seemed to be open and going well. He adds, "It would be less expensive and the people would learn the methods Gene used to scan the texts."

In September 2007, negotiations with the Southwest University for Nationalities in Chengdu did result in that

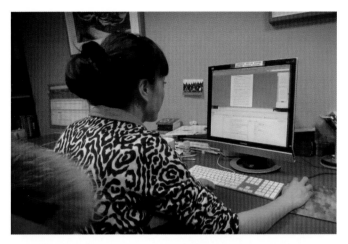

"Gene was the first one to think of digitizing Tibetan books and thereby preserving and creating greater access to the Tibetan literary legacy."

—LEONARD VAN DER KUIJP

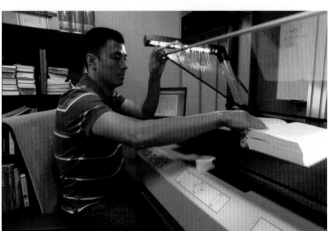

This page: TBRC librarians scan and catalog recovered texts.

Left: Gene in 2000 at the recently opened Cambridge headquarters of TBRC, with Wisdom Publications director Tim McNeill, Ribur Rinpoche, Geshe Tsulga, and Wisdom editor David Kittelstrom.

Bottom: Gene surveys the texts he brought from Asia.

Photo courtesy of the Rubin Museum of Art.

institution's agreeing to receive the texts. Everything changed, however, during the 2008 Olympics, when Tibetan demonstrations against China led to deadly violence before a worldwide audience. Tuttle notes that "Everything shut down . . . all the nonprofit organizations that did work on the plateau were just blocked out." And Leonard van der Kuijp recalls: "Everything was put on hold. For this reason no books were sent to Chengdu, even though the plan was to start sending books to Chengdu in 2008."

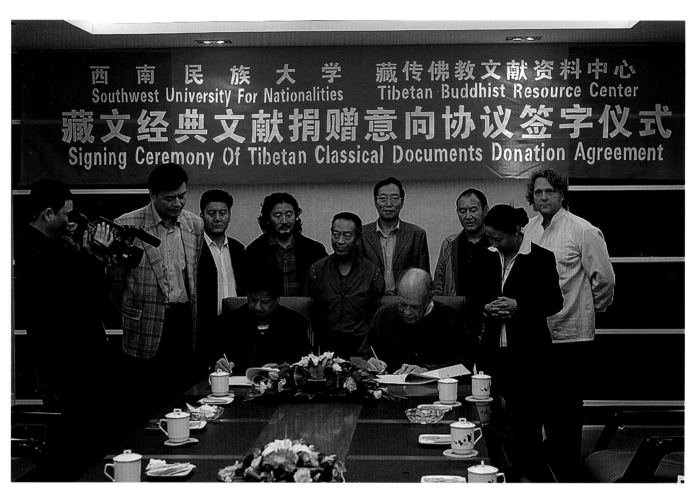

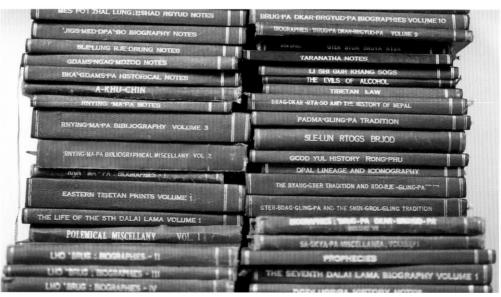

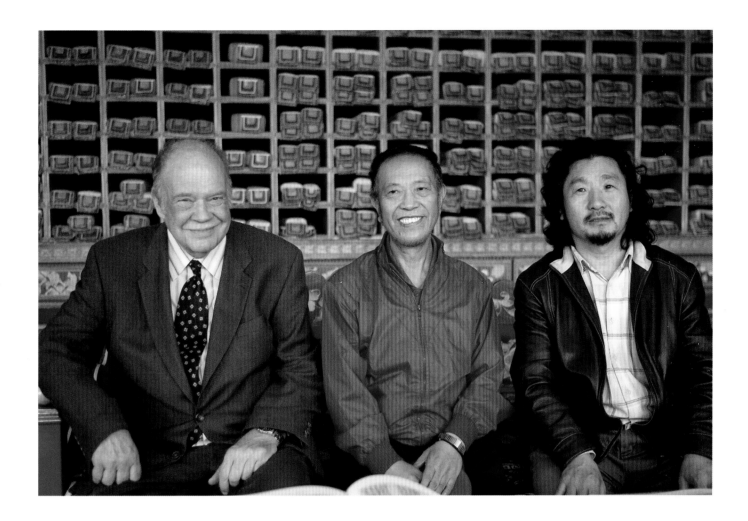

"What's important is to keep and pass on, for the people to whom it's important, these cultures. As we go into this cultural homogeneity, which is everybody smashed together in New York, it's important to keep all of these cultures and recognize that each one is important and they deserve to be kept."

—GENE SMITH

This page and top of facing page: The signing ceremony in Chengdu.

Facing page, bottom: Gene's "Greenbooks," containing his typed transcriptions of Tibetan texts and annotations.

RETURN TO INDIA AND NEPAL

UNITED STATES

● NEW YORK

MEXICO

THE BAHAMAS

CUBA

BELIZE
GUATEMELA HONDURAS JAMAICA

NICARAGUA

COSTA PANAMA
RICA

VENEZUELA

COLOMBIA

DELHI ●● KATHMANDU

Delhi: Mangaram's Son's Wedding

GENE RETURNS TO India in December 2008 and again we go with him. Gene times his return to coincide with Mangaram's son's wedding, at which he is a guest of honor and to which the crew is also invited.

Mangaram became Gene's assistant in the 1960s, shortly after Gene began working in India for the United States Library of Congress. Just out of high school, Mangaram began by dusting and maintaining the many books in Gene's library. Later, he picked up visitors at the airport and eventually took charge of managing the very busy household. He recalls how Gene "was using all his salary and putting it into books and giving gifts to lamas and to parties and entertaining people." Mangaram also remembers how bundles of original books were often dropped off for Gene at 6:00 a.m., and how Gene always returned them once they were reprinted. "He was not interested in collecting antiques," he tells us, "but in having the reprints so that all the scholars and lamas would use that for their studies."

Theirs was a mutually beneficial friendship, one they would enjoy for the remainder of Gene's life. Whether it was simply keeping the house in Delhi in livable condition or ensuring that Gene's books followed him to his other Library of Congress outposts in places such as Egypt and Indonesia, Mangaram played an understated yet important role in the success of Gene's mission. As Leonard van der Kuijp tells us, "The books were packed by Mangaram, packed in a ship, and unpacked by Mangaram and put on the shelves." For his part, Gene paid for Mangaram's education. Mangaram came from a segment of Indian society for whom higher education was not ordinarily an option, but was thus able to earn a teaching degree, as well as subsequently to do work for TBRC from his location in Noida, India.

At the wedding, we see how Mangaram's entire family loves and reveres Gene, who is the groom's godfather.

Wedding in Delhi—Nikhil Kashyap, who is Mangaram Kashyap's son, and his bride, Priyanka.

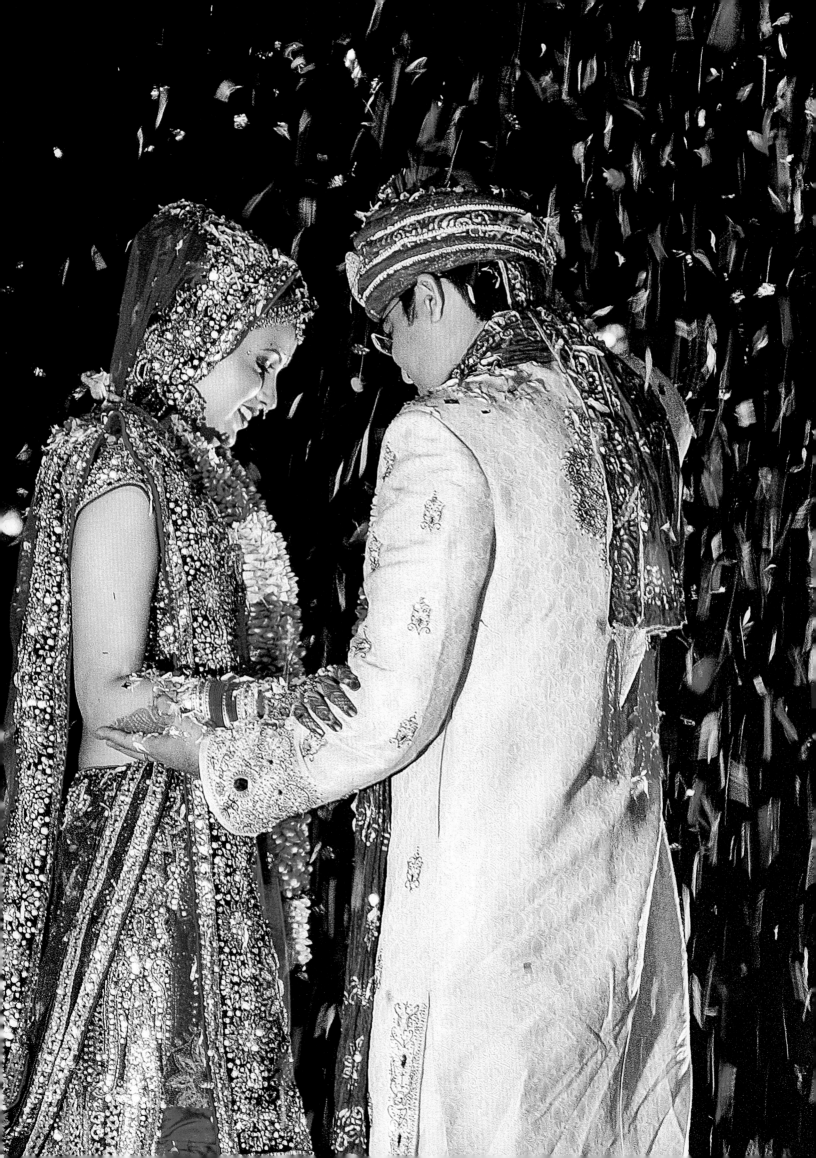

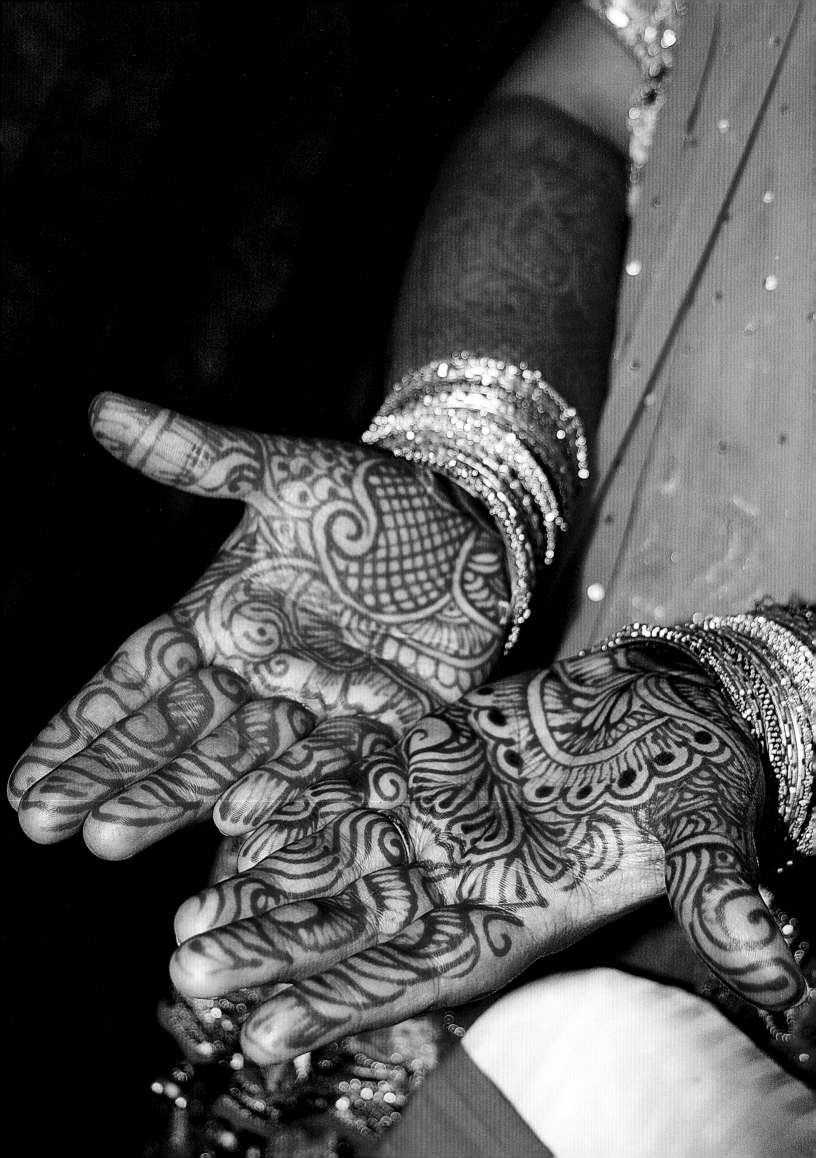

Facing page: Traditional henna tattoo.

This page: Mangaram, his beautiful wife, Bimla, and the groom, Nikhil Kashyap.

A traditional wedding footman waits to take the groom to the wedding grounds.

Next page: The groom with the man he calls "Grandfather."

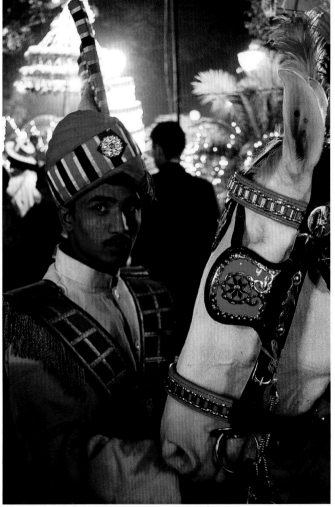

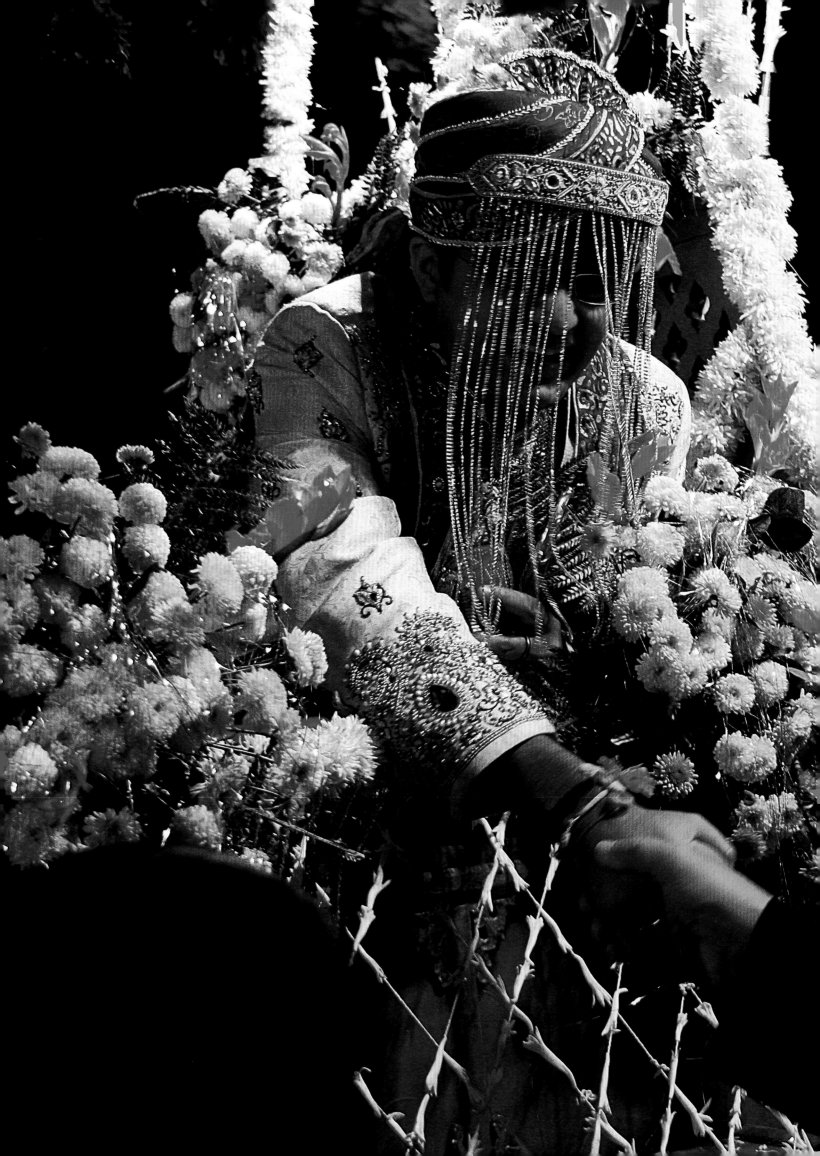

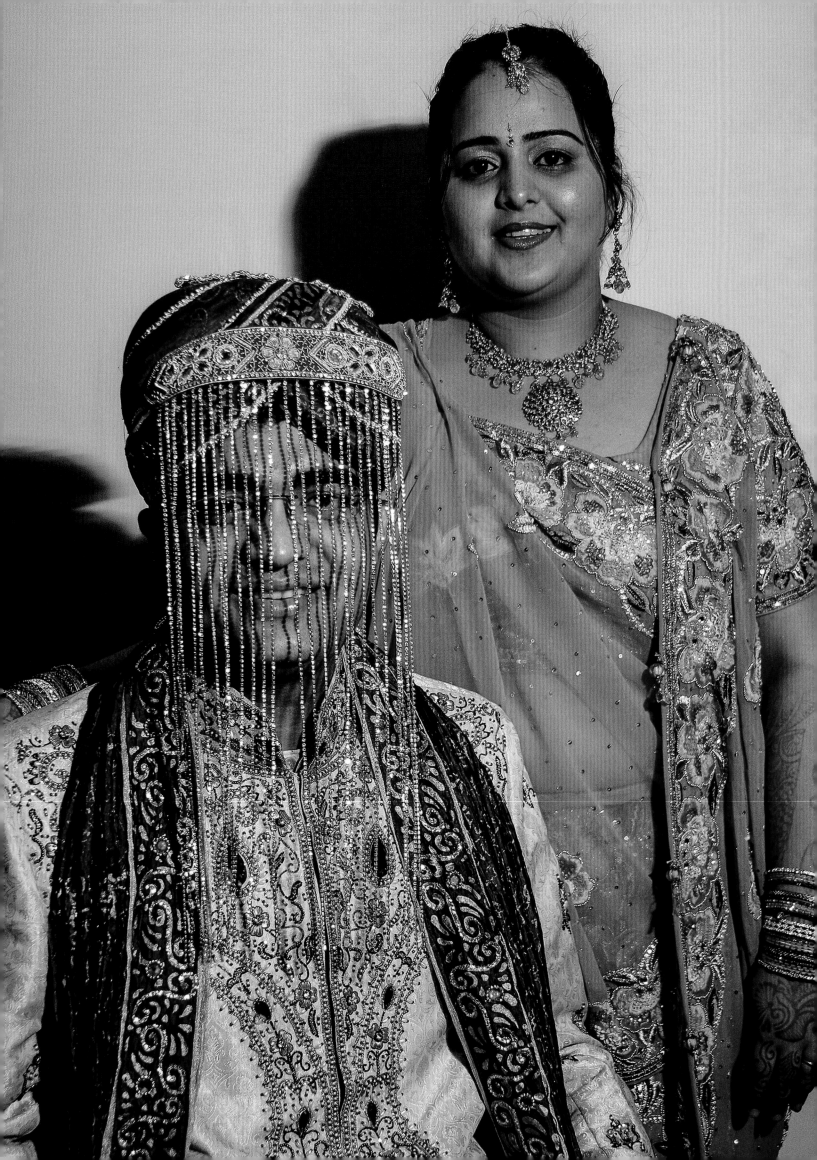

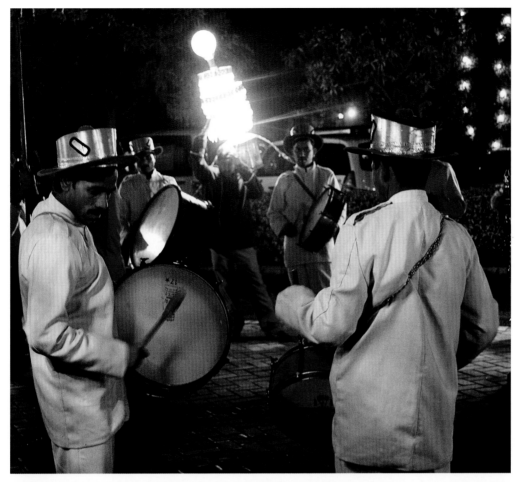

Facing page: Nikhil Kashyap and his sister, Neha.

This page: Wedding drummers.

Below and next page: The groom in a traditional carriage.

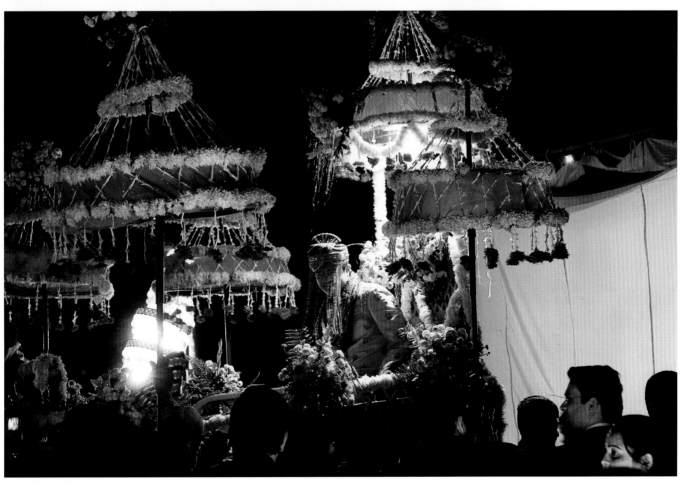

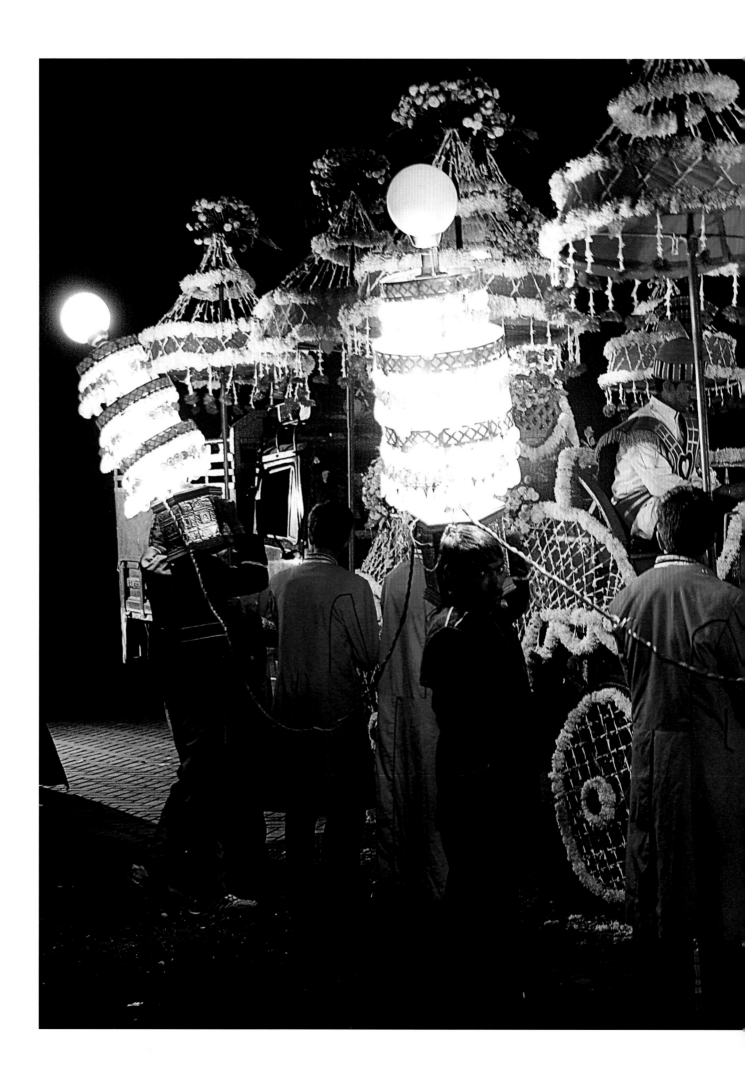

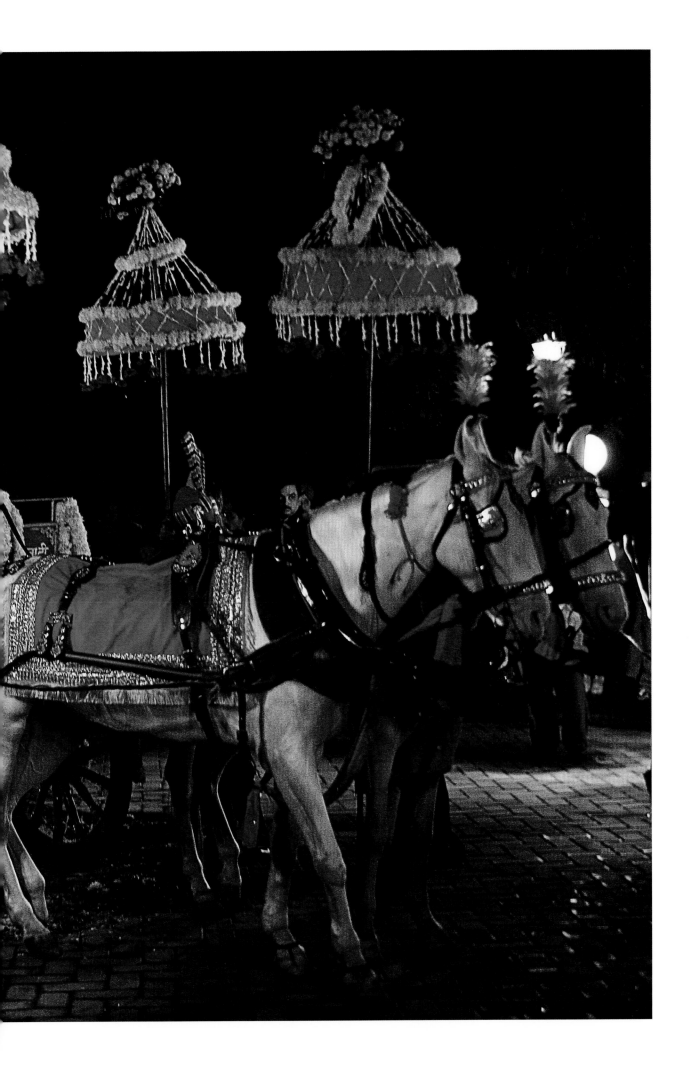

ROAD TO LUMBINI
"BIRTHPLACE OF THE BUDDHA"

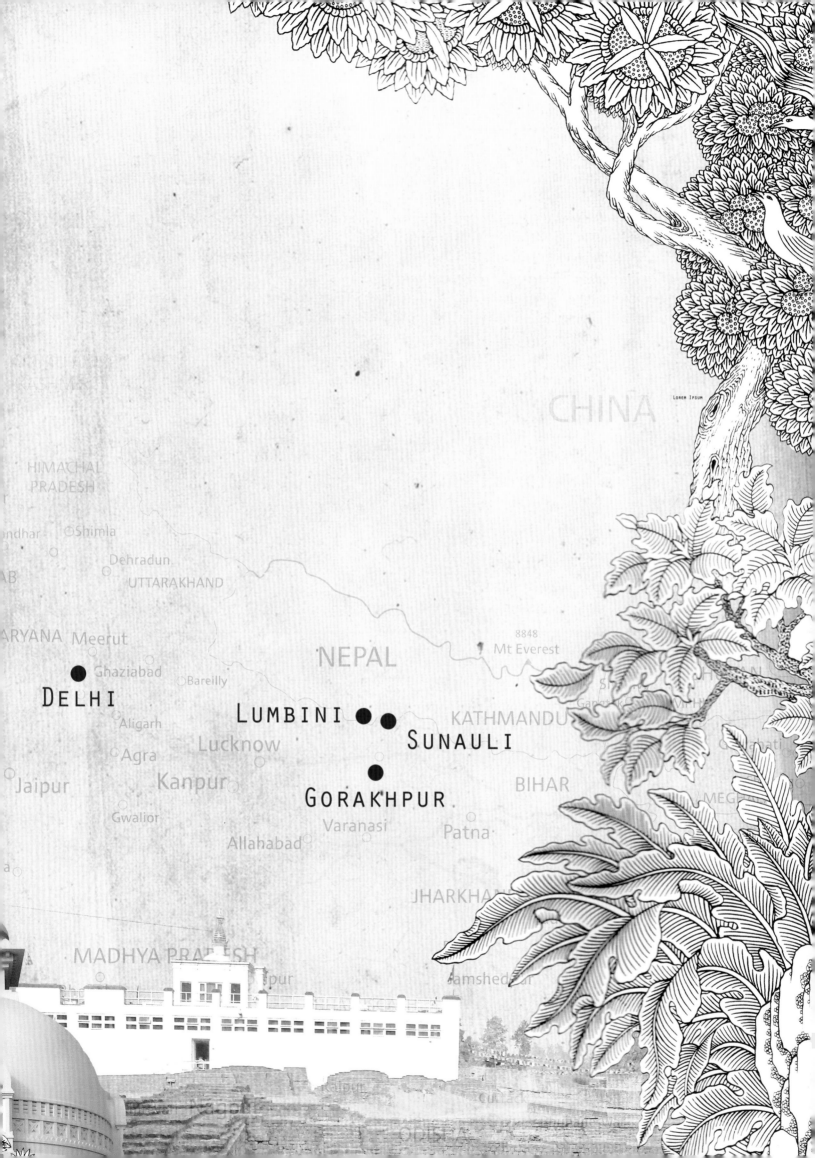

CHINA

HIMACHAL
PRADESH

ndhar ○ Shimla

Dehradun
UTTARAKHAND

ᴀʙ

ᴀRYANA Meerut

● Ghaziabad

DELHI

Aligarh

○ Bareilly

NEPAL

8848
Mt Everest

LUMBINI ● ●

Lucknow

○ Agra

SUNAULI

KATHMANDU

Jaipur

Kanpur

●

GORAKHPUR

BIHAR

Gwalior

Varanasi

Patna

Allahabad

a ○

JHARKHA

MADHYA PRADESH

pur

amshed

MEGH

 ODISHA

MANGARAM ARRANGED for us to travel to Lumbini, Nepal, where Gene plans to deliver the drive containing the Tibetan Buddhist canon to the tulku of his first teacher, Dezhung Rinpoche. We travel via an overnight train to Gorakhpur, followed by a pair of jeeps in which to pile ourselves and our gear. The Delhi trains prove to be quite an adventure. Porters quickly appear, then just as quickly disappear with our luggage and expensive camera equipment. Although Wade, the photography director from our last trip, is in China and unable to help us navigate these unfamiliar circumstances, we are grateful to have along with us our Indian crew, Rajesh and Nandu, from Flamingo Films. When we finally crowd into our tiny four-bunk compartments (with a movable curtain between each compartment), Gene indulges us with stories about the Sakya sect and what to expect during the Monlam. He is clearly looking forward to seeing Dagmola and talking with the tulku.

Our Nepal "fixer," his fiancée, and their production assistant meet us in Sunauli to help us with the journey by road to Nepal and with getting through customs. After that, they will assist with the filming in Nepal. Along the way, while we wait on the side of the road for another jeep, Gene points out what he tells us are the largest cranes in the world, standing in a nearby field. Local children, curious about the crew and their cameras, approach us and soon get their photos taken with Gene.

To get from Gorakhpur to Sunauli, on the India–Nepal border, requires multiple payoffs to individuals who block the road while seated at desks or standing by homemade barricades of fallen trees. Nepal has just had an election in December 2008 and the border officials, new to their position, are reluctant to permit a camera crew to pass. On top of that, Nepal is experiencing a labor strike; they are common in this country and often last for a month or more. We learn that, for some travelers, getting caught in the middle of a strike can mean not being able to cross the border for weeks. Fortunately, our Nepalese "fixer and grip," Ram Krishna Pokharel, engages in a masterful bit of negotiating that gets us, a few hours later, back on the road to Lumbini.

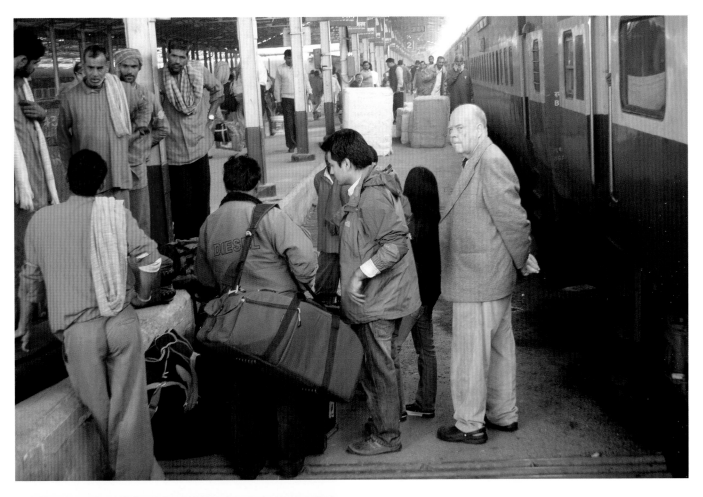

Gene and crew travel by train from Delhi to Gorakhpur.

Traveling from Gorakhpur to Sunauli on the way to India–Nepal border.

Gene and the crew wait on the side of the road for vehicle assistance. Gene tells us that this area boasts the largest cranes in the world.

Facing page: Children watch with fascination as the crew films local scenery.

Next page: We must cross the border by foot.

Lumbini

In all his years in India and its surrounding countries, Gene had never visited Lumbini, Nepal, the birthplace of Buddha. On this trip, he has been invited to attend two events here—a graduation ceremony at Sakya College, and the Sakya Monlam, a ceremonial peace prayer involving more than ten thousand monks. He looks forward to meeting the young tulku, Ngawang Kunga Tegchen Chokyi Nyima, the reincarnation of his first teacher, Dezhung Rinpoche. Gene also leaves ample time to visit the conserved structures and surrounding gardens at the site of Buddha's birth. The preservation efforts on this historic site include the archeological remains of monasteries and stupas, some dating as far back as the third century BCE.

Gene's first visit to the birthplace of the lord Buddha.

Next page: Pilgrim at the foot of a bodhi tree.

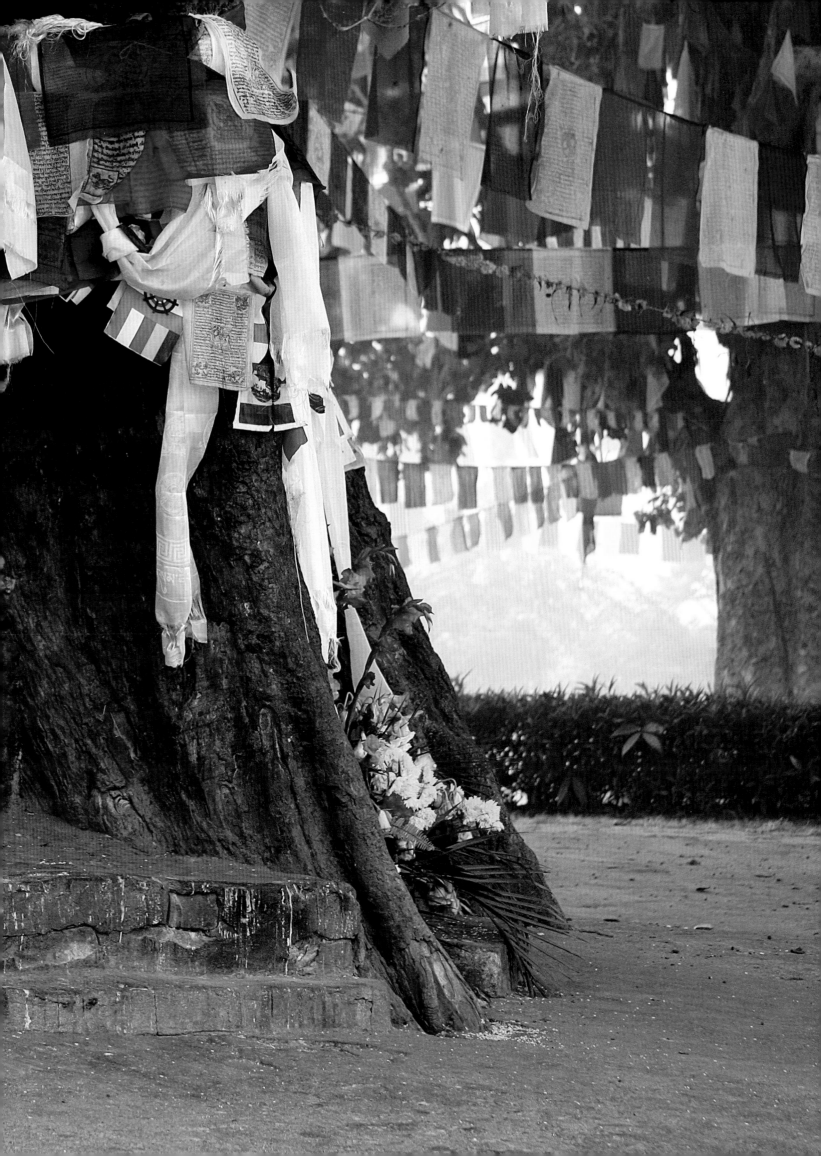

Women prostrating near the site of the preservations.

Little monk deep in thought.

Butter lamps and incense at the foot of the holy tree.

Facing page: Woman walks with child as she prays under prayer flags.

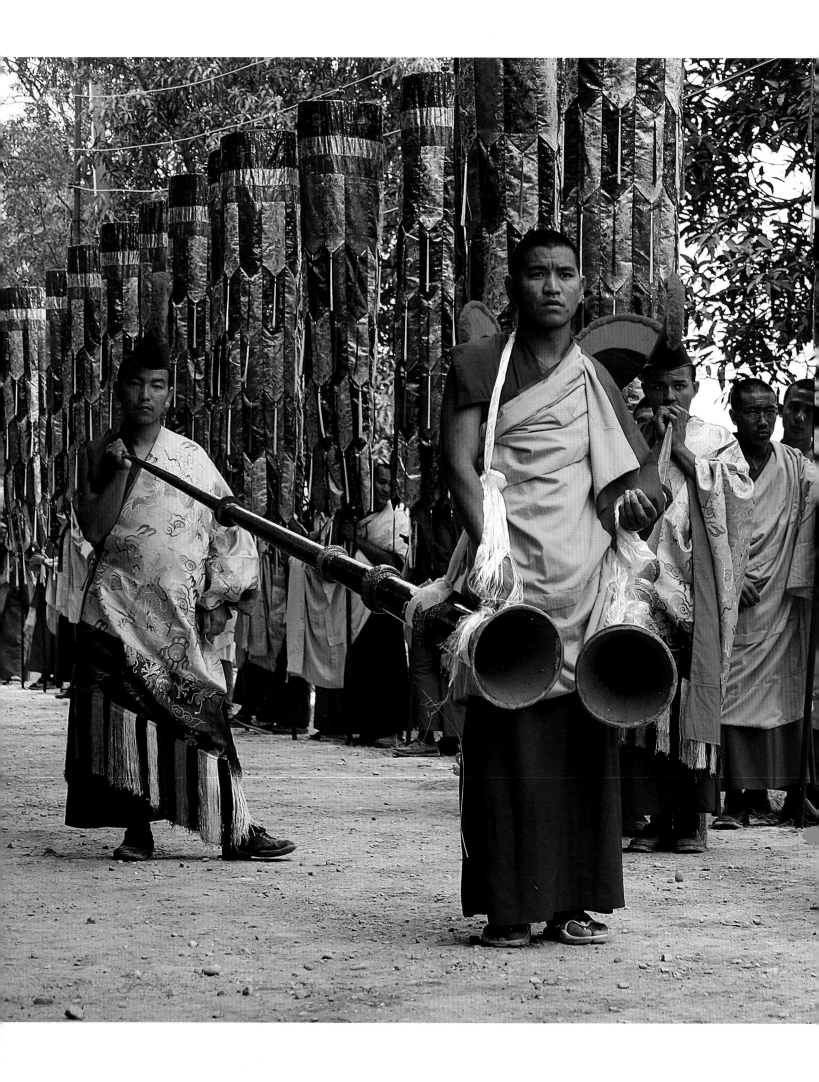

Sakya Graduation

Gene is a guest of honor at the graduation of a senior class of monks at Sakya College. We witness their rich commencement traditions and colorful entertainment. Gene sees the tulku for the first time at the graduation and briefly meets with him later to present him with the drive.

The tulku is the incarnation of Gene's first teacher, Dezhung Rinpoche. This young tulku, who is half Tibetan and half American, was born in Seattle. The birth of tulkus in America is further evidence that cultural transmission has spread beyond South Asia. Dezhung Rinpoche, who died in 1987, was a lama of the Sakya school. This tradition has two head lamas—one in India (His Holiness the Forty-First Sakya Trizin) and one in Seattle (His Holiness Jigdal Sakya Dagchen Rinpoche).

This page and following two pages: Procession awaiting dignitaries and lamas before Sakya graduation ceremony.

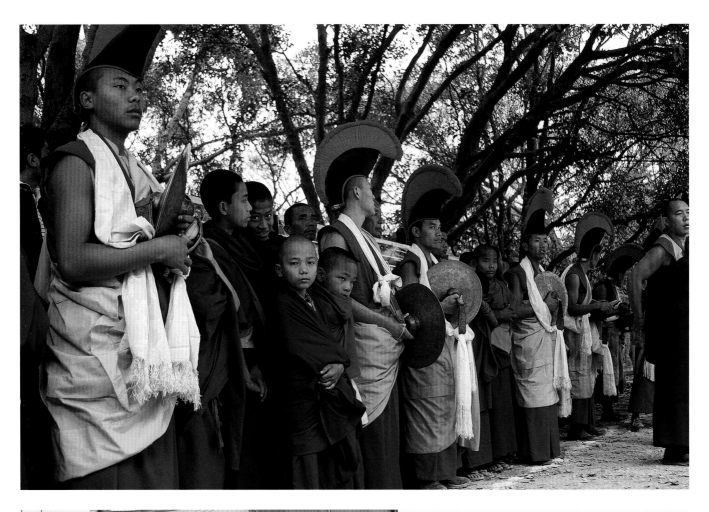

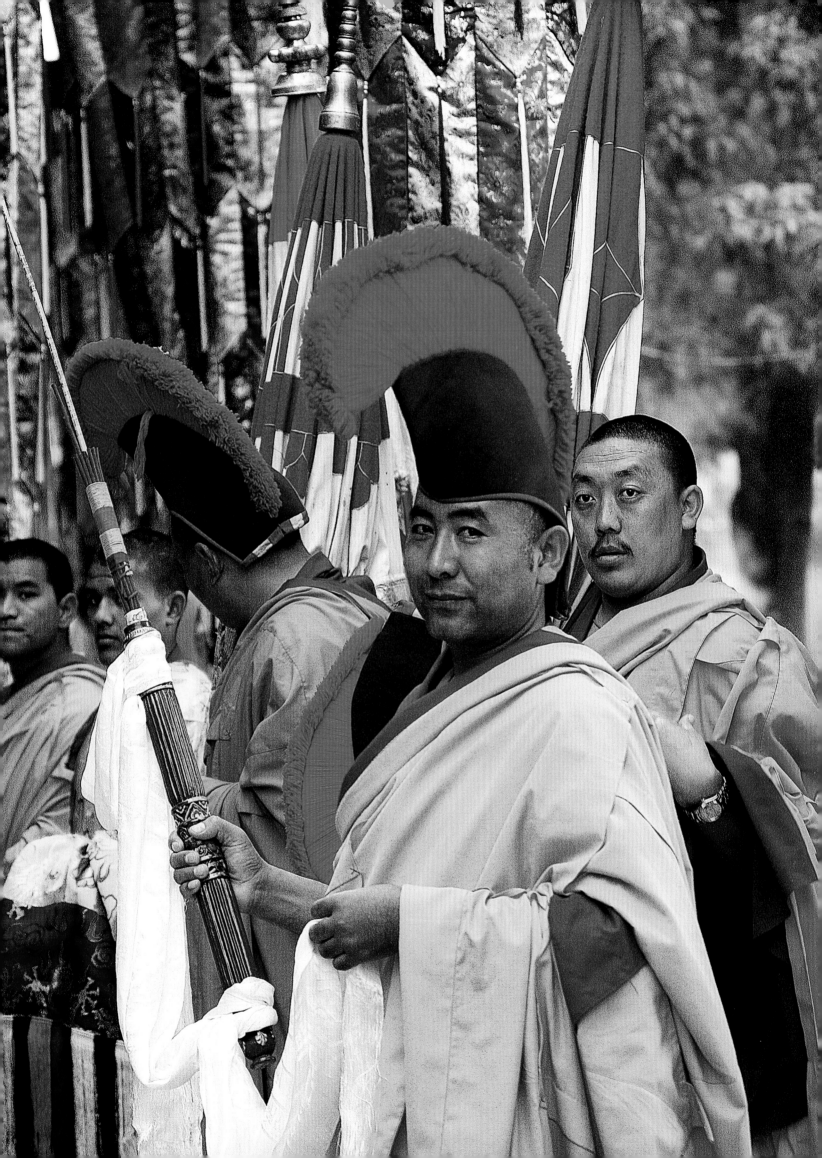

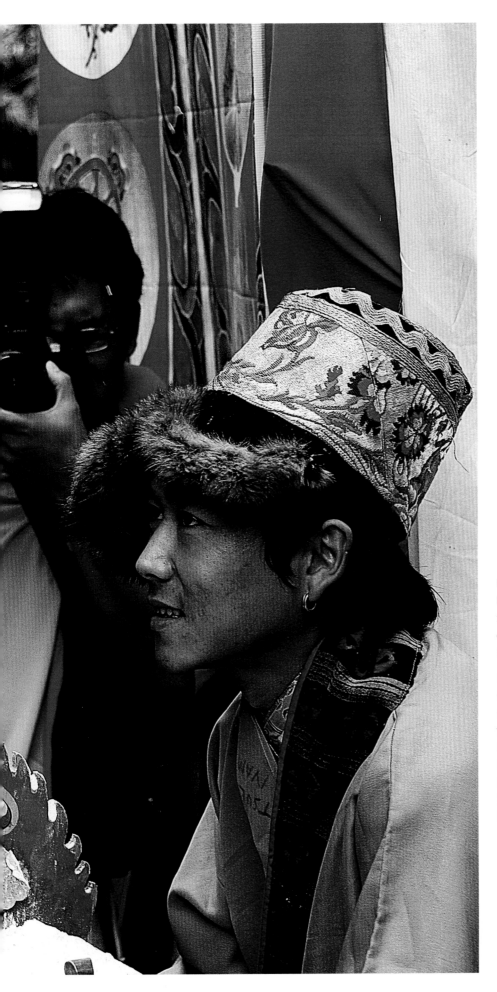

His Holiness the Forty-First Sakya Trizin being welcomed at the procession of the 2008 graduating class of Sakya College during the Seventh Convocation Ceremony held in Lumbini, Nepal.

Following pages: The Seventh Convocation Ceremony of the graduating class of Sakya College in Lumbini, Nepal. The young tulku Dezhung Rinpoche distributes books; Sakya leaders applaud graduates; Her Eminence Dagmo Kusho and her daughter-in-law look on; Gene sits with noted Tibetan language specialist and historian Christoph Cueppers.

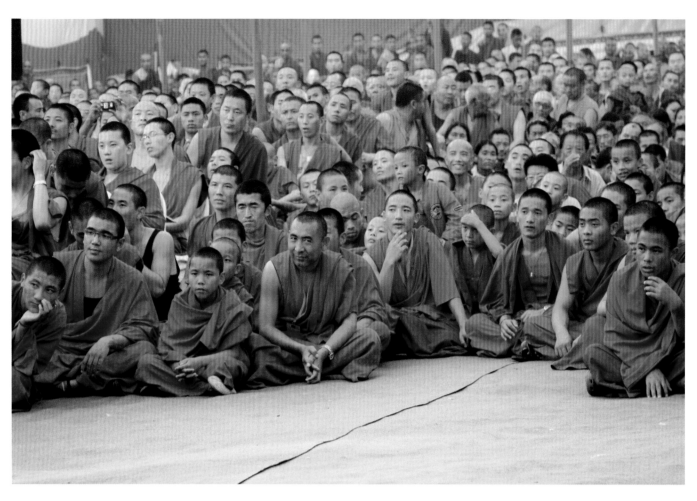

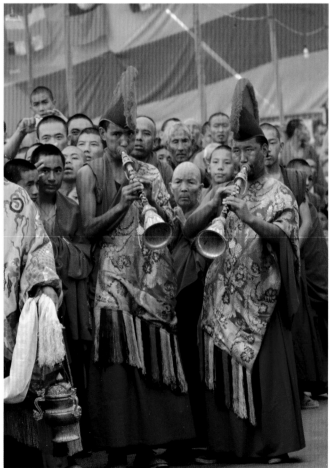

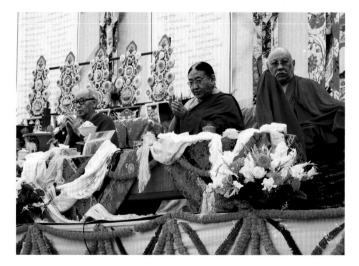

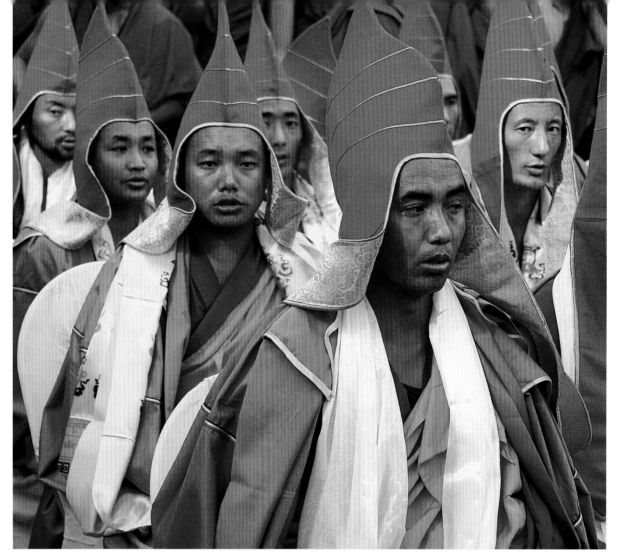

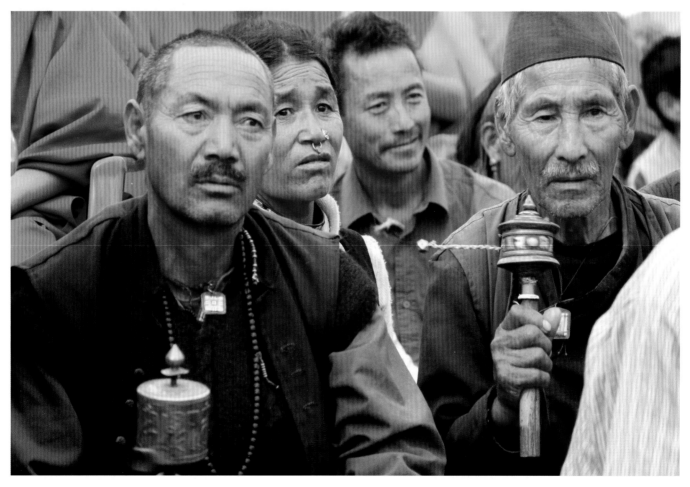

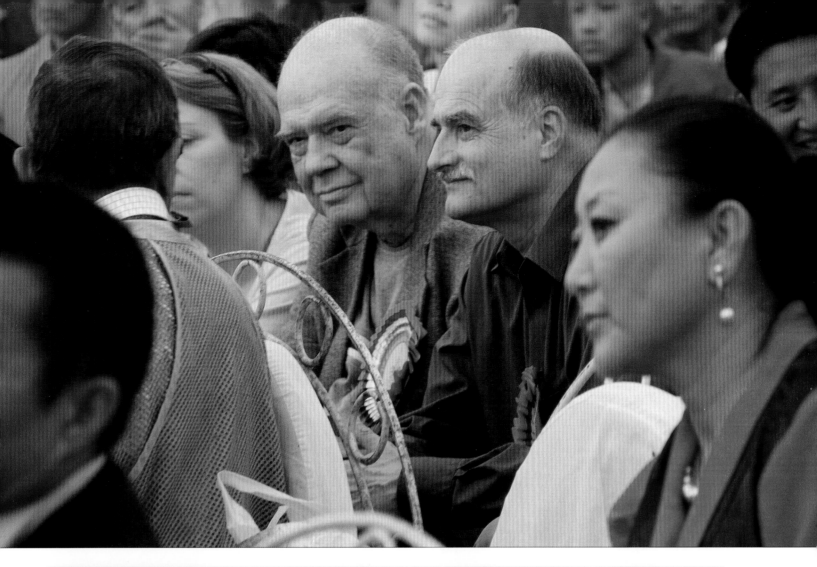

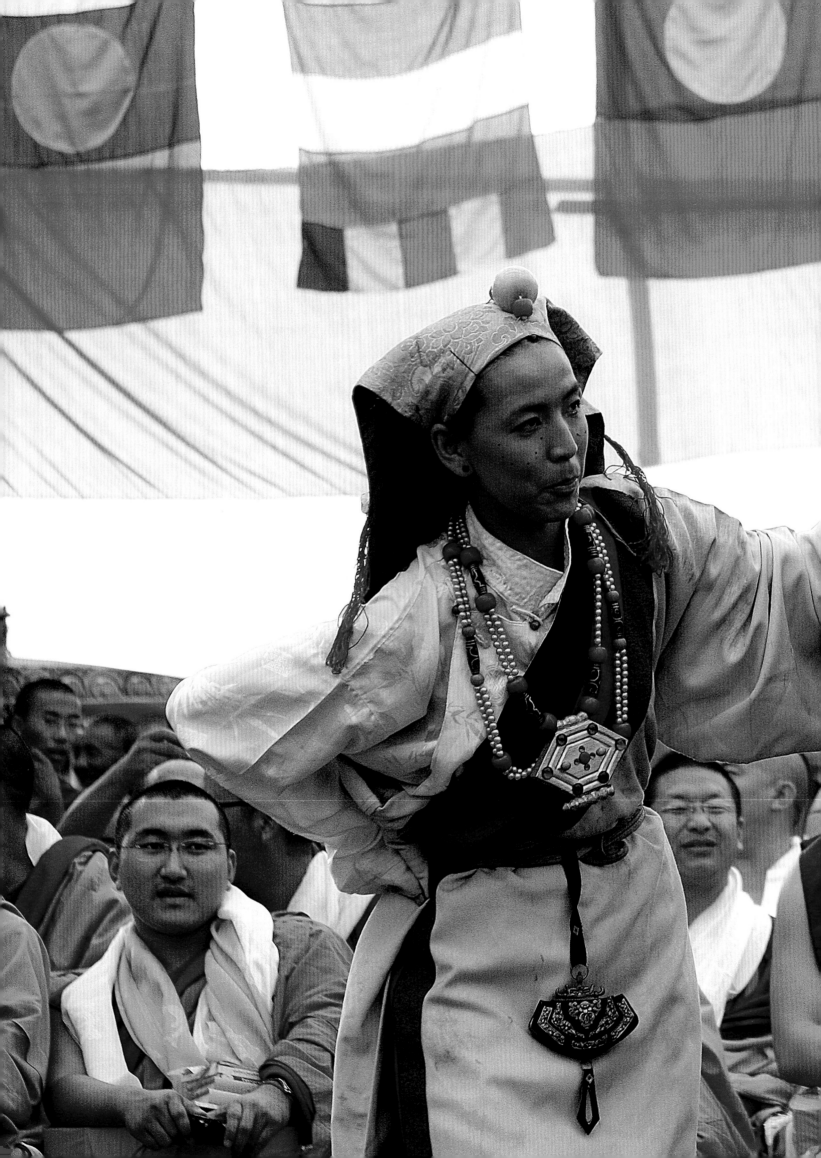

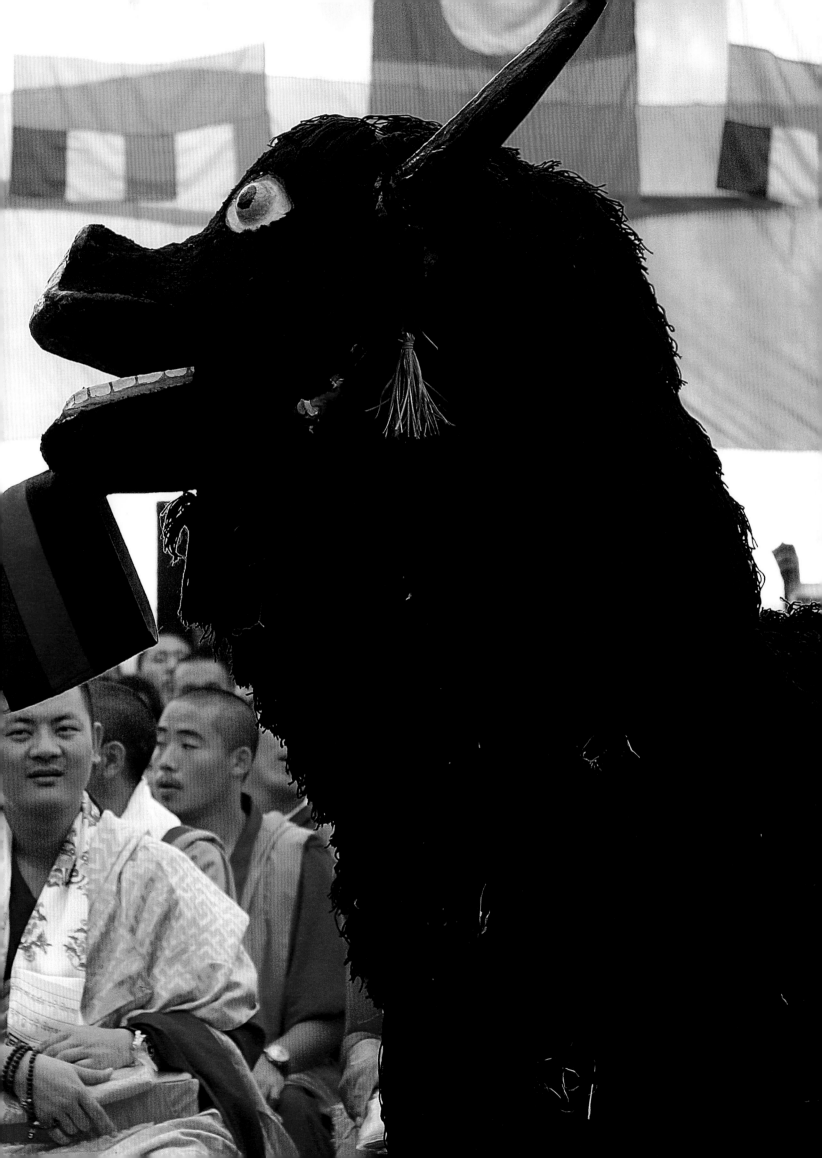

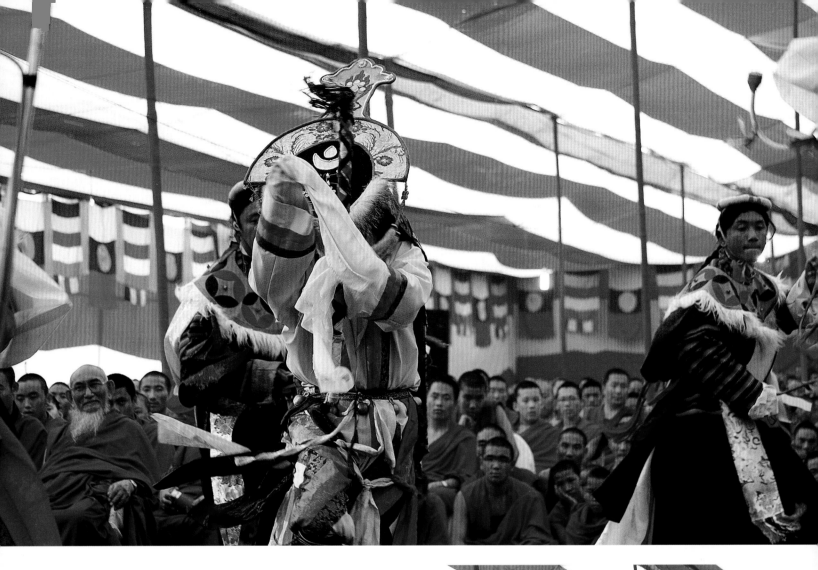

Previous page and this page: The Tibetan Opera
Group performing at the graduation ceremony.

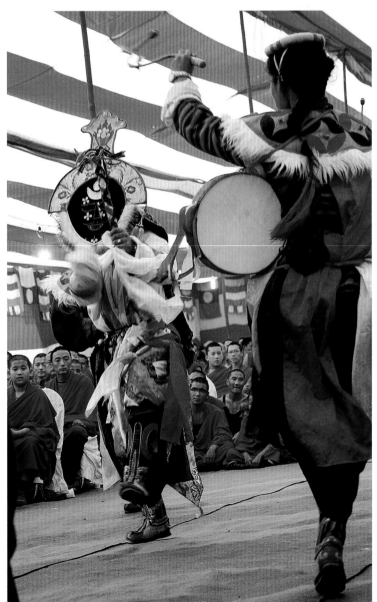

Sakya Monlam: Peace Prayer

We experience one of the world's largest peace prayers, guided by the texts for which by now we have a much greater appreciation. Prior to the event, Gene is able to spend time speaking with Dagmola, whom he hasn't seen in many years, and to deliver to the young tulku the hard drive containing the text that Gene was originally sent to recover by Dezhung Rinpoche. Gene is also given time during the Monlam to speak with His Holiness the Forty-First Sakya Trizin, the leader of the Sakya tradition, and we gain some insight into the latter's hope regarding the negotiations with China and Tibet begun since the 2008 Olympics.

"To learn the teachings, to practice, we need the teaching. We need a lot of teaching, so the more texts, the more texts we have, the better to enrich our knowledge. There are enormous books on many different subjects, so therefore it is very important to find all these books and also to preserve them."
—HIS HOLINESS THE FORTY-FIRST SAKYA TRIZIN

Tulku Ngawang Kunga Tegchen Chokyi Nyima, the reincarnation of Gene's first teacher.

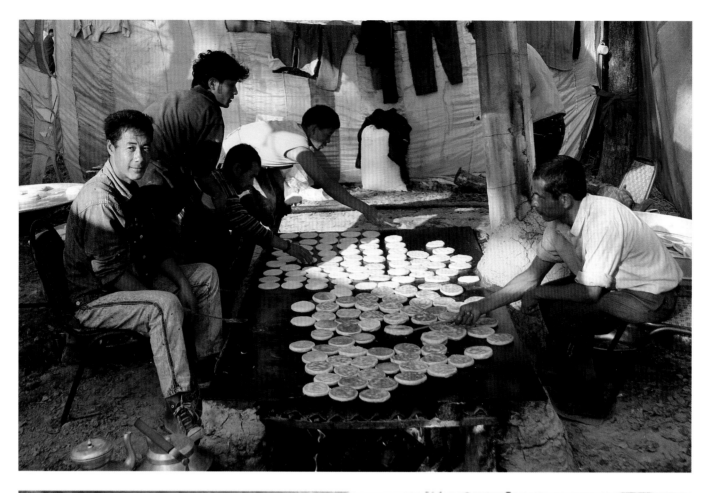

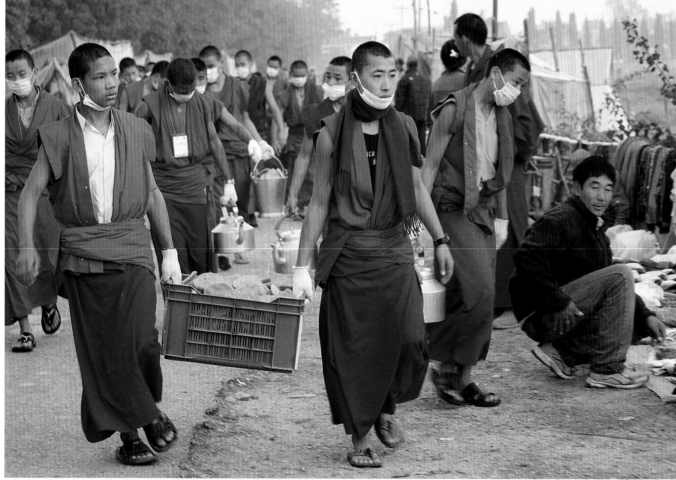

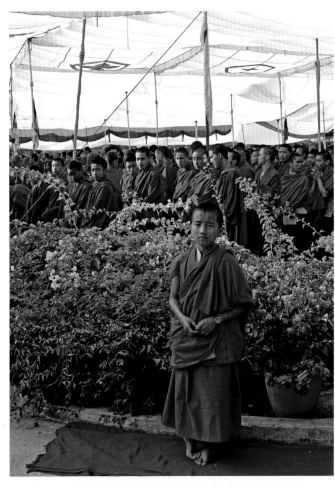

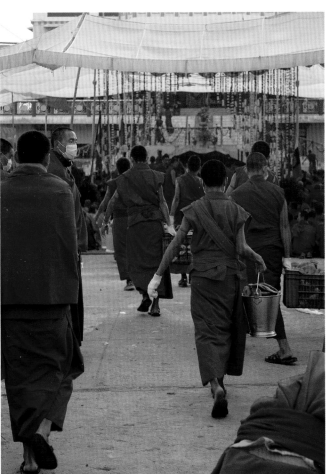

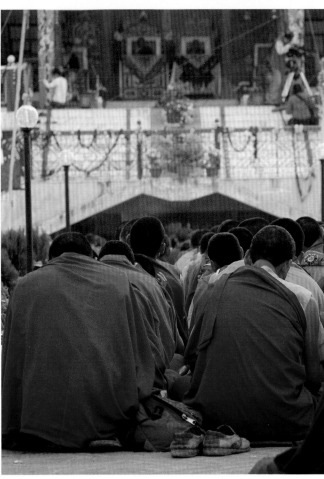

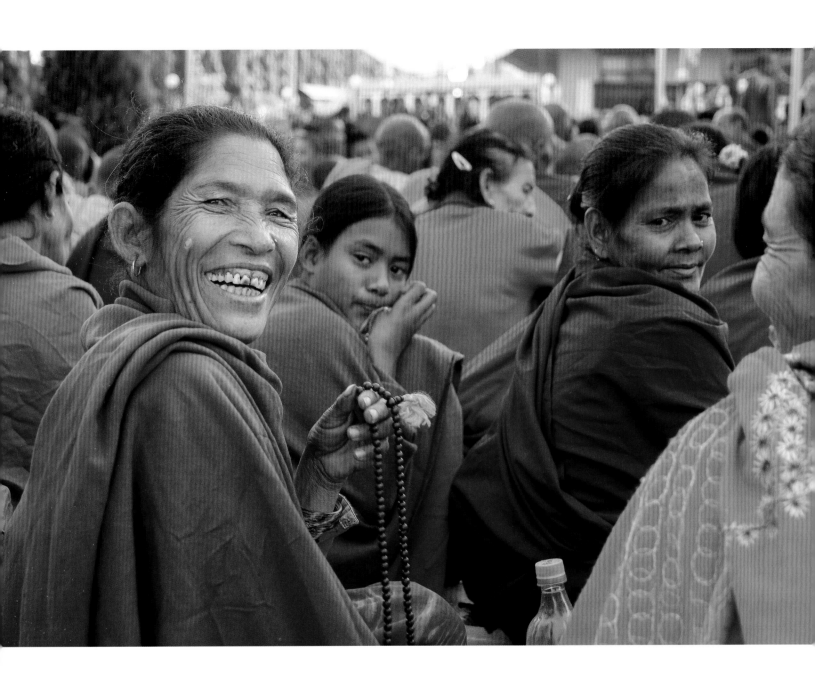

This page and previous page:
Behind the scenes; feeding ten thousand monks at the Sakya Monlam prayer festival.

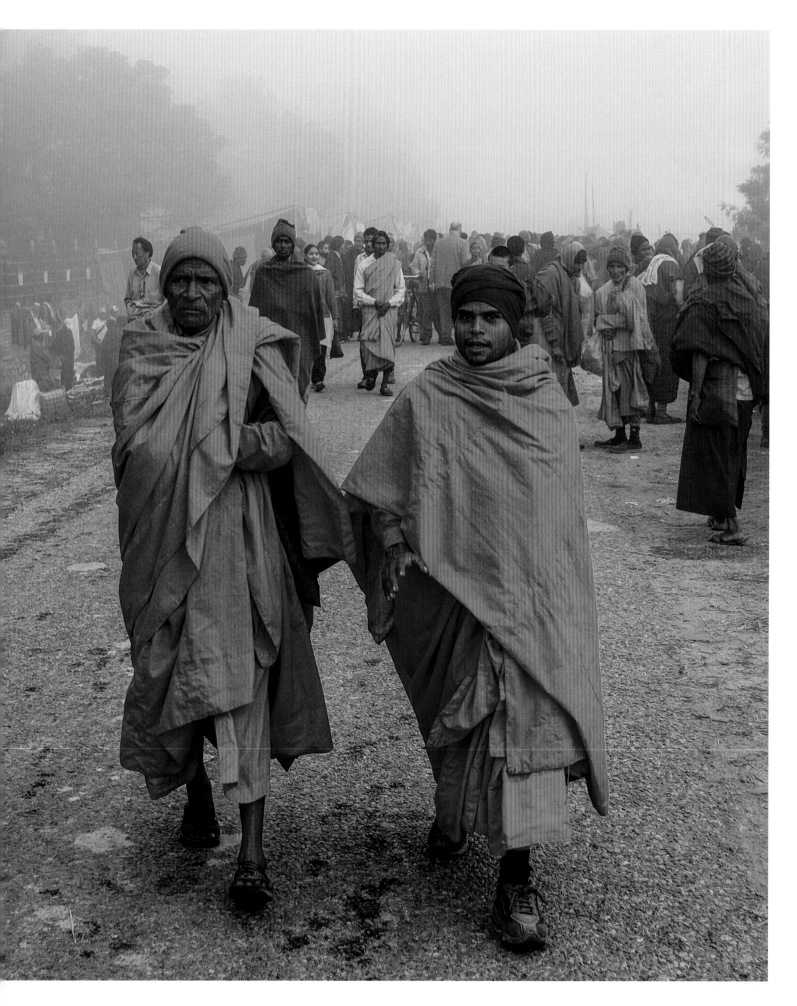

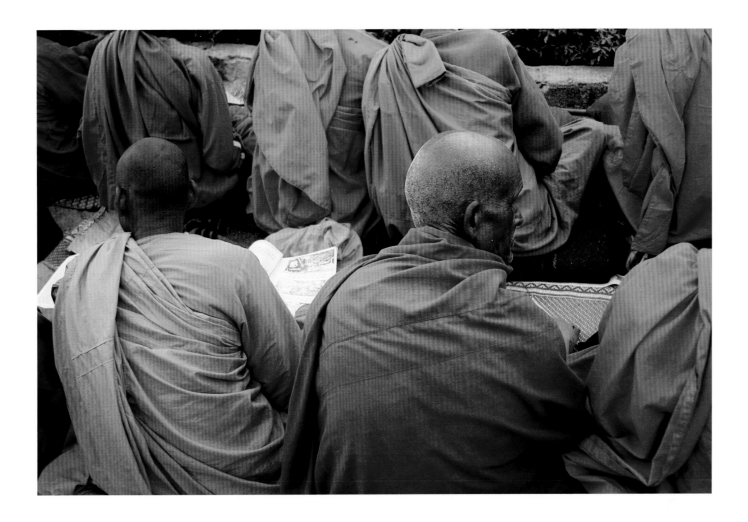

Monks from India and Sri Lanka participate in the Sakya Monlam.

Next page: Monks read from Tibetan texts at the Sakya Monlam prayer festival.

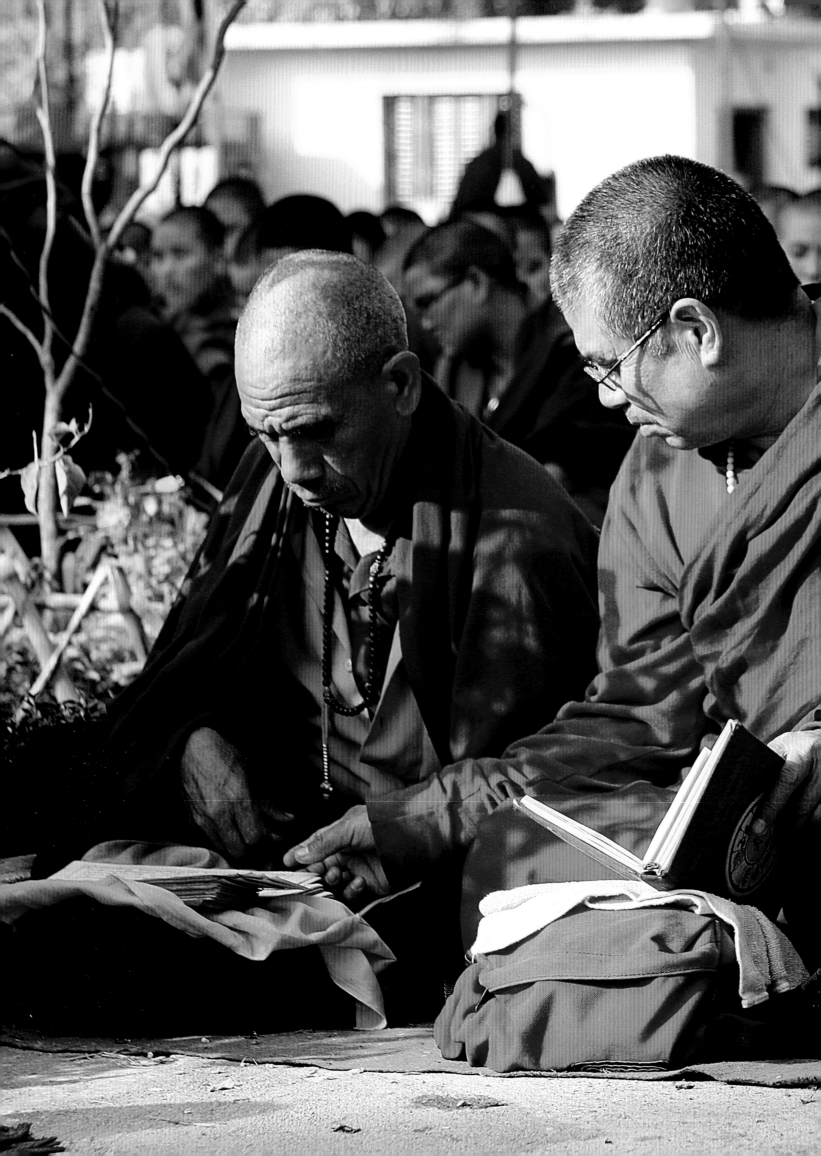

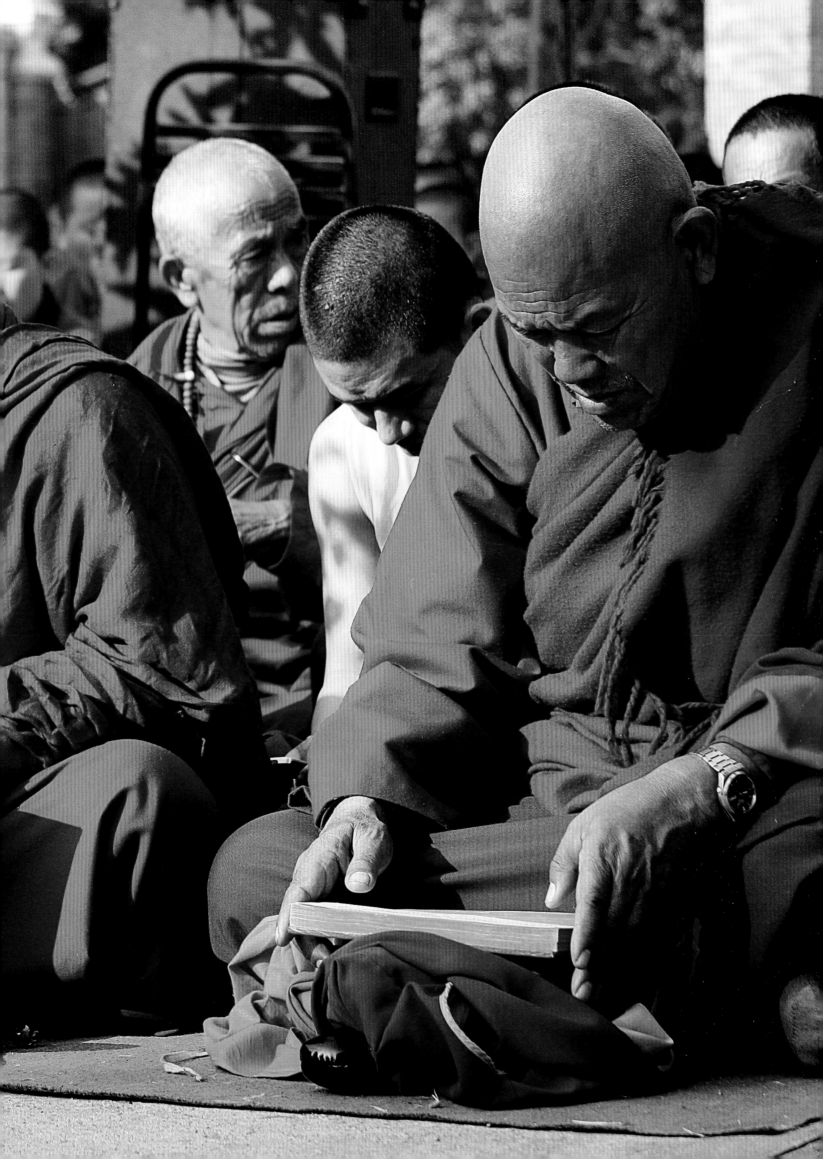

DHERADUN
"CITY OF JOY"

JAMMU AND
KASHMIR

Jammu

HIMACHAL
PRADESH

mritsar

Jalandhar Shimla

dhiana

PUNJAB Dehradun
UTTARAKHAND

DHERADUN

HARYANA Meerut

Ghaziabad

DELHI Bareilly

Aligarh

Agra Lucknow

Jaipur Kanpur

Varanasi

Patna

NEPAL 8848
t Everest

IM

THIM

JHARKHAND

Dhanbad Asansol

Ranchi WEST BENGAL

Jamshedpur

CHHATTISGARH

Ko

Bhilai-Durg

Raipur ttako

Nagpur Bhuban

ODISHA

Songtsen Library

GENE TRAVELS BACK to India, this time to Dheradun, where we meet Drikung Kyabgön Chetsang Rinpoche, one of the highest lamas of the Kagyü tradition. After spending some time in the United States while in exile, working in a McDonald's, Drikung Chetsang Rinpoche returned to India and built the Songtsen Library, which Gene believes has the best collection of Tibetan books in the world. The library is a valuable resource for Tibetan monks, especially those studying medicine.

Right and next page: Gene reviews with scholars and students how to access and use the database created by the Tibetan Buddhist Resource Center. Songtsen Library is one of the few locations in Dheradun with a good internet connection.

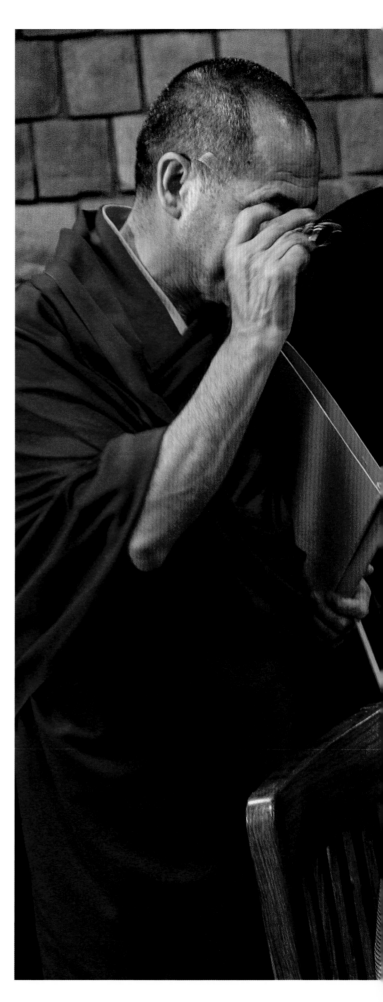

Songtsen Library's collection includes Tibetan literary works. The library is dedicated to preserving and disseminating these and other works of interest to students and scholars of Tibetan history and culture for use in research, publication, and conferences.

The library is named for Songtsen Gampo, the thirty-third ruler of the Yarlung Dynasty and founder of the Tibetan Empire. He is also credited with creating the Tibetan alphabet. Buddhist teachings were delivered orally until about 100 BCE, when the canon was first written down in Sanskrit, but no Tibetan translations of the Buddhist scriptures existed, in part because there was no written form of Tibetan. Recognizing, as Gene did, the importance of texts in preserving Tibetan Buddhism, Songtsen Gampo instructed his minister, Thonmi Sambota, to travel to India, study Sanskrit, and develop a Tibetan script. He then commissioned the translation of several thousand texts.

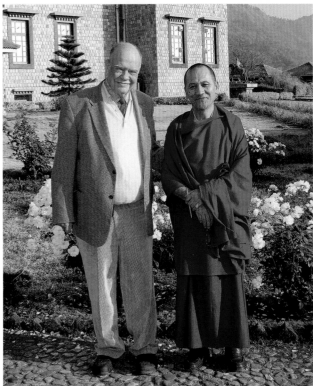

Top: His Holiness Drikung Kyabgön Chetsang Rinpoche.

Left: Gene with Dr. Tashi Samphel, director of Songtsen Library.

Following page: Medical students studying in the library.

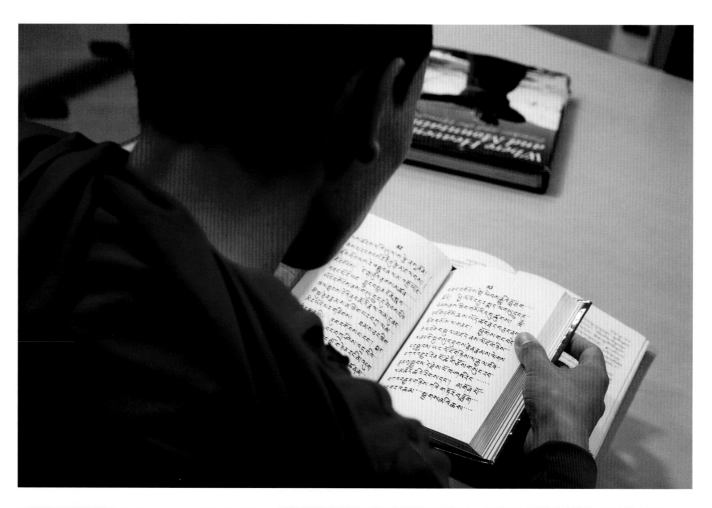

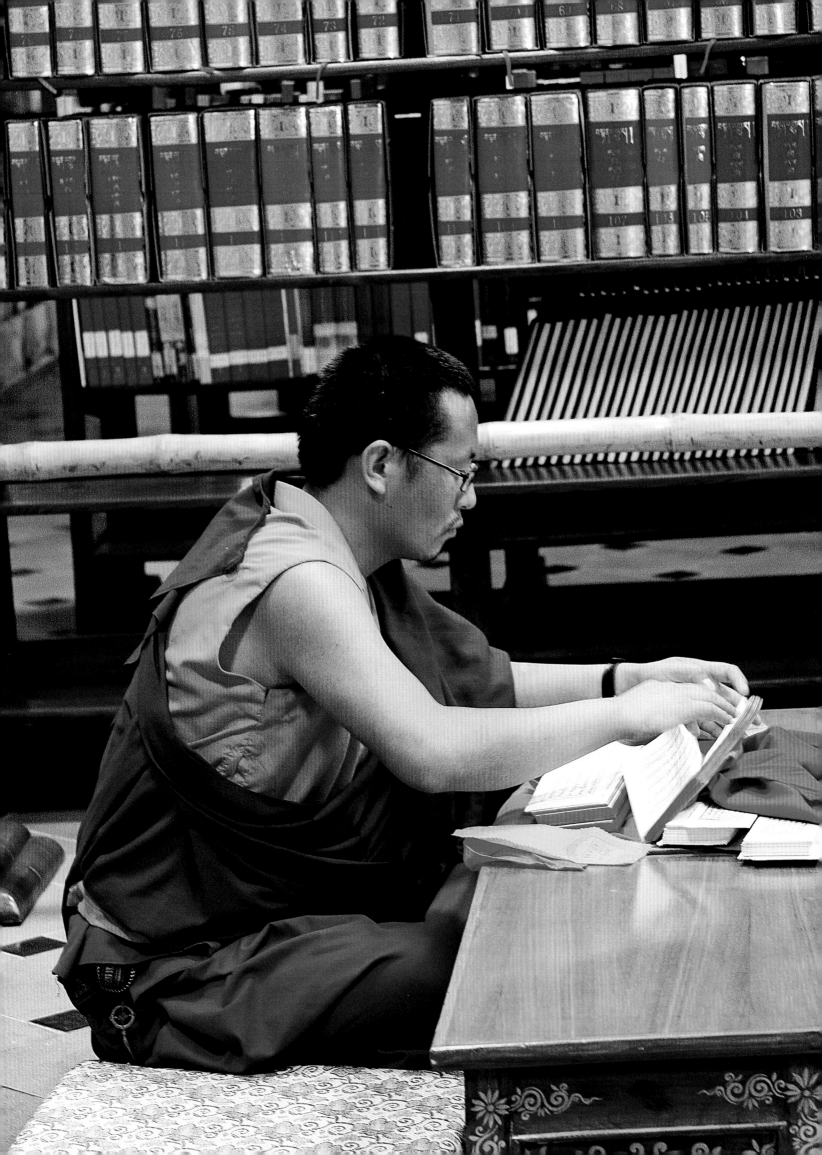

The grounds of Songtsen Library, with a statue
of King Songtsen Gampo in front.

Next page: Gene and His Holiness Drikung Kyabgön
Chetsang Rinpoche have tea and discuss the mission
they share—preserving the texts.

What's in the Books?

Tibetan belongs to the Tibeto-Burman language family, whose many languages are found throughout the Himalayan range and beyond, including Myanmar. There are many dialects of Tibetan spoken on the Tibetan Plateau and the Himalayas, and Tibetans are passionate about preserving their language in the face of many challenges.

The origins of the spoken Tibetan language are lost to history. The Tibetan alphabet was based on South Asian scripts used in Buddhist scriptures in North India and Nepal. The alphabet, with thirty letters and four vowels, has changed only slightly since it was first devised. Datable Tibetan rock inscriptions from the ninth century are still on display in Lhasa, and thousands of fragments of Tibetan texts from the tenth and eleventh centuries can be found in several major museums. This makes Tibetan one of the oldest literary languages in Asia.

The translation of Buddhist scriptures and Indian arts and letters into Tibetan involved a costly and labor-intensive effort that was carried out by committees made up of South Asian *panditas* and Tibetan translators and editors. Between the eighth and thirteenth centuries, the Tibetans and their South Asian partners translated over five thousand works from Sanskrit and other Indic languages. Virtually all of this was included in the broader Tibetan edition of the Buddhist canon. The main sections of the Tibetan Buddhist canon comprise scriptures attributed to the Buddha himself—such as sutras and the monastic legal codes—and hundreds of scholastic treatises about Buddhist thought and practice composed by South Asian masters. The Tibetan canon also includes all of the other genres of Buddhist writing from India, such as narratives, praises, rituals, epistles, and songs, as well as astrology, poetics, and the healing sciences. The contents of the Buddhist canon that the Tibetans and Gene heroically preserved and reproduced are vast and could be thought of as constituting not just a religion but an entire civilization.

The works in Tibetan translation in the Buddhist canon span over 1,200 years of Buddhist and South Asian culture. For this reason, the Tibetans claim that their canon is the most complete. The Tibetan canon is especially valuable in that it contains dozens of works from the tenth, eleventh, and twelfth centuries whose Sanskrit originals were lost and which were never translated into Chinese. A major caveat to the claim that the Tibetan canon is "complete" is that Tibetans translated very few works representing, for lack of a better term, the Pali Canon, which is adhered to by the Theravada tradition.

Aside from the classical canon, by at least the eleventh century Tibetans had developed many distinctive genres of vernacular writing to express Tibetan interpretations of Buddhism and Tibetan aesthetics. The early vernacular works render Buddhist teachings in earthy Tibetan

A damaged manuscript that was preserved and fortunately scanned just in time.
Only digital preservation will ensure that damaged manuscripts like these are not lost forever.

This illuminated page from the Buddhist canon is a good representation of the beauty of many Tibetan manuscripts. It is the opening page of one of the central scriptures of Tibetan Buddhism, the *Prajnaparamita* or *Perfection of Wisdom in 8,000 Line*s. It is illustrated with the Buddha and the goddess Prajnaparamita, the embodiment of the Perfection of Wisdom.

language, imagery, and humor, and for this reason were especially effective in spreading the Dharma among the villagers and nomads. The best known of these early teachings are the *lojong*—or mind training—teachings, which are also accessible in a variety of English translations. Vernacular Tibetan narratives are another medium for the genius of native Tibetan literature. Tibetans composed many eloquent "legends" about semi-mythical Tibetan kings and Indian masters who established Buddhism in Tibet in the seventh to ninth centuries. Inspiring biographies of Tibetan masters who attained enlightenment on Tibetan soil are also a hallmark of Tibetan writing, and the *Life of Milarepa* is considered the high point of the biographical tradition. The *Epic of Gesar*—the written form of the songs of Tibetan bards—is another classic of Tibetan literature, and several long episodes are available in English translation. There is also a popular genre of Tibetan Buddhist writings about making one's way through the long and arduous Buddhist path. After Tibetan writings were brought to India by Tibetan refugees, Gene played a central role in their republication, preservation, and introduction to the rest of the world.

The only available blockprint edition of a classic Tibetan commentary on the Three Cycles of Doha, songs of realization, composed by the Indian mahasiddha Saraha, who is depicted in the top right illustration.

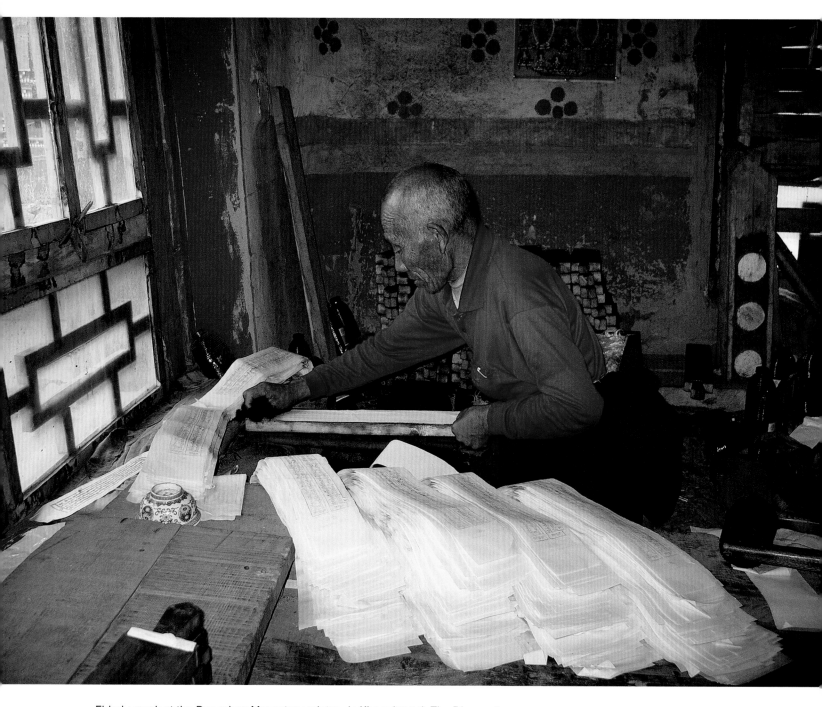

Elderly monk at the Dzogchen Monastery printery in Kham (2004). The Dharma has thrived in Tibet, thanks to the efforts of countless generations in preserving and transmitting the teachings of the Buddha. Photos on this and facing page courtesy of Jann Ronis.

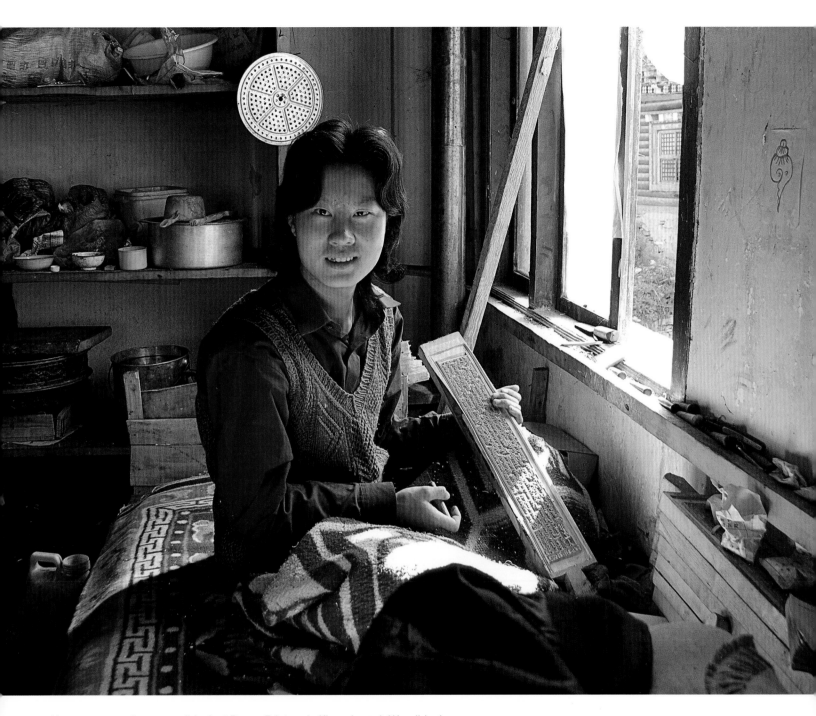

Young man carving a woodblock at Derge Printery in Kham (2004). Woodblock printing is a centuries-old technology in Tibet that is still alive today as the younger generation learns and practices traditional printing methods.

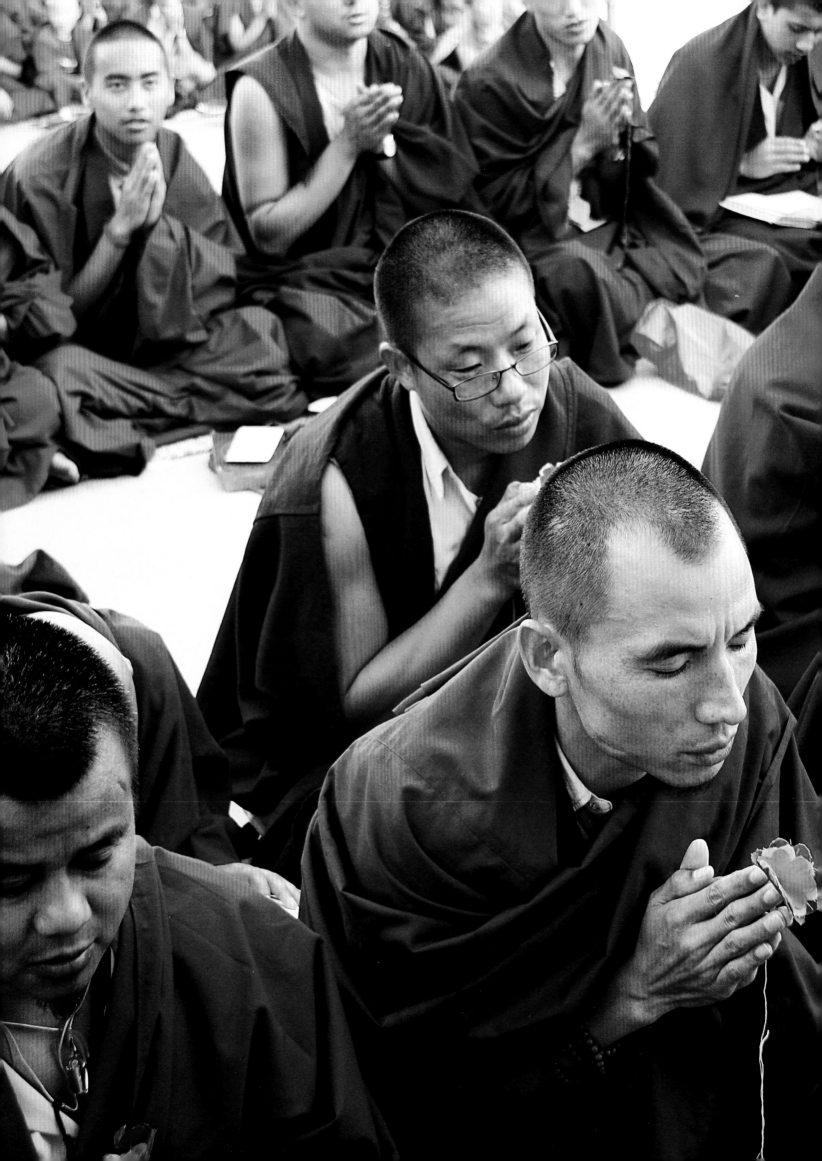

Mindrolling Monastery

We meet His Eminence Khochhen Rinpoche, head lama of Mindrolling Monastery, who escaped Tibet after the 1959 invasion and helped His Holiness Mindrolling Trichen reestablish the Nyingma monastery in Dheradun, in Northern India. The original Mindrolling Monastery is located in South-Central Tibet, not far from Lhasa. Still noted for its strong program in the literary arts, it served for generations as something akin to a finishing school for the families of Tibetan aristocrats. Following the 1959 occupation, the Eleventh Mindrolling Trichen was forced to flee Tibet prior to his enthronement. In 1976, Mindrolling Monastery in India became the official monastic seat of Mindrolling in exile. It remains committed to the preservation and promotion of Buddhism and Tibetan culture. Commentaries by Indian and Tibetan masters on the Buddha's teachings reside in the library of Mindrolling's Institute of Advanced Buddhist Studies.

———————————— ◆◆ ————————————

"All the four schools of Tibetan Buddhism, including
the Bönpo lineage, benefited
tremendously from Professor Gene Smith's
contribution—in the ability to have our texts
preserved and brought forth, and in giving us
the financial resources to sustain them."
—His Eminence Khochhen Rinpoche

———————————— ◆◆ ————————————

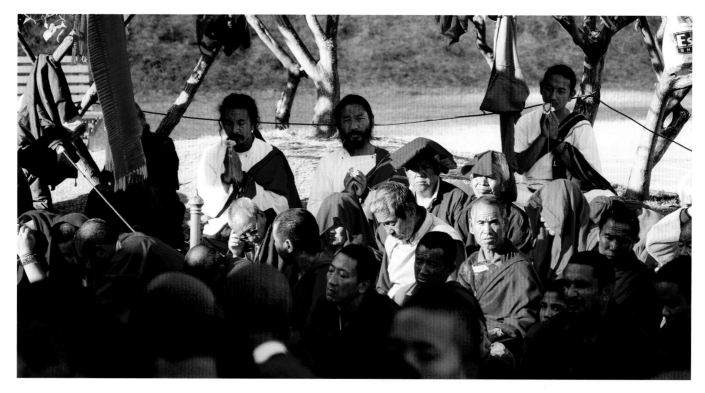

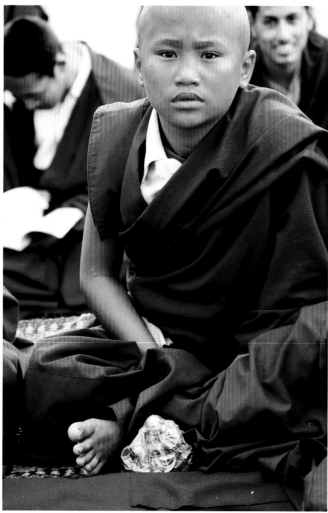

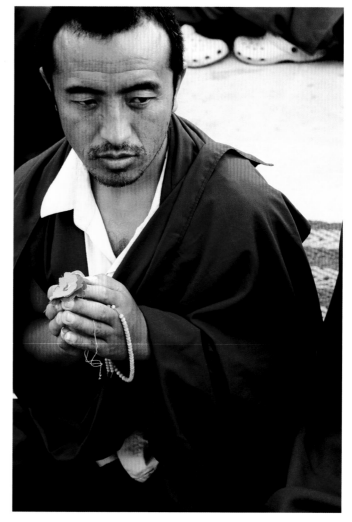

Prayer services at Mindrolling.

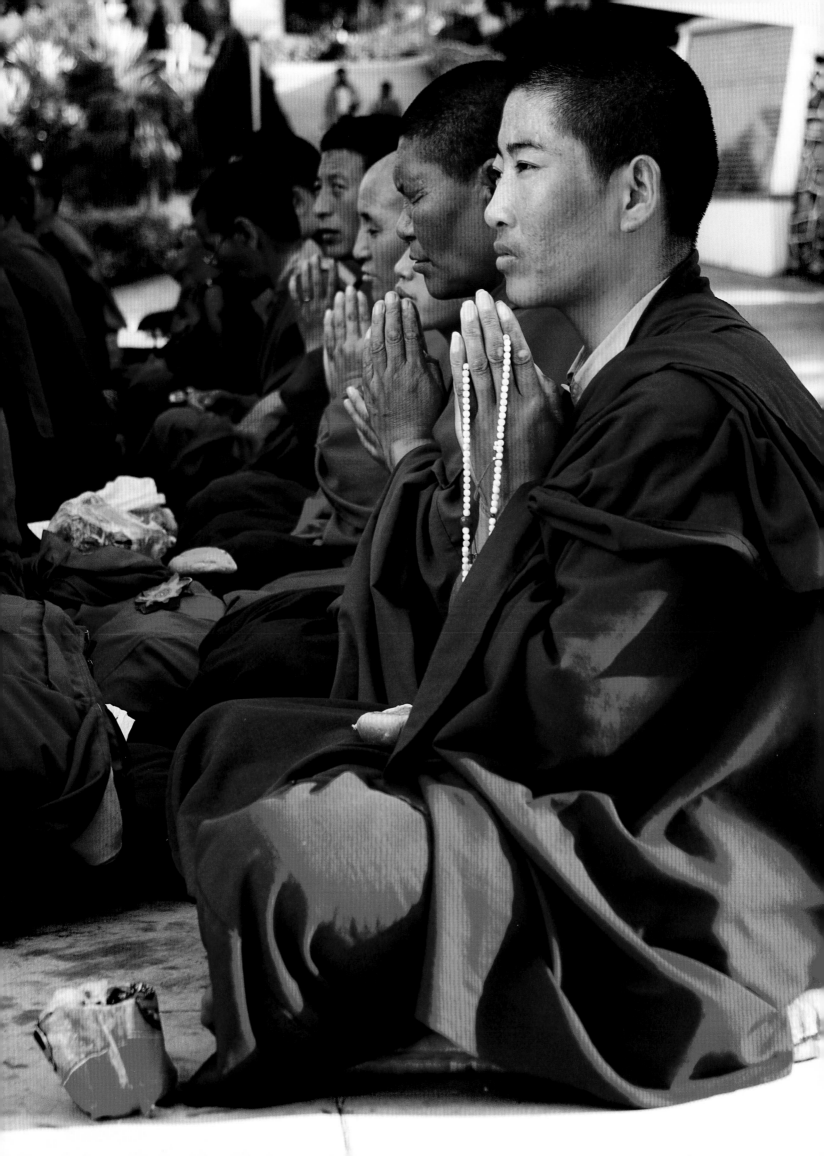

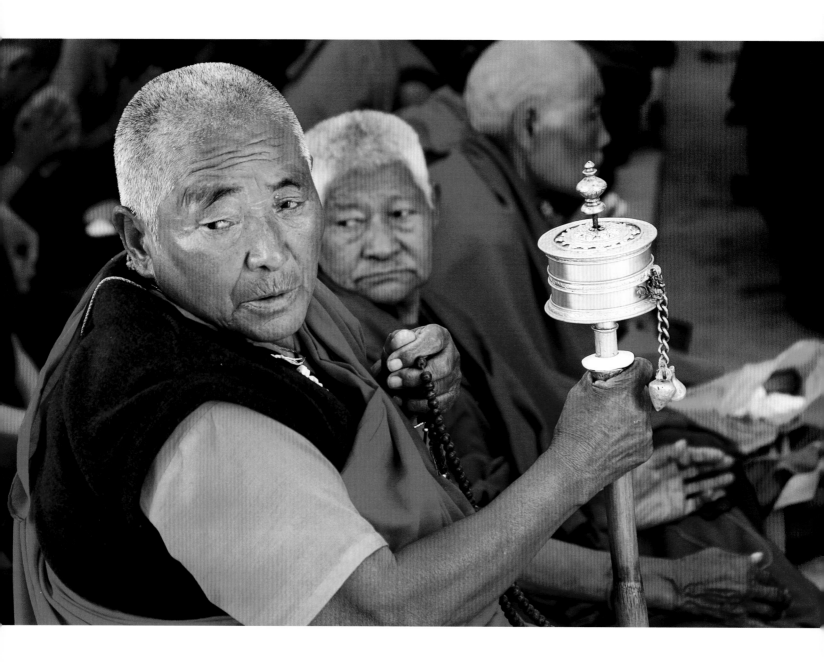

"The whole essence of Buddhadharma and Tibetan Buddhism
is that it has to be a living lineage. If it becomes a nice museum
or a beautiful shrine that nobody visits, then that doesn't make sense."
—HER EMINENCE MINDROLLING JETSÜN KHANDRO RINPOCHE

Tradition meets technology.

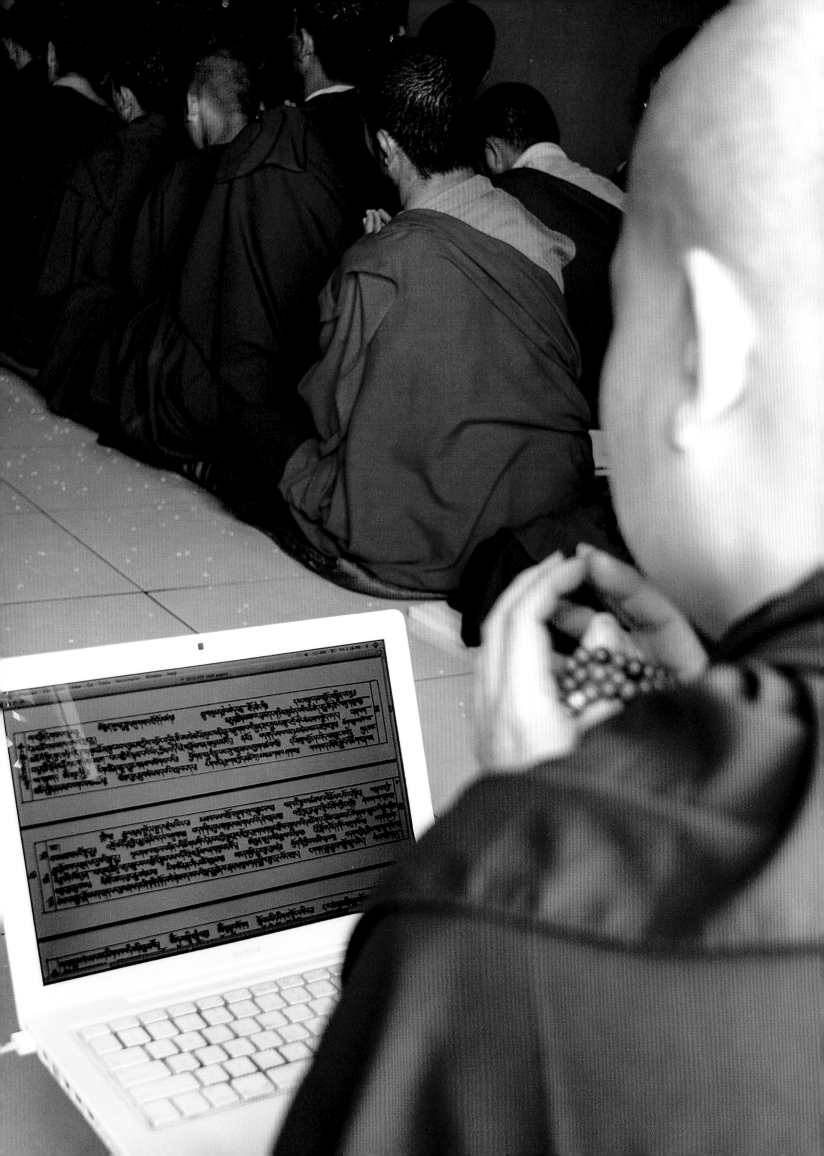

It is at Mindrolling that Gene speaks with the sixteen-year-old Khyentse Yangsi Rinpoche, who is believed to be the incarnation of Dilgo Khyentse Rinpoche, Gene's second teacher. Gene has not seen the young incarnation since he was four years old. Khyentse Yangsi Rinpoche talks about being an incarnation and the importance, for his generation, of preservation and tradition. The young tulku, who has come from Shechen Monastery to study at Mindrolling, tells Gene that he hopes to continue on the path followed by his previous life in printing thousands of books and thereby helping to preserve the Nyingma tradition.

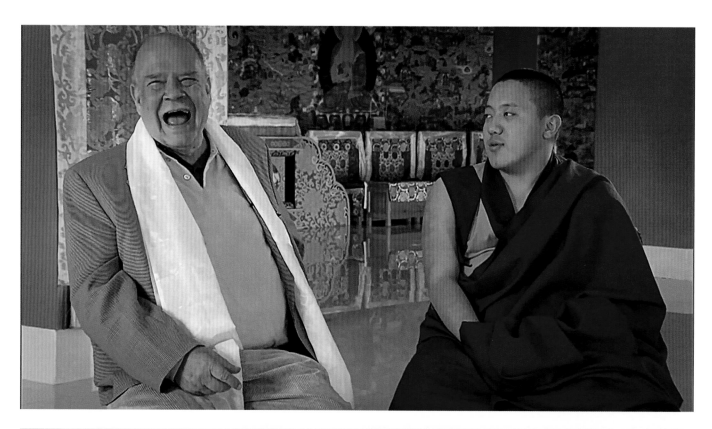

Gene delivers drives to Khochhen Rinpoche.
When asked what's in the box, Gene says, "Everything."

Mindrolling is known for its Jetsunmas, a line of great female masters beginning with Jetsün Mingyur Paldron (1699–1769). Gene looks forward to speaking with Her Eminence Mindrolling Jetsün Khandro Rinpoche, a teacher in both the Kagyü and Nyingma schools and the daughter of His Holiness Kyabje Mindrolling Trichen, who died in 2008, shortly before our visit, and whom Gene knew and admired. It is Jetsün Khandro Rinpoche's commitment to carrying on her father's involvement in the preservation of Tibetan Buddhist texts that makes the meeting of special interest to Gene.

Through her two decades of teaching in Europe, North America, and Asia, Jetsün Khandro Rinpoche has developed a huge international following. She established the Mindrolling Lotus Garden Retreat Centre (the North American seat of Mindrolling International) in Stanley, Virginia, in 2003, as well as centers in France, Germany, Greece, Denmark, and several other countries. In 1993, Jetsün Khandro Rinpoche and her sister, Jetsün Dechen Paldrön, founded the Dharmashri Foundation, which has worked to preserve the teachings of the Nyingma school and Mindrolling lineage.

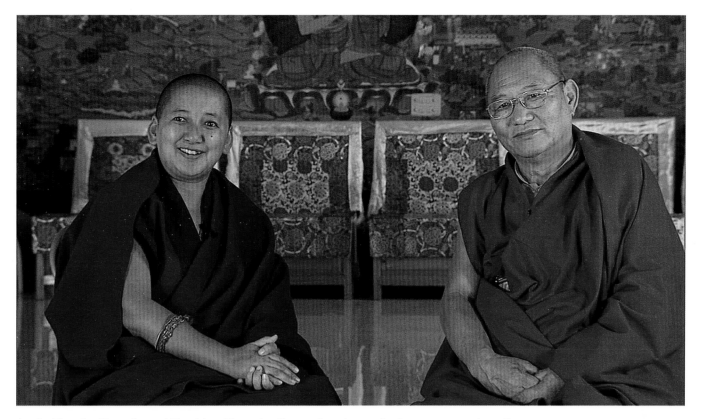

Jetsün Khandro Rinpoche and Khochhen Rinpoche discuss Gene's contribution to preservation efforts.

"The presence of anything that is very precious doesn't have a value if it is not cultivated, if it is not practiced. Our generation is sitting under a tree that is fully blossomed with the efforts of [Khochhen] Rinpoche and Gene Smith. But now, who maintains this? Who benefits from the fruit of this tree? I think that's probably the next generation's responsibility."

—Her Eminence Mindrolling Jetsün Khandro Rinpoche

Sikkim Translation Conference

Gene knew the importance of translating the texts if they were to be preserved. "It's not a mission of just preservation," he said. "It's passing it on, transmitting it on to other generations, to other cultures. To make this literature available, it has to be translated into English."

In March 2009, Gene attended the Khyentse Foundation's "Translating the Words of the Buddha Conference" at Bir, Himachal Pradesh, India. Conference attendees included masters and holders of all the lineages, as well as translators. Dzongsar Khyentse Rinpoche, a Bhutanese lama, filmmaker, and writer, recalls how, as soon as anyone at the conference mentioned translating the words of the

Buddha, Gene would move to the edge of his seat, listening intently. Then, rising to speak, Gene declares, "I'm here as a servant. My dream is to see something concrete at the end—a five-year plan and maybe even a twenty-five-year plan, or a one-hundred-year plan." At the conclusion of the conference, attendees resolve "to adopt the one-hundred-year vision, twenty-five-year goals, and five-year goals" that they have developed. Originally called the Buddhist Literary Heritage Project, in March 2021 the translation project is renamed 84000: Translating the Words of the Buddha.

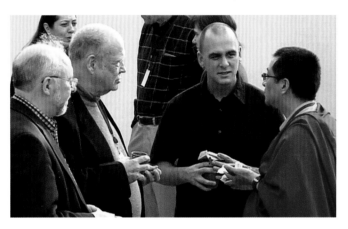

Dzongsar Khyentse Rinpoche.

Photos on this page courtesy of Khyentse Foundation.

"Now that Buddhism in the West has grown very fast, students will want to know, 'What are the Buddha's original words?' Tibetan culture and language are very fragile. In translating Tibetan Buddhist texts into modern languages, we may well be saving a vast swath of Buddhist civilization and culture from global annihilation."

—DZONGSAR KHYENTSE RINPOCHE

Facing page: Leading lamas of the Nyingma tradition, including Shechen Rabjam (grandson of Dilgo Khyentse), honor Gene with khatas.

Nyingma Monlam

In January 2009, Gene makes a special trip to receive the first-ever Sambhota Award, a lifetime achievement award for his contributions to the preservation of the Buddhadharma. The award is presented by the Nyingma Monlam Chenmo International Foundation, which unanimously nominated Gene for his work in preserving and ensuring access to Tibetan Buddhism's sacred literature. The ceremony is held at the holy site of Bodh Gaya, India, where the Buddha gained enlightenment sitting under the Bodhi Tree. Gene, a humble man who was never comfortable with the praise he received from lamas and scholars alike, does not want the film crew to accompany him on this journey. Noa Jones, who is writing an article about Gene for *Tricycle*, does make the trip with him and graciously provides us with photos that she has taken.

New York City: The Final Stop

By Dafna Yachin

IN LATE 2010, back in our Lunchbox Communications office in Philadelphia, Art and I were busy trying to complete the editing of the *Digital Dharma* film. More than a little of our time was spent in the never-ending search for grants and other funding sources that would enable us to complete and distribute the film.

Gene had reviewed a rough cut of about three and a half hours that our amazing post-production team had assembled from hundreds of hours of interviews and onsite footage. He liked where it was going but joked that it might need a big Bollywood dance number if we hoped to attract a wider audience. We knew that to have any hope of distribution or broadcast, we would need to trim the film to ninety minutes. We had already been rejected by a number of cable networks that didn't see how anyone could possibly be interested in a story about a librarian. Those rejections only made us more determined to bring Gene's amazing story to a wider general audience.

Around Thanksgiving, I went to Jerusalem on another project and met up with a Tibetan-scholar friend of Gene's. Together we decided to call Gene in India. We left a silly message for him about walking around old Roman ruins and missing him. Gene sent me an email later that day and promised to meet me in New York for dinner when he returned from Delhi in December. Since the start of our filming, we would meet regularly at various Indian restaurants in New York. I always looked forward to those meetings to hear about the next phase of his mission.

That was our last communication.

On December 16, 2010, I received a Facebook message from one of Gene's nieces. She wanted to know if she could see the film, explaining that her uncle had just passed away, in his sleep, alone in his modest Manhattan apartment.

I was inconsolable at the loss of such a great mentor and friend. But I knew my loss was small compared to what the world had just lost. *Jewel and gem.* Those were the words I had heard in Kathmandu—the words that Chökyi Nyima Rinpoche had used in describing Gene's importance in helping to keep alive Tibetan culture. The words are with me to this day. *Jewel and gem.* The world had indeed lost one of its great treasures.

Gene's family and closest friends attended a private traditional Tibetan Buddhist ceremony. Hundreds more, whose lives were touched by the life and work of E. Gene Smith, came to memorial services in Delhi and at St. John the Divine in New York City to honor the man whom many called an American bodhisattva—an "enlightened being."

"If he's a Tibetan by birth, there will be monasteries and lamas and about a hundred pregnant women at the moment claiming that we have the reincarnation of Gene Smith."

—DZONGSAR KHYENTSE RINPOCHE

One dictionary defines *bodhisattva* as a person who can attain nirvana but chooses to delay doing so to have more time to save those who are suffering. No one who knew Gene had any doubt that, for him, saving sacred Tibetan texts and thereby saving the Tibetan culture was more important than his own well-being. His sister Rosanne said that he "never did take care of himself. He ate too much. He drank too much. He ate all the wrong things. That wasn't his priority."

The New York Times called him "a guardian of cul-tural treasures that were imperiled by war and political upheaval." *Tricycle* called him "the man who saved Tibetan Buddhism." But perhaps *The Economist* said it best when they called him "always a librarian, with a librarian's love of catalogues and connections."

And, they might have added, a librarian whose story deserves to be of great interest to anyone who cares about keeping alive all that is enriching and beautiful from our past.

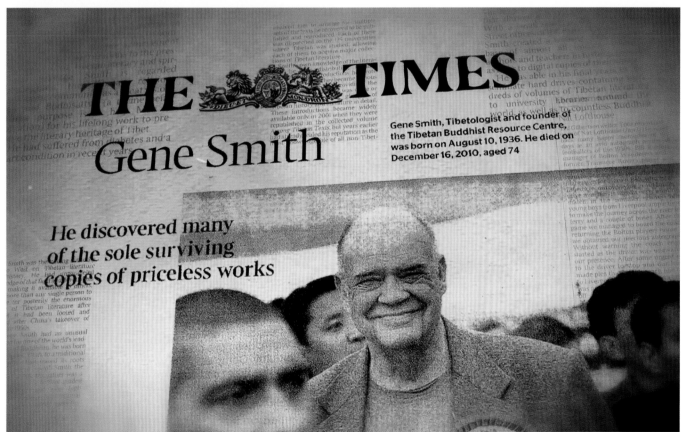

2011: Chengdu, China

Throughout his life, Gene insisted that the Tibetan canon belonged not to him or to other scholars who had embraced its teachings, but to the Tibetan people in their homeland. "It belongs to them," he said repeatedly, preferring to characterize his role and that of others outside of China involved in the preservation effort not as "the actor" but rather as "the encourager." On June 1, 2011, in a ceremony attended by TBRC Executive Director Jeff Wallman and other TBRC representatives, the Southwest University for Nationalities, located in Chengdu, China (in Sichuan province), opened the E. Gene Smith Library. The library houses nearly twelve thousand volumes from Gene's personal collection—the largest private collection of Tibetan literature in the world.

Bust of E. Gene Smith sculpted from a photo.

Next pages: Gene's photo hangs on the wall in the interior of the E. Gene Smith Library.

Gene's personal items are on display under glass in the center of the beautiful main room.

Ben Jia, director, Tibetan Literature Research Center, Library of China, inspects the new display.

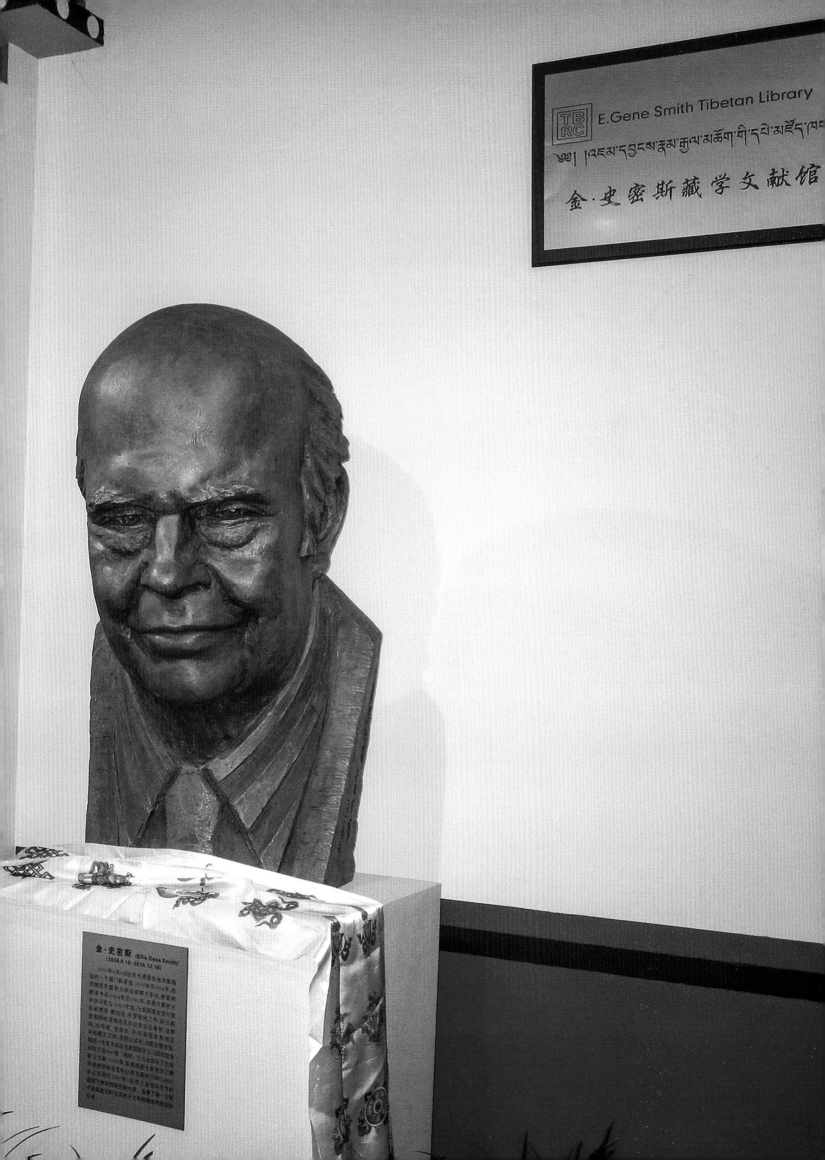

E. Gene Smith Tibetan Library

ཨེ། །གནས་དབྱངས་རྣམ་རྒྱལ་མཚོག་གི་དཔེ་མཛོད་ཁང་།

金·史密斯藏学文献馆

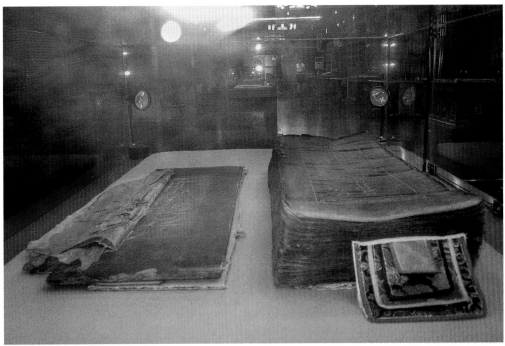

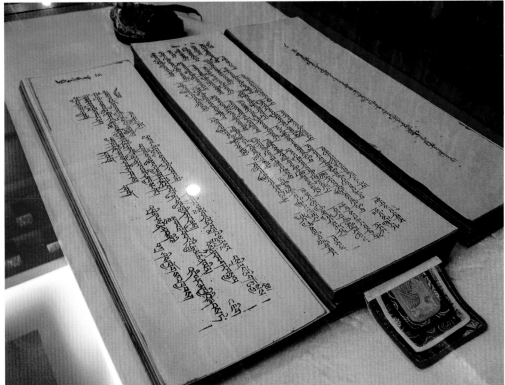

"[D]onating these documents to the university, allowing more Tibetan scholars—scholars from other nationalities and experts from the whole world—to study and research them . . . in Buddhist terms, this is a deed of 'boundless merits and virtues.'"

—BEN JIA, DIRECTOR, TIBETAN LITERATURE RESEARCH CENTER, LIBRARY OF CHINA

Gene's Legacy: The Buddhist Digital Resource Center

On a wintry day in February 2011, Gene Smith's memorial service was held at the Cathedral of St. John the Divine in New York City. Luminaries from all over the world attended to pay their respects to the man who had done more for the preservation of Tibetan literature than any other Western scholar. Philip Glass played at the service. Alak Zenkar Rinpoche, an accomplished Tibetan scholar and Gene's dear friend, delivered a moving eulogy. He called Gene one of the most brilliant people he had ever met and said, "Some people may compare his brain to a computer, but I feel it was much greater." Dzongsar Khyentse Rinpoche spoke about Gene's legacy and what Gene had achieved with his digital library: "It's not for Tibet. It's for sentient beings. It's for everyone." Indeed, what was originally intended to be a digital archive of Gene's personal Tibetan library of over ten thousand volumes would become the largest digital repository of Buddhist literature in the world.

The death of its charismatic founder left the Tibetan Buddhist Resource Center with an uncertain future. But the staff, the board, and Gene's successor, Jeff Wallman, were determined to secure its future, recognizing that its critical work must continue. Realizing that it was necessary for the survival of the organization to leave New York, Jeff relocated with the librarians to Cambridge, Massachusetts. The librarians, all of whom Gene had personally hired, chose to stay with the organization and resettled their families in the Boston area.

After establishing headquarters in Cambridge's Harvard Square, Jeff greatly expanded TBRC's cultural partnerships, both domestically and internationally. He negotiated an agreement with Harvard University Digital Repository Services to secure the TBRC archive and established partnerships with Zhejiang University (Hangzhou) and Southwest University for Nationalities (Chengdu) in China. Most significantly, between 2012 and 2014 Jeff oversaw the completion of the scanning of Gene's massive library, thereby achieving the mission of the organization.

The first phase was now over. What would come next for TBRC?

In 2015, TBRC called together a large gathering of Buddhist Studies scholars to discuss its future. The meeting was sponsored by the American Council of Learned Societies. Held in Berkeley and convening leading Euro-American scholars in each of the major Buddhist canonical traditions, the gathering arrived at a consensus to redefine the mission and change the name of the organization. The Tibetan Buddhist Resource Center would henceforth be known as the Buddhist Digital Resource Center (BDRC) and enact an expanded mission to preserve and disseminate not just Tibetan Buddhist literature but Buddhist literature as a whole.

The year 2018 saw the planned leadership transition from Jeff Wallman to Jann Ronis, BDRC's new executive director. With a PhD in Tibetan Buddhism from the University of Virginia, Jann had taught at UC Berkeley for several years. Leading the organization through an era of growth and expansion, Jann moved BDRC into a new home—its present location on South Street in Boston. A gift from the Seventeenth Karmapa, BDRC's new and expanded office space, belonging to Karma Triyana Dharmachakra, has an events space to foster public programming and greater engagement with the local Tibetan and Buddhist communities. The space, BDRC's home for the next ten years, will allow BDRC to be a dynamic hub for Buddhist culture, research, and outreach.

More importantly, under Jann's leadership BDRC launched the Buddhist Digital Archives (BUDA), a public digital library that serves as both a new interface for BDRC's vast archive and an advanced library platform built for collaboration. Partnering with other Buddhist resources and collections, BUDA gives users access to a whole universe of Buddhist texts and manuscripts in various languages and marks a major technical advancement for Buddhist projects. It was made possible by the ingenuity and dedication of data architects Élie Roux and Chris

Tomlinson, and with the generous support of The Robert H. N. Ho Family Foundation. Gene, who was working at the forefront of technology in his day by digitizing Tibetan texts, would have been delighted to see the latest technology in service to Buddhist literature.

Apart from building the Buddhist Digital Archives, BDRC has now taken its proven Tibetan textual preservation model and applied it to preservation programs for other Buddhist languages and cultures. It has launched ambitious projects in Cambodia, Mongolia, Nepal, and Thailand. In Cambodia, working with Dr. Trent Walker and the Fonds pour l'Édition des Manuscrits du Cambodge as well as the École française d'Extrême-Orient, BDRC is carrying out the Khmer Manuscript Heritage Project with support from A Khmer Buddhist Foundation to digitally preserve all surviving traditional Cambodian manuscripts. For instance, BDRC has already secured the digital collection of the monastic library of Vatt Phum Thmei, the only complete palm-leaf library surviving from prewar rural Cambodia. In Thailand, BDRC is working with the Fragile Palm Leaves Foundation and its founder, the legendary scholar Peter Skilling (the Gene Smith of Southeast Asian manuscripts), to produce the world's largest open-access online collection of palm-leaf texts in the Burmese script, including thousands of Pali texts. In the meantime, the Digitizing the National Library of Mongolia project, launched in collaboration with the Asian Classics Input Project (now known as Asian Legacy Library), will preserve thirty-one thousand volumes of previously uncataloged and undigitized Tibetan texts, many from the private collection of the last Khan.

As with the other regional projects, BDRC built a scanning station in Kathmandu and trained Nepalese staff,

improving local capacity and digitizing Newari and Sanskrit manuscripts. Additionally, BDRC launched a partnership with the Nepal-German Manuscript Cataloguing Project to ingest their metadata and provide another search-and-discovery avenue for their incomparable collection of Nepalese and Himalayan manuscripts. As a result, BDRC's hugely enhanced library of texts now offers canonical and vernacular works in Newari, as well as in Sanskrit, Chinese, Pali, Burmese, Khmer, and of course Tibetan.

Preserving Tibetan texts is still a core part of BDRC's expanded mission, and BDRC will continue text preservation work in Tibet, which is at the heart of the legacy bequeathed by Gene. In fact, over the past five years BDRC has added more Tibetan language texts to its archive than ever before. In carrying out its current text preservation work among endangered archives in Asia, BDRC has been fortunate in receiving major gifts from longtime donors such as Khyentse Foundation, The Robert H. N. Ho Family Foundation, and the Peter and Patricia Gruber Foundation. Thanks to their generosity, BDRC's library now contains over 24,500 works comprising more than twenty-five million pages. Over the next ten years, the library will continue to grow as BDRC scales up its international text acquisition and scanning initiatives. Continued data-sharing collaborations with current and new partners will add to an ever-expanding Buddhist library.

The coronavirus pandemic has highlighted the global significance of open-access online archives. Even as libraries and archives have had to shut down around the world, BDRC's work has made the Buddhist literary heritage accessible online to more people in more places than ever before. Gene Smith, BDRC's visionary founder, would be proud of his legacy.

The staff with Gene in New York, enacting the mission of sharing the Dharma with the world (circa 2009).

Digitizing Ragya Kangyur. The woodblocks of the Ragya Kangyur were carved two hundred years ago under the direction of the abbot of Ragya Monastery, Shingza Pandita. The Ragya Kangyur itself was thought to be lost until 2013, when monk and educator Jigme Gyaltsen found the Kangyur languishing in a monastery. Following that discovery, BDRC worked with the Ragya monks to scan, catalog, and preserve the Kangyur (2015).

BDRC Executive Director Jann Ronis at Songtsen Library in 2019, making the same trip Gene made years before. Jann offers an updated drive to Dr. Tashi Samphel, director of Songtsen Library.

From his base at the Ragya Buddhist Center in Virginia, the Eleventh Shingza Rinpoche (b. 1980), the reincarnation of the great lama who created the Ragya Kangyur in the early nineteenth century, is able to read the Ragya Kangyur online in the BDRC digital library (2021). This photo, which illustrates BDRC's global role in facilitating the preservation and the spread of the Dharma, is kindly provided by Ragya Mahayana Buddhist Cultural Center.

BDRC Librarians Remember Their Mentor, Gene Smith

Karma Gongde

Karma, the head librarian, speaks fondly of Gene Smith as a real gentleman and someone he was very fortunate to work with. Gene spent a lot of time in the office creating catalog records and outlines, and Karma remembers how fast Gene used to touch-type Tibetan on the computer. Indeed, as it wasn't possible to directly type Tibetan script then, Gene was in fact transliterating complex Tibetan syllables in the Roman alphabet, a conversion that was second nature to him because of his many years keying in Tibetan texts on standard American typewriters. "He typed without taking his fingers off the keyboard. The letters would appear on the screen much later." Chuckling, Karma adds, "Of course, back then computers were also slower." In his spare time, Karma, who was formerly a research assistant in the Dictionary Unit of the Central Institute of Higher Tibetan Studies in India, enjoys reading history and the biographies of great lamas and saints, which are also guides to enlightenment. He downloads the majority of his texts from the BDRC site because they are generally not available in print. He says, "Each time you read a life story of a master, you find a path to follow."

Kelsang Lhamo

Gene hired Kelsang Lhamo as TBRC's first librarian in 2001. Gene was her teacher. Although she spent nine years in retreat in India meditating and studying Tibetan texts, working under Gene Smith would prove to be her real education. Reading the texts, creating catalogs, and listening to Gene every day exposed her to teachings from all the Tibetan Buddhist traditions. Gene insisted that she read the whole book before writing its summary. "He wanted no mistakes in the catalog. Nobody else has such detailed and authoritative catalogs, not even the Library of Congress. When we made an excellent catalog, Gene took us to Merchants for drinks," she laughs.

Chungdak Nangpa

Chungdak, who is also an interpreter and translator, was hired by Gene to join the BDRC team in 2009. He comes from central Tibet and taught Tibetan Buddhist history for many years at the Nationalities University in Beijing as well as at the China Advanced Institute of Tibetan Buddhism. Many of his former students from the Panchen Lama Institute are now heads of monasteries across the Tibetan plateau. Chungdak describes BDRC's work as essential. "BDRC does the best work toward cultural preservation," he says. "Our work saves the essence of Tibetan culture. We are saving the texts, the Dharma." He says that Gene "trained me with purpose and with patience. He never compromised on quality, and he knew how to get the most out of his staff."

Lobsang Shastri

Before BDRC, Lobsang Shastri was chief librarian at the Library of Tibetan Works and Archives in Dharamsala. Long before meeting Gene in person in 1998, he knew Gene through the books published by the PL 480 program, whose prefaces, written brilliantly by Gene, he always read. Conscious of the need to document history before it was lost, Lobsang wrote *The Local History of Ruthok* to textually preserve local knowledge that had previously only been transmitted orally. Lobsang, who has moved from a physical library to a digital library, marvels at the latter's far greater reach. "People used to have to go book hunting for texts in India and Tibet; now they can just sit at home and browse these texts. People used to have to read the whole book, now they can just read our outlines and find what they are looking for." He says, "We help scholars, researchers, lamas, and practitioners by making all this literature available for free. Even governments can't do this work. We are giving it away for free. That was Gene's commitment."

"My Friend Gene," by Leonard van der Kuijp

In my early days, back in the 1970s, when I was a student at the University of Saskatchewan in Saskatoon, Canada, Gene was a concept, an idea, to us fledgling students of Tibetan. An idea impossible to wrap our heads around! This did not change when I later studied for the DPhil at Hamburg University. The difference was that some of us graduate students decided to copy all those immensely valuable introductions that he had written for the Tibetan books that were published under the PL 480 program, his farsighted brainchild. We planned to bind these ourselves in a DIY fashion and turn them into a book. This never materialized. Many years later, a number of them were ably collected by Kurtis Schaeffer, whose ever-so-useful edited book was published under Gene's name as *Among Tibetan Texts: History and Literature of the Himalayan Plateau* (Boston: Wisdom Publications, 2001).

Having finished my DPhil, I returned to Saskatoon. Since I wasn't exactly looking for a position, I embarked on the study of agricultural economics at the same university. After my very brief one-semester stint, Professor A. Wetzler of Hamburg University gave me a call and offered me a position with the Nepal-German Manuscript Preservation Project (NGMPP) in Kathmandu, Nepal, of which he was the director. It was initially a six-month position, but it ended up enabling me to work and stay in Kathmandu for five years. His call and those five years forever changed my life. And it was there that I met Gene in the flesh for the first time.

I do not recall the particulars, or how this came to pass, but I believe it was in early 1981. The first meeting was quite memorable, since Gene had apparently heard that a Newar family wished to sell a Tibetan xylograph copy of a collection of the biographies of the Dalai Lamas. An inveterate bibliophile, Gene could barely wait to procure this rare collection of xylographs. He flew to Kathmandu, and we got in contact and hit it off straight away. It was as if we had known each other from before. I drove him around in search of these texts until we found the family. And after their purchase, he stayed on for a few days and then returned to Delhi.

Not long thereafter, Gene was once again in Nepal. This time it was during Tihar—a three-day-long festival with attendant celebrations—which, in Nepal, occurs around November. Peter Burleigh, an old friend of Gene's when both were in Nepal during the mid-1960s, was the temporary chargé d'affaires at the US embassy in Kathmandu, and the three of us drove around to visit and congratulate several of their old friends and acquaintances. One of these visits was quite unforgettable. The rather well-to-do family we were about to see was that of Rishikesh Shaha (d. 2002), a well-known aristocrat, diplomat, and historian. It was early evening and already dark when we knocked on the door of his villa and were let in by one of his several servants. As we entered a large room, we nodded at a rather portly woman who, we later learned, was his wife. She was playing cards—for money—with servants and a cook. We were then ushered downstairs where, in a smoke-filled room, Rishikesh and his guests were playing *kauda*, a fast-paced gambling game with cowrie shells. We sat ourselves down on some chairs and I watched in astonishment as bundles of one-hundred- and one-thousand-rupee notes changed hands in rapid succession. This was Nepal, one of the poorest countries on the planet! I must confess that I had never seen that much money during my years in Nepal, save in the casino at the Oberoi Hotel. In those days, a thousand rupees went a very, very long way!

During the rest of my years in Nepal, I saw a great deal of Gene in Kathmandu as well as in Delhi. There is a memorable photograph of one of these visits. Along with Christoph Cüppers—my friend, Hamburg classmate, and successor with the NGMPP—I drove to Delhi to pay Gene a visit and ask for some advice. Christoph and I had done this several times before, and as Gene would insist, we stayed at his residence where we were very well looked after by Mangaram Kashyap, his right-hand man. When Gene insisted on something, it was almost impossible to refuse, and Mangaram would always make sure that everything was arranged and organized to perfection, from the rooms where Gene's many guests would stay, to the breakfasts, lunches, and dinners. The photograph shows

the three of us in his living room in a moment of easy conversation.

Truth be told, the successes that I was able to achieve during my stay in Nepal, I owe to the information that I received from Gene. Always generous with his vast knowledge and always ready to share, Gene was the one who told me about a copy of the almost complete xylograph of more than one hundred volumes of the Lithang Kangyur that had been carried across valleys and over mountains in the late 1950s and was now in the possession of a ranking Tibetan family in Orissa. In 1983, I microfilmed this collection with the help of Mr. Navraj Gurung of the NGMPP; in 1984, Christoph Cüppers and I did a number of necessary retakes. Through Gene, I also was able to film the library of the main monastery in Langtang, in northern Nepal, which was completely destroyed during the catastrophic earthquake of 2015. If it had not been for Gene, its treasures, both manuscripts and xylographs, would have been lost forever. Now they exist in microfilm alone.

Gene's effort in having Tibetan books reprinted, and thus preserved, under the PL 480 program resulted in some 6,000 volumes of text and was a natural precursor to the Tibetan Buddhist Resource Center (TBRC), now the Buddhist Digital Resource Center (BDRC), which he founded in 1999 with friends and the financial help of generous patrons in Cambridge, Massachusetts. The transition from PL 480 to TBRC/BDRC parallels the progress that was made in the technology of book production, from printed books to digital/digitized books. When all was said and done, TBRC made some thirteen million pages of Tibetan text available on its website—and, very importantly, free of charge. In expanding the scope of TBRC, BDRC has grown into a much larger creature under the leadership of its executive director, Jann Ronis, and his staff. And, like its precursor, BDRC comfortably stands on the cutting edge of the technologies that are becoming available to preserve, archive, and search through texts.

In sum, it goes without saying that Gene's genius has changed the ways in which many of us study Tibetan literary culture. Indeed, I am one of many students of Tibetan culture, broadly defined, who owe him a profound debt of gratitude. It is safe to say that many of us, who were fortunate to know this unique human being and to benefit from his legendary generosity, would not otherwise be where we now find ourselves in 2021.

Acknowledgments

THIS BOOK would not be possible without the vision of Patricia Gruber, a long-time advocate of E. Gene Smith's work. Pat is ever so humble, crediting her husband, Peter Gruber, for being the catalyst to this project. It is, however, Pat's leadership, time, and creativity that made possible the sixteen-year journey from concept to documentary to book. She is a gift.

Many thanks to our friends at the Buddhist Digital Resource Center (BDRC)—Executive Director Jann Ronis and his communications coordinator (who does much more than her title indicates), Tenzin Dickie. Both Jann and Dickie demonstrated extraordinary patience in explaining to us the rhyme and reason—and the history—behind much of what we heard and saw. With their enthusiastic participation, what began as a biographical journey evolved into an in-depth course in history, religion, and culture, with a healthy dose of politics, music, geography, and literature thrown in. Perhaps most important, they led us to an even-deeper appreciation of all that Gene had accomplished. Thanks are also due to the librarians and staff at BDRC, along with the Tibetan Buddhist Resource Center's (TBRC) past leadership, especially Jeff Wallman and the TBRC board members from 2010.

The Book's Creative Team

We want to thank Andrea Bitai, who helped us visually bring to life the journey described in the book through her beautiful chapter illustrations; the talented Robert Carter, for keeping the color correction true to what the field team captured in 2008 and for creating the authors' headshots; Gopa Campbell for designing the jacket and, with Tony Lulek, for solving the five-hundred-piece puzzle of the book's beautiful layout; and Laura Cunningham, our editor from Wisdom Publications, for her clarity, diplomacy, and patience. We're grateful to the entire *Digital Dharma* team at Wisdom Publications.

Thanks also to Robert Beer and Shambhala Publications,

for graciously granting us permission to use the Tibetan line drawings that you see throughout the book.

This book was completed during Covid with teams from Lunchbox, BDRC, and Wisdom. We will miss our weekly Zooms, which included fond remembrances of Gene; discussions about the current status and glorious future of BDRC; photos of our pets, plants, what we were eating, and anything else that came up, all while sipping chai tea (except for Art). It is no exaggeration to say that the time spent with everyone online was a source of hope for all of us and helped to impart some small semblance of normalcy during a very difficult time.

Contributors

So many of Gene's family, colleagues, and friends provided context, information, and photos, including Mangaram Kashyap, Gene's right hand, confidant, and friend; Gene Smith's sisters—Rosanne Smith, Carma Wood, and LaVaun Ficklin; Lisa Ross, Lisa Schubert, Tashi Tsering, and Tim McNeill; Noa Jones, Isaiah Seret, and the Khyentse Foundation; and The Rubin Museum of Art.

We are grateful for two iconic images from Gene's friend and Magnum photographer, Rosalind Fox Solomon.

A special thank you to Matthieu Ricard, Khyentse Rinpoche, and Leonard van der Kuijp, who were so generous with their time in providing background and details about Gene's work and his relationship with the lamas from whom he learned and to whom he gave so much.

Many of the photographs for Gene's story were created with help from the documentary's talented teams: Director of Photography (and my first digital camera teacher) Wade Muller; field producer, photographer, and "besty" Tamela Knapp; our personal diplomat and catch-all support person in India, Sarah Hreha; from Pink Flamingo in India, Nandhu Kumar and "our brother from another mother" Rajesh Kumar; our lovely India "fixers," Shernaz Italia and Freny Khodaiji; from Ice Fall Productions in Nepal, Ram Krishna Pokhare, Hari Krishna Pokharel, and Bhim Thapa; Joy Li Le and Justyn Field for the library photos in Chengdu; and Paul Van Haut and Nelson Walker for US filming.

Thanks especially to the heroic Lunchbox team: Kevin Malone and Danielle Wells, whose talents kept us together during all sorts of change (including their marriage), and Char Scott and Danielle Pleines, who held down the fort by themselves for a time; Don Creamer, for helping us start the journey; Duncan Fraizer, Orley Fields, and Patricia Saphier; Ninni Saajola, Dita Gruze, Molly Brennen, Patricia Bradley, Hillary Hanak, and Gabriel Weiner; our consulting EP, Bill Harris; our legal counsel, F. Emmett Fitzpatrick, III; film distribution consultant, Anita Reher; Leah Houck, Nicholas Madeja, and Kody Roman for sifting through and organizing thousands of photos and completing this book's first draft photo layout; Jim Graham for additional photo enhancements; Mary Lou Magyarits for the lovely end sheets; and our fiscal sponsor, the Greater Philadelphia Film Office. Our loudest shout-out goes to the film's senior editor and co-writer, Timothy Gates.

We thank our Kickstarter film supporters and so many others who embraced this project.

From Art: Special thanks to my incredible family: to Janet, for supporting me in so many ways; to Anna and Molly, for always being there to help when needed (especially when technology is involved); and to Max and Jean, for keeping me on my toes.

From Dafna: Contrary to popular belief, you can choose your family. Special thanks to the "giving girlz": Eileen Brady, Elle Brunswick-Hanks, Patty Kleiner, Gillian Fields-Morrison, MJ Paschall, Linda Taylor, Naomi Wexer, and Dorry Yachin.

For more information, please visit DigitalDharma.com and BDRC.io.

In Memoriam

To all the lamas who, before leaving this earth, showed their gratitude to Gene Smith by sharing with us their time, hospitality, and important history.

And to Susan (Shoshi) and Gideon Yachin, who believed that everyone wants to hear a story about a librarian.

Index

About the Authors

Dafna Zahavi Yachin is a director, producer, and writer of award-winning documentaries, broadcast series, national commercials, educational programs, and multimedia campaigns. She has been instrumental in creating lasting formats for projects airing on CBS, ABC, NBC, CNN, Discovery, History, and SyFy. Her first Indie Feature Documentary, *Digital Dharma*, was Oscar qualified in 2012. Dafna has focused her documentary and online initiatives in the humanities, justice, and women's rights arenas. She holds a BA in rhetoric and communications, and a BA in international political science from the University of Pittsburgh. Candid and documentary photography has been her avocation since she could hold a Polaroid. Dafna lives in Philadelphia with a one-eyed Shih Tzu and three terrorized cats.

Arthur. M. Fischman holds a BA from Queens College and a JD from Temple Law School. Coauthor of *The Living Memories Project*, he is a freelance writer whose video and interactive scripts have won numerous awards, including a Telly, an ITVA Silver Award, and a New York Festivals Bronze World Medal. He co-wrote the award-winning documentary *Digital Dharma* and has written radio, TV, and print ads for leading consumer product manufacturers. A veteran speechwriter and ghostwriter, he was director of executive communications and internal communications at a Fortune 500 company. He and his wife, Janet, live in Philadelphia, where he also writes plays and moonlights as a jazz pianist.

TENZIN DICKIE is a writer and a translator, as well as communications coordinator at BDRC. She's the editor of *Old Demons, New Deities: 21 Short Stories from Tibet*. Her work has been supported by a fellowship from the American Literary Translators' Association and a Fulbright fellowship. She is currently translating Pema Bhum's memoir into English and writing a book of essays about her family. An alumna of the Tibetan Children's Village school, she holds an MFA from Columbia and a BA from Harvard.

JANN RONIS, PHD, has been the executive director of BDRC since 2018. He studied Tibetan Buddhism and literature at the University of Virginia and taught for seven years at UC Berkeley. On many occasions he has lived in Tibetan monasteries on the Tibetan plateau for months at a time. Jann first met Gene Smith in 2002 and had the good fortune to work under Gene at TBRC in New York in 2006 and 2007. Gene provided Jann with the materials for his first published article, and Gene's writings were a huge inspiration to his dissertation research. Jann aspires to carry on Gene's legacy by bolstering BDRC's Tibetan programs while expanding the organization's reach and guiding the overhaul of its technology. He invites all readers of this book, especially the nonspecialists, to visit BDRC's website to see more of BDRC's immense archive.

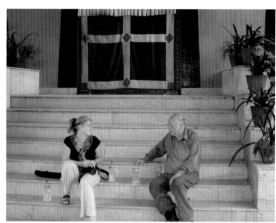

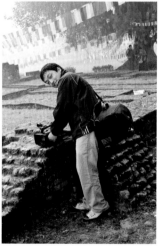
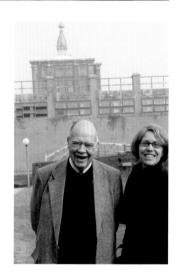
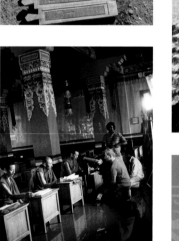

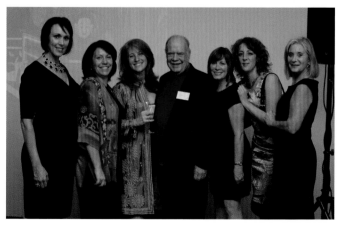

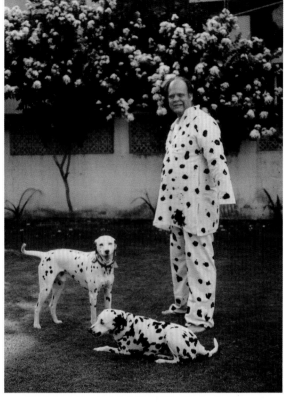

The rivers of India and Nepal,
Divided by different valleys,
Flow in different directions.
Yet, as rivers, they are all alike—
In the great ocean they will meet again.

Divided by the Four Continents,
The sun rises in the East, the moon
Sets in the West; as light-bearers
They are both alike: on a cloudless
Autumn evening they sometimes see each other.

Veiled by ignorance,
The minds of man and Buddha
Appear to be different;
Yet in the realm of Mind-Essence
They both are of one taste.
Sometime they will meet each other
In the great Dharmadhatu.

ཀྱུ་གར་གྱི་ཆུ་དང་བལ་པོའི་ཆུ།
།ལུང་བའི་དབང་གིས་སོ་སོ་ཡང་།
།ཆུ་པོའི་ངང་དུ་རོ་གཅིག་པས།
།ཆུ་མཚོའི་ཀློང་དུ་མཇལ་ཏེ་མཆི།

།ཤར་ནས་འཆར་བའི་ཉི་གདུགས་དང་།
།ནུབ་ཏུ་ཚེས་པའི་ཟླ་བ་གཉིས།
།གྲིང་བཞིའི་དབང་གིས་སོ་སོ་ཡང་།
།འོད་ཟེར་གྱི་ངང་དུ་རོ་གཅིག་པས།
།དགུང་སྟིན་མེད་ཀྱི་ངང་དུ་མཇལ་ཏེ་མཆི།

།རྒྱལ་བའི་ཐུགས་དང་འགྲོ་དྲུག་གི་སེམས།
།མ་རིག་དབང་གིས་སོ་སོ་ཡང་། །
སེམས་ཉིད་ཀྱི་ངང་དུ་རོ་གཅིག་པས།
།ཆོས་དབྱིངས་ངང་དུ་མཇལ་ཏེ་མཆི།

—excerpts from *The Hundred Thousand Songs of Milarepa*, translated by Garma C. C. Chang

Wisdom Publications
199 Elm Street
Somerville, MA 02144 USA
wisdomexperience.org

Library of Congress Cataloging-in-Publication Data
Names: Yachin, Dafna, author. | Fischman, Arthur M., author.
Title: Digital dharma: recovering wisdom / Dafna Zahavi Yachin and Arthur M. Fischman,
 with the Buddhist Digital Resource Center.
Description: First edition. | Somerville: Wisdom Publications, 2022. | Includes index.
Identifiers: LCCN 2021056449 (print) | LCCN 2021056450 (ebook) |
 ISBN 9781614297994 (hardcover) | ISBN 9781614298212 (ebook)
Subjects: LCSH: Smith, E. Gene (Ellis Gene), 1936–2010. | Archival materials—
 Digitization—China—Tibet Autonomous Region. | Archival materials—Conservation
 and restoration—China—Tibet Autonomous Region. | Buddhist sects—China—Tibet
 Autonomous Region. | Buddhism—China—Tibet Autonomous Region. | Buddhist
 literature, Tibetan. | Buddhist literature, Sanskrit.
Classification: LCC CD973.D53 Y33 2022 (print) | LCC CD973.D53 (ebook) |
 DDC 025.3/4140951/5—dc23/eng/20211221
LC record available at https://lccn.loc.gov/2021056449
LC ebook record available at https://lccn.loc.gov/2021056450

ISBN 978-1-61429-799-4 ISBN ebook 978-1-61429-821-2
26 25 24 23 22 5 4 3 2 1

Cover and interior design by Gopa & Ted2, Inc. Digital modification of Arhat Pantaka
by Dafna Yachin/©Lunchbox Communications, LLC, and Andrea Bitai. Image of
monk reading: Dafna Yachin/©Lunchbox Communications, LLC. Line drawing of
monk reading created by Gopa & Ted 2 from Lunchbox's digital modification of the
Rubin image.

Printed on acid-free paper that meets the guidelines for permanence and durability
of the Production Guidelines for Book Longevity of the Council on Library Resources.

Printed in Turkey.

About Wisdom Publications

Wisdom Publications is the leading publisher of classic and contemporary Buddhist books and practical works on mindfulness. To learn more about us or to explore our other books, please visit our website at wisdomexperience.org or contact us at the address below.

Wisdom Publications
199 Elm Street
Somerville, MA 02144 USA

We are a 501(c)(3) organization, and donations in support of our mission are tax deductible.

Wisdom Publications is affiliated with the Foundation for the Preservation of the Mahayana Tradition (FPMT).